JOHN CAGE

OCTOBER FILES

George Baker, Yve-Alain Bois, Benjamin H. D. Buchloh, Hal Foster, Denis Hollier, Rosalind Krauss, Carrie Lambert-Beatty, Annette Michelson, Mignon Nixon, and Malcolm Turvey, editors

Richard Serra, edited by Hal Foster with Gordon Hughes
Andy Warhol, edited by Annette Michelson
Eva Hesse, edited by Mignon Nixon
Robert Rauschenberg, edited by Branden W. Joseph
James Coleman, edited by George Baker
Cindy Sherman, edited by Johanna Burton
Roy Lichtenstein, edited by Graham Bader
Gabriel Orozco, edited by Yve-Alain Bois
Gerhard Richter, edited by Benjamin H. D. Buchloh
Richard Hamilton, edited by Hal Foster
Dan Graham, edited by Alex Kitnick
John Cage, edited by Julia Robinson

JOHN CAGE

edited by Julia Robinson

essays by Heinz-Klaus Metzger, Konrad Boehmer,
Yvonne Rainer, David W. Patterson, Branden W. Joseph,
Liz Kotz, Rebecca Y. Kim, and Julia Robinson

OCTOBER FILES 12

The MIT Press
Cambridge, Massachusetts
London, England

Page 221 constitutes a continuation of the copyright page.

For information about special quantity discounts, please email special_sales@mitpress.mit.edu

This book was set in Bembo and Stone by Graphic Composition, Inc., Bogart, Georgia. Printed and bound in the United States of America.

Library of Congress Cataloging-in-Publication Data

John Cage / edited by Julia Robinson.
 p. cm.
Includes bibliographical references and index.
ISBN 978-0-262-01612-4 (hardcover : alk. paper) — ISBN 978-0-262-51630-3 (pbk. : alk. paper) 1. Cage, John—Criticism and interpretation. I. Robinson, Julia E., 1969–
ML410.C24J537 2011
780.92—dc22

2011002050

10 9 8 7 6 5 4 3 2 1

Contents

Series Preface vii
Acknowledgments ix

Heinz-Klaus Metzger **John Cage, or Liberated Music (1959)** 1

Konrad Boehmer **Chance as Ideology (1967)** 17

Yvonne Rainer **Looking Myself in the Mouth (1981)** 35

David W. Patterson **Cage and Asia: History and Sources (1996)** 49

Branden W. Joseph **John Cage and the Architecture of Silence (1997)** 73

Liz Kotz **Post-Cagean Aesthetics and the Event Score (2001)** 101

Rebecca Y. Kim **The Formalization of Indeterminacy in 1958: John Cage and Experimental Composition at the New School (2008)** 141

Julia Robinson **John Cage and Investiture: Unmanning the System (2009)** 171

Index of Names 217

OCTOBER Files addresses individual bodies of work of the postwar period that meet two criteria: they have altered our understanding of art in significant ways, and they have prompted a critical literature that is serious, sophisticated, and sustained. Each book thus traces not only the development of an important oeuvre but also the construction of the critical discourse inspired by it. This discourse is theoretical by its very nature, which is not to say that it imposes theory abstractly or arbitrarily. Rather, it draws out the specific ways in which significant art is theoretical in its own right, on its own terms and with its own implications. To this end we feature essays, many first published in *OCTOBER* magazine, that elaborate different methods of criticism in order to elucidate different aspects of the art in question. The essays are often in dialog with one another as they do so, but they are also as sensitive as the art to political context and historical change. These "files," then, are intended as primers in signal practices of art and criticism alike, and they are offered in resistance to the amnesiac and antitheoretical tendencies of our time.

The Editors of *OCTOBER*

Acknowledgments

Heinz-Klaus Metzger's "John Cage, or Liberated Music" was originally published as "John Cage o della liberazione" in *Incontri Musicali* 3 (May 1959). It was translated by Ian Pepper for *October* 82 (Fall 1997), an issue he also edited. Konrad Boehmer's "Chance as Ideology" was originally published as "Zufall als Ideologie," a chapter in Boehmer's *Zur Theorie der offenen Form in der neuen Musik* (Darmstadt: Edition Tonos, 1967). It was also translated by Ian Pepper for *October* 82. Yvonne Rainer's "Looking Myself in the Mouth" was published originally in *October* 17 (Summer 1981). David W. Patterson's "Cage and Asia: History and Sources" is developed from "Appraising the Catchwords, c. 1942–1959: John Cage's Asian-Derived Rhetoric and the Historic Reference of Black Mountain College" (PhD diss., Columbia University, 1996). It was subsequently revised and published in its present form in *The Cambridge Companion to John Cage*, ed. David Nicholls (Cambridge: Cambridge University Press, 2002). We thank Cambridge University Press for permission to reproduce it here. Branden W. Joseph's "John Cage and the Architecture of Silence" was published originally in *October* 81 (Summer 1997), an issue he also edited. Liz Kotz's "Post-Cagean Aesthetics and the Event Score" was published originally in *October* 95 (Spring 2001). Rebecca Y. Kim's "The Formalization of Indeterminacy in 1958: John Cage and Experimental Composition at the New School" is a modified excerpt from chapter 3 of "In No Uncertain Musical Terms: The Cultural Politics of John Cage's Indeterminacy" (PhD diss., Columbia University, 2008). Julia Robinson's "John Cage and Investiture: Unmanning the System" is a substantially revised version of the essay of the same title in *The Anarchy of Silence:*

John Cage and Experimental Art (Barcelona: Museu d'Art Contemporani [MACBA], 2009).

Thanks to the individual authors for allowing us to present their essays here. My sincere thanks to Manfred Leve for his generosity in allowing us to use his photographs, to Gene Caprioglio at C. F. Peters (who contributes daily, and has done for many years, to registering and preserving Cage's legacy), for his unfailing support and consideration for this project, and to my colleagues at MACBA for precious assistance. For their important support, advice, and help in bringing this volume into being, I thank Yve-Alain Bois, Benjamin Buchloh, Annette Michelson, Christian Xatrec, Adam Lehner, Laura Kuhn, Melissa Larner, Delia Solomons, Christina Rosenberger, and Tyler Dean.

John Cage, or Liberated Music

Heinz-Klaus Metzger

Histoire oblige.

—*John Cage*

Both before and after World War I, reproaches against the first radical works of New Music were occasionally formulated out of ignorance. They essentially said that in such music the tones are combined arbitrarily, simply according to chance. Within this cacophony it becomes impossible, for instance, to distinguish what is correct from what is not and even whether the musicians of the ensemble play together according to a larger plan or are free to strike out on their own, performing more or less in the absence of external control. In this connection may be mentioned those anecdotes from the 1920s, still peddled today, according to which this or that famous modern composer failed, during a rehearsal of one of his own works, to notice that the second clarinet had played in an incorrect transposition throughout or that the third trombone had at one point played in the wrong clef. Such tales were favorites among orchestral musicians for whom this type of dereliction would have been common practice. Hardly ever in its entire history have such uninstructed arguments against the most legitimate consequence of composing been formulated—without even the benefit of the most cursory glance at the score or the most minimal listening experience.

Nevertheless, such opinion seems to have shaped the character of the public perception strongly enough to have dictated, as in counterpoint, the terms of the more serious theoretical treatments of New Music.

Whether technical analysis or aesthetic commentary, these theoretical statements—when intended apologetically—flow together indistinguishably into a single point, namely, that the perceptible chaos of this music is a kind of higher organization, a more difficult musical articulation (often, incidentally, as though these were identical), in short, that it is conventional. This is not actually false but rather resembles the mule in Schiller's rhetorical question in his treatise on the reason for the enjoyment of tragic subjects: "Doesn't the vulgar crowd often see only the ugliest confusion where the thinking mind rejoices in the highest order?" Thus music theory reduces itself to functioning against the hooting public as a kind of musical vigilante.[1] It thereby deprives itself of insight into some of the most important aspects of the historical advancement of artistic discipline, namely, those that touch, through the most diverse technical connections, on the idea of freedom, to which New Music has declared its allegiance from the beginning. In their horror, the reactionaries have thus understood more than the progressives who cling to their constructive ideas of a higher order, and it required all the recklessness of a dialectic that withstands such stupefaction to recognize in 1940 or 1941 that "the possibility of music itself has become uncertain. It is not threatened, as the reactionaries claim, by its decadent, individualistic, and asocial character. It is actually too little threatened by these factors."[2]

But this unjust charge, made against New Music from the beginning—that it is essentially anarchic—has now in fact been redeemed by John Cage. This explains the wrath his music provokes. Those who have acted for decades as the official advocates of New Music, obligingly establishing the precise inner consistency of the scores they analyzed, find themselves ultimately derailed by the phenomenon of Cage. In the case of his *Concert for Piano and Orchestra* (1957–1958), there is no full score but only the separate parts, which in no way correspond to one another. Further, their internal arrangement, which is compositionally achieved essentially by chance operations and which provides the interpreter/performer with a setup for experimental actions, is constituted by the strict avoidance of coherence or of a relationship between the elements. The piano part is the most developed, both in terms of the dimensions and potential density of events; it is notated on sixty-three loose pages, on which accidentally—through the coincidence of procedures—as many sequences are overlaid as would formerly have been the case only in orchestral scores of the most daring complexity. During the performance, the pianist may perform as he wishes, in whatever succession he chooses,

either all of the sections or a selection, when the manual possibilities lag behind the simultaneous layers of the parts and the pianist declines to use a previously recorded segment to complete what he cannot do all at once on the instrument with hands, feet, and mouth.

Cage uses eighty-four different notation systems; these are themselves compositional techniques from the very outset since he defines composition not, for instance, as the codification of musical representations but as a procedure of writing, almost as the method of the physical act of writing. Several of these eighty-four techniques are in their own right the techniques of other works by Cage. For example, in the relatively simple *Music for Piano* (1952–1953), the number of notes per page was determined by tossing coins, while chance imperfections of the manuscript paper determined the possible locations on which to write them. Only then were the five-line system for tones and the one-line system for sounds superimposed in order to read the notes wherever they had landed. Finally, he established the accidentals, the clef, and the manner of technical realization of the piece by tossing coins. Durations and dynamics, and, within wide limits, tone quality, were left to the discretion of the performer to draw from three defined technical categories: keyboard attack, pizzicato, or damping of the strings, the last—already more susceptible to nuances than the second—always intended to be combined with one of the other two in order that the section be acoustically perceptible. The procedures used in *Winter Music* (1957) accord with this compositional principle. In this piece, tone cluster aggregates are produced on the keyboard that can be read in various ways as a consequence of the ambiguity of the clef; another notation leads in the direction of aggregate time tendencies and simultaneously to various kinds of arpeggiation. At times, Cage's proliferating graphic fantasy describes bizarre linear networks on paper, something like tree structures, with the terminal points of the branches selected as notes that are then rendered legible by the superimposition of the five-line system. We encounter graphic notations that are reminiscent of grass in water; laid over them like aquariums are geometric display cases in which notes waft up like bubbles among grass. That Cage also investigated the medium of painting is clearly reflected in this graphic characteristic of his composing. In this notation, time does not always appropriately run one way, from left to right, although the score is written in this manner. Sometimes it curves and twists back on itself, as though wanting, through the power of suggestion, to render time itself reversible. Closed perimeters, whose adventurous forms here and

Figure 1.1 John Cage in Japan, 1962.
Courtesy John Cage Trust.

there bring the borders of a country in an atlas to mind, are threaded through with notes, and the interpreter is supposed to play them simultaneously clockwise and counterclockwise. Or there are notes distributed on the spokes of large wheels that seem to turn. There are also labyrinths of lines with notes at the intersections—tangles with notes at the knots—where the interpreter can find his way in the direction he pleases, even backward. Such a suspension of time, without ever requiring any musical imagination, to say nothing of performance according to the stopwatch, is a musical utopia that results—without a glance at the acoustic outcome—from a purely unfolding graphic inscription. The dignity of the great composers up to Schoenberg and perhaps even Boulez and Stockhausen resulted from faith in acoustic imagination and confidence in their capacity to imagine structure. These composers hardly dreamed of what could suddenly flare up solely from notations on paper under the conditions of the current moment. For those composers, this also would have meant remaining attached to the superstition that performance allows for the communication of the written score, a superstition that Cage, hardly out of solipsistic tendencies alone, has seen through totally. Graphic signs might still have served to communicate acoustic intentions, however clumsily, when binding conventions seemed unquestionably to continue to guarantee the way in which those signs would be interpreted. But in light of the degree to which even the historians failed to interpret Bach adequately, one should be suspicious of the musicological argument that this condition could be traced back to the seventeenth century. In any event, Rudolf Kolisch's theory and practice of performance as the realization of musical meaning—beginning as it does from the premise of a minute analysis of the score and then striving to translate this knowledge into its correlate in performance—is already an extreme expression of the prohibitive difficulty that is involved.[3]

When, by contrast, Cage conceives of composition as simply a way of working the paper with ink, one can suppose that the impulse behind it is a rebellion against music as the real passage of time. It becomes the objective corollary of the deep sense that "historically . . . the idea of time is itself based on the order of private property,"[4] namely, on the experience of temporal priority, already invested in objects; all musical form is nothing but the treatment of relationships of priority in time. In the piano part of Cage's *Concert*, this leads to a notation that shrewdly acknowledges the succession of sound events—its sequence—only in order to outwit it. The composer has drawn a small rectangle on the paper and strewn a

number of points irregularly across it that the player must transform into an equal number of sound events. To assist him in making a more exact determination, five straight lines cut off various corners of the rectangle, each of which is furnished with a key in the form of an initial indicating to which of the five categories—frequency, duration, intensity, timbre, and sequence—it belongs. Now the interpreter has to measure—presuming whichever of the scales—the distance between each point and the five lines, thereby clarifying which tonal event is the highest, the longest, the loudest, and the spectrally most complex, but also which occurs first. Adding to the classical parameters of sound phenomena as defined by serial music, we encounter an additional parameter here, namely the position in the sequence, inasmuch as this aspect is treated as a parameter of the single event, in the same manner as pitch or timbre. Through such mimesis, music breaks the spell of temporal priority, and a myth is thus rendered powerless. Gottfried Michael Koenig's critique—that the integration of sequence within the definition of parameter was based on misunderstanding—misses the point that such compositional achievement comprehends itself as a graphic procedure.

A notation developed from the same principle, using small, medium, and large points corresponding respectively to one-part events, two-part intervals, and multitone aggregates, goes further in its attempt to assign a temporal order to the single elements; since every component of the combined phenomena may be explored by means of a single measurement, the significance of the five-line stave is defined as exchangeable after each measuring operation, in order to obtain various definitions for the same graphic points. The most radical application of this procedure resulted in *Variations I* (1958), one of numerous works by Cage that call for an unspecified number of pianos or other sound sources. Here, the various large graphic points appear on a now squared small piece of paper; the five-line systems are laid out in constantly differing constellations on several identically sized squares made of Lucite that can be superimposed in diverse positions on the points. Incidentally, the description of the eighty-four related systems of writing used in the solo part of the *Concert for Piano and Orchestra* is not a task for musicological research into musical notation, since Cage provides a clarification in his preface and thus graphic systems are the most authentic illustration of the preface. One also finds, among other things, diagrams that are reminiscent of the principle used in certain scores of electronic music, with various numerical and geometric depictions. At one point, the geography of a

concert piano is indicated in order to define the pianistic actions locally; at another, one finds the procedure of Cage's electronic work *Fontana Mix* (1958) almost literally anticipated.

The various orchestral parts, among them vocal parts,[5] however, do not exceed twelve, fourteen, or sixteen pages, from which the musicians of the ensemble, like the pianist, may translate a number, chosen according to their own discretion, and in the time they choose, into actions aimed at sound phenomena. For each part, the number chosen can also be zero: any part may be omitted—or if the occasion should arise, all, so that the presentation of a nonperformance as one possible interpretation of the work is explicitly defined in its conception. Conversely, it is possible to play each part as a solo piece or with other smaller or larger chamber music combinations; finally, should the piano be absent, the musicians may come together as a symphony. In order for the musicians of the ensemble to agree on the duration of the performance, it is advisable for the individual participants to divide the material each intends to play accordingly, and to work out a timetable, which may be checked with a stopwatch. If a conductor joins them, he functions as a clock and does not conduct but instead indicates the time: the circular motions of his arms are read by the musicians as rotating second hands. He does not follow a score but rather a particular part, the conductor's part; it contains nothing but the deviation of conductor time from clock time. The conductor is an irregularly running clock.

It is a slap in the face of every traditional European aesthetic concept that the performance of Cage's work is a procedure largely constituted by accidents that are, strictly speaking, accidents of performance that cannot be related conclusively to notation. It is a further slap that during the performance the notations themselves refuse to generate a correlative sensuous appearance that would communicate meaning, since these notations are the results of mere chance operations in the technique of writing and in no way the formulations of a composing subject. According to this idea, the artist is expected to determine the form, articulated to the smallest detail as a meaningful whole, whose necessity is measured by the degree to which nothing in it could be otherwise than it is, so that the precise function each element fulfills in the whole can be grasped. That notes should stay exactly where they have fallen through blind chance, for example, or that performers should take those that first strike them accidentally and—God knows how—translate them into definite actions, cannot be reconciled with this idea. In Cage, the explosion of

the Western work of art is finally consummated in music. He lets an
age-old cat out of the bag—that there is something secretly false in this
necessity for the inner complexity of the work of art, that this claim has
only to be raised so emphatically the less it is necessary to imagine that
traditional works are actually conceived in the minutest detail. Cage sees
through this as ideology. The chaos of the *Concert for Piano*, which is more
complex than any conceivable procedure that could organize it, is noth-
ing but the swarm boldly set free just at the right moment from under
the stone of musical organization. Cage's repudiation of organization is,
however, not a capitulation of compositional reason, not an abdication
of the compositional subject. To the contrary, this reason manifests itself
throughout in a manner that justifies the forgotten category of originality
in a new way. It functions, banal as it is, as a game of loser wins. Con-
cretely, almost too concretely, Cage's most recent works propose social
visions. Until now, musicians, even those trained to perform chamber
music, only knew the law of coerced labor as specified in the musical text
and the conductor's baton, invisible, virtual, reigning over both quartets
and quintets. Cage set the musicians free, allowing them to do what they
like in his works and giving them—although he is not always thanked
for this at performances—the dignity of autonomous musical subjects: to
act independently and to understand the significance of their work, just
as in an emancipated society everyone will be permitted to realize his
work without enforcement, watched only by the clock as a sign that even
then morning would be followed by evening. In relation to social praxis,
musical praxis remains theoretical. The idea of freedom is performed as
a theatrical play—whereas outside, it would be necessary to murder the
conductor and tear to pieces that score according to which the world at
large is performed, that codified relationship of the voices of its counter-
point that reproduces the machinations of domination.

> It is always problematic to specify the "social content" of music: In
> establishing the independence of its tasks and techniques, traditional
> music removed itself from its social basis and became "autonomous."
> (That the autonomous development of music reflected social de-
> velopment could never be deduced so simply, unquestioningly, as it
> could, for example, in the development of the novel.) It is not only
> that music *per se* lacks that unequivocal objective content, but rather
> that the more clearly music defines its formal laws and entrusts itself

to them the more, for the moment, it closes itself off against the manifest portrayal of society in which it has its enclaves.[6]

Only in those formal laws, themselves crystallized by the very technical configurations of the work, can the social content be grasped, in particular the way art turns against the principle of domination whose stigmata it is also compelled to reproduce at its center.

In contrast, politically engaged music has rarely been successful. It can only express its engagement through its external choice of text, as vocal or theater music, where, not accidentally, the assimilation of its immanent form complex to the stupefying slogans of a mass movement organized according to the leader principle testifies to a reactionary identification in musical terms as well. Engaged works succeed only seldom, as in the case of Schoenberg's *Survivor from Warsaw* (1947) or Nono's *Canto Sospeso* (1955–1956), where the music's own meaning does not disavow the political appeal contained in the text but even lends its power to that appeal. The texts are strictly, and certainly not arbitrarily, those of suffering, not those of a call to reconstruction. Through the spectacular element of decomposition, Cage's disorganization of musical coherence, as of the performing ensemble that has nothing more to represent, may be understood as an attempt to place immanent musical meaning in accord with the bluntness of a political appeal.

With such disorganization, however, the musical impulse reverses itself. What was once conceived of as music breaks apart. "You need not think of it as 'music,' if this expression shocks you," Cage said in a lecture. Today, musical organization essentially means the organization of divergent parameters of sound phenomena by means of serialization. This serialization goes back to Schoenberg, who was accused of concentrating his constructive efforts too exclusively on the parameter of frequency since the formulation of the so-called twelve-tone row is in fact not composed of twelve tones but of twelve pitches. In any event, it is obvious that Schoenberg understood the row as the vehicle for the totalization of thematic work: even the smallest accompaniment figure must verify itself as thematic. This stands in extreme contrast to Webern, for whom the row was almost always made up of the elaboration of interval constellations and for whom the row became a structural formula, capable of folding harmony, counterpoint, and form into a unity and thus of transforming the row principle into a new concept, but one with a tendency to

serialize the other parameters. The truth concerning the ostensible constructive primacy of pitch level in Schoenberg's twelve-tone works can be discovered by examining what objectively occurs in his own medium of construction, that of thematic work. If he organized with the pitch levels, it was with the other parameters that he composed.

There are countless examples, such as the last movement of Schoenberg's *Wind Quintet* (1923–1924), where thematic work becomes almost exclusively rhythmic, thus unfolding itself within the parameter of duration, and themes are indeed defined exclusively by rhythm. Despite its many exemplary performances by Webern, one of Schoenberg's works that is still underrated by the twelve-tone school, on account of the simplicity of its row treatment, is the *Begleitmusik zu einer Lichtspielszene* (1929–1930).[7] Yet this work, because of its original, untraditional form and its unequaled identity of construction and expression, belongs to the best works of Schoenberg's twelve-tone period. Throughout its course, as it attempts illustratively to show fear, anxiety, and catastrophe, it is also the most extreme paradigm of a musical coherence that forms itself from the most subtle relations among rhythmic shape, time lengths, timbre, dynamic areas, and sound mass. Pitch relationships, already fixed, "organized" by the quite transparent disposition of the row, are really immobilized by it, nearly excluded from compositional work. These are its only perceptible contributions to form: the exposition of the third E–G♯ at the beginning, which returns at the end, becomes, as does the fifth relationship that divides the row in the *Wind Quintet*, a reminiscence of the principle of tonality against which the "method of composition with twelve tones related only to each other" had been conceived in the first place.

From this one can learn the difference between organization and articulation, whose sublation was Webern's project; specifically, the function of the interval in his compositional activity increasingly constituted both organization and articulation. Nevertheless, in his later works the tones remain together as they could not have done had Webern been able to compose them; the row has written them, not the composer. In the first piece of the first book of Boulez's *Structures* (1952), there are actually only such notes. The organization, concocted by the compositional subject in order to be able to control all the consequences of his musical conception, now detaches itself from him and, confronting him as something reified, alienated, and dictating to him what he must write, ends by controlling itself. Cage's enterprise starts from this extreme condition of

alienation, namely, from chance, within which the compositional subject cannot intervene. One may say that whether the composer is dictated to by chance or by the row as to what to write in this or that place amounts to the same thing, except that the subject can finally dedicate him- or herself to chance—which is not filled with intentions—while the organization that the composer himself has produced as objectified opposes itself to him as something alienated and, assuming an evil aspect, turns against his own intentions.

The fortuitous as accidentally encountered can also be fortunate, as "happy-go-lucky" can eventuate in "happy ending." Organized luck is unthinkable. With the Cagean work the question as to whether good or bad music results has lost its point. One attends to good music in order to verify whether the means are employed with a logical relation to the artistic purpose, and this principle is essentially a reflection/replica of the economy and, finally, of material production, just as the idea of artistic quality was assimilated from the market into artistic achievement. But if one views this question of production in relation to the historical situation, it would hardly be possible to advocate an undiminished idea of artistic quality, and one would instead be interested only in the truth content of works of art.[8]

Cage's music insists on its own absolute lack of purpose and value. Thus the only thing left is to inquire after its truth or untruth. Its truth consists in the fact that it proclaims a condition in which the hierarchy of purpose—without which the inherited idea of musical meaning itself would be unthinkable—and the law of value would no longer be assumed; its untruth lies in the fact that it undertakes this under social conditions that mock all of this. In this sense it is also experimental. It does not pretend to be something in fact already attained. That Cage defines experimental composition conclusively as that whose results cannot be foreseen is at the same time the subtle metaphysical tact of a musical beginning that, according to its immanent perspective, dares to gravitate toward the precise political meaning of a future world that has been emancipated from the principle of domination.

Since this can only be conceived together with technological progress, Cage has devoted his greatest attention to the expansion of instrumental-technical possibilities. He has obtained a comprehensive new catalog of methods for tone production for nearly all of the orchestral instruments, as when the wind instruments are taken apart and put together again during the performance in various instances, or the violin

strings are played longways with the bow, contrary to the mechanical design of the instrument, or the most diverse means are taken up—objects that themselves have nothing to do with music.[9] In this way, he also denounces the dominant technological regression that is imposed by social contradictions onto a world facing the currently possible fulfillment of all the technological dreams. For such makeshifts attest to a state of poverty. As long as, for example, no such instruments exist that offer richer tonalities up to the complex spectra that include noise, one should not indict the composer for employing children's trumpets but should instead call the technical deficiency of the epoch by its social name and insist on the technically available beginning of the messianic age, a humanity that is fully supplied in each and every sector. What Cage stages for piano or trombone calls, in the final philosophical instance, for the abolition of hunger and at the same time struggles with the conditions of its continuing existence. In a certain sense, the problematic of instrumental technique conveys the astronomical distance between Cagean consciousness and the situation of the epoch. Liberated music is not freed, as disorganization, from music-theoretical formations, and a theory of experimental music quickly encounters the tendencies of the very tradition it puts to death. With his demolition of the "obbligato style," the development of which really accounts for the relevance of Western music, Cage, whose composition tends to oppose all object creation, probably marks the absolute antitraditionalist extreme. His conception of the musical object strikes at what he can no longer bear in this tradition: that the themes and figures within it are like cast objects, which are always recognizable, even when they are shifted to a new position, so that finally the entire work is literally such an object, a thing that every performance merely presents in its condition of persistent preservation.

In a certain sense the oeuvres of Schoenberg and Webern certainly mark the historical climax of this object formation in Western instrumental and vocal music. In their scores, care is taken to specify even the smallest detail with such precision that the least differences in interpretations are hardly legitimate any longer and only the absolute identity of the work with itself remains. Perhaps this is more securely established in those electronic works where forms are fixed once and for all on tape. Indeed, this object formation logically implies the reduction of music to acoustic phenomena, precisely as it has been fulfilled in those electronic works at the performance of which there is nothing to be seen.

When, to the contrary, Cage determines the work as praxis, process, action, it must not be overlooked, however, that what has always been referred to as form in traditional music had already tended in this direction. What Schoenberg's music ambitiously aimed for and took great pride in at the level of object formation—that one could not know beforehand what was to come—will only be realized in the experimental work of art. But Schoenberg's principle of nonrepetition, of the varied reprise, is applied in Cage to the performance of the work itself. This work does not remain identical with itself in the primitive sense of the identity of the performances with each other, but more intensely in the identity of the conception. This shifts the relationship between composition and interpretation, which in the traditional work is a constitutive demarcation line between the two fields. Not that a simple reaction asserts itself against the further expansion of composition. In fact, until only recently, the course of music history displayed the contrary tendency. If Johann Sebastian Bach, for instance, still left categories in his notation—such as tempo, phrasing, articulation, dynamic, and accent—almost entirely open so that these fell within the competence of the interpreter's capacity to convey meaning, subsequent composition increasingly subjected these areas to its own discipline, transforming them into elements of strict composition until they thus became integral. Beginning with Kolisch, generally with Schoenberg's Association for Private Musical Performances in Vienna, a concept of an integral interpretation was developed that would even be applied retroactively to Bach's music. Not that the realm of interpretation is once again expanding. Instead, a change of function is taking place, instructed by the musical text. It is hardly necessary to emphasize that in a traditional work, a sonata by Beethoven, for example, the notes are not instructions that tell the pianist when and how to depress and release which keys—they are not specifications for actions—but the description of a resulting sound that refrains from conveying with which technical means this could be produced. This is so true that during a performance—that is, the sounding of this very result—one does not simply read the notes but may actually judge the quality of the performance by the greater or lesser agreement between the acoustic phenomena and the notation. This is not self-evident, and one can only hope to comprehend such music when one relinquishes this habit in order to reflect upon it. Such a notation of results communicates precisely the formation of the object. Fixing the result is already the casting of an object, and

imagination, that is, the capacity to anticipate the result on the basis of the notation as acoustically embodied, has as its precondition and as its exclusive project such traditional music and the experience of its praxis. With Cage, however, the displaced relationship between composition and performance is essentially a shift in compositional efforts from results to actions whose outcomes are not foreseeable. This last condition is, incidentally, the basis of the difference from Stockhausen's instructions for action in, say, *Zeitmasse* (1955–1956) or in the *Klavierstuck XI* (1956). There, commands that the performer perform specific actions replace an intelligible text, and interpretation itself is actually eliminated; obedience takes its place, guaranteeing a result that has been precisely precalculated by the composer, one that would be endangered if represented by a text indicating results, where, in order to realize it, the interpreter would have to introduce reflection into the process.

In contrast to this, the composer of Cagean music is no longer the figure of the leader. It is this, and not the canceling out of the compositional subject, that is the point Cage makes in a lecture by stressing that until now, rather than calling attention to the tones, music always recalls the presence of the composer, whose task should be to place the tones in a social situation instead. Cage's work proposes specific possibilities of action to the musicians and, if one wants to define it at all, is nothing but a field of possibilities. One cannot fail to recognize an affinity, however subtle, with the barbarity of the musical practices of song plays, youth, and school songs, and other musical activities of a healthy vitalism, which expect results from the unleashing of the ludic dimension as such—possibly even the so-called rejuvenation of society. But in contrast to Cage, these do not really liberate play but regiment it instead through particularly stolid musical texts that jettison the traditional concept of the work of art not by dissolving it critically but only as a result of their wretchedness. The formal principle of their musical ensembles is that of the social gang and of a repressive discipline; it is thus the polar opposite of Cage, who assumes the emancipation of the individual musician. Further, Cage's liberation of action goes beyond acoustic phenomena, to which the constitution of a musical object is restricted. Action is visible. The attack of the keyboard, the pizzicati on the piano strings, the pianist's transit to the other end of the piano, the taking up of mallet or whistle—these actions remain pianistic. The spectacular aspect of such actions may remain less important than the acoustical character, or they may outweigh it. One can form an entire scale of combinations of

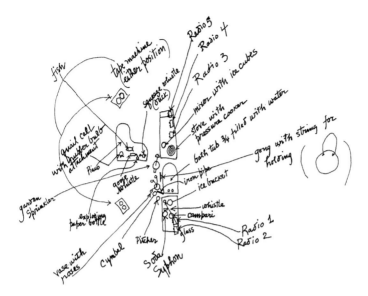

Figure 1.2 John Cage, *Water Walk*,
1959. © 1961. Used by permission of
C. F. Peters Corporation on behalf of
Henmar Press Inc.

actions. In *Music Walk* (1958) for pianos and radio apparatus, and in *Water Walk* (1959) for pianos, radio apparatuses, kitchen equipment, and water, arranged in three aggregates, the principle is pushed to such an extreme that the pianists must be involved with all the sound sources, which are as widely distributed in space as possible, so that the performers are thus in transit most of the time. Here—after the downfall of opera, the failure of the epic music theater, and the necessary end of realism in theater itself— is the beginning of a new music theater, tentatively evident, responsible only to not betraying its own possibilities.

Notes

1. On occasion, literally. Before a Cage concert, the organizers asked me to explain to the public the technical reasons for the use of the entire piano, that is to say, not just the keyboard but also certain other devices that often provoke laughter since one is more ac- customed to seeing those devices in the hands and mouths of children. My argument was that we were dealing with the presentation of a scale of sound colors (*Klangfarbenskala*) that begins on this side of the "normal" piano tones with sinusoidal whistling, then with attacks on the keyboard, going on to the pizzicati and sordino performed on the strings with the fingers, to sounds produced both within and without the piano case all the way to those

complex phenomena produced via radios or other apparatuses. This argument pacified the public to a degree that on the occasion of this concert it collaborated hardly at all in this scale. Cage refused to offer the public such a clarification, instead making a provocative text available.

2. Theodor W. Adorno, *Philosophy of Modern Music*, trans. Anne G. Mitchell and Wesley V. Blomster (New York: Seabury Press, 1980), 112.

3. The violinist Rudolf Kolisch (1896–1978) was the founder of the Vienna String Quartet, which premiered works of Schoenberg and Bartok. He emigrated to New York City in 1940 and, through teaching and performance, had an enormous impact on music in the United States, for example, with his seminar "Musical Performance: The Realization of Musical Meaning," given in 1939 at the New School for Social Research. He taught at Black Mountain College in 1944 and at the New England Conservatory in Boston until his death. He was also active at Darmstadt in the 1950s. [Trans.]

4. Theodor W. Adorno, *Minima Moralia: Reflections from Damaged Life*, trans. E. F. N. Jephcott (London: New Left Review Books, 1974), 140.

5. Cage's revolution in vocal technique is complete. First of all, he sees through the conventional character of the so-called "natural vocal range." When one goes beyond this range, the result is only a change in sound color, which traditional music cannot endure but which for him is quite agreeable. Cage has the same opinion of the bel canto as Kolish has of the "beautiful tone" of the strings. In truth, the most diverse manners of singing are possible, actually through inhalation and not just through exhalation.

6. Adorno, *Philosophy of Modern Music*, 129.

7. This expressive score of *Musical Accompaniment to a Cinematographic Scene*, composed in three movements entitled "Danger Threatens," "Panic," and "Catastrophe," was recorded in 1978 by the BBC Symphony Orchestra under the direction of Pierre Boulez. Apparently conceived for silent cinema, it remained wholly neglected within film production until Jean-Marie Straub's employment of it in the core of his *Introduction to Arnold Schoenberg's "Accompaniment to a Cinematographic Scene"* (1973). To a brilliant silent montage of the cinematic documentation of destruction by war and fascism in our era, Straub added Schoenberg's coruscating epistolary denunciation in 1923 of Kandinsky's anti-Semitism. [Ed.]

8. Adorno disputed Metzger's tendency to conflate *Sinn* (meaning), *Zweck* (purpose), and *Qualität* (quality), in order to show that none of them could survive music's "suicidal emancipation" (see "Kriterien der neuen Musik" [1958], in the volume *Klangfiguren* [Frankfurt and Berlin: Suhrkamp Verlag, 1959]). After quoting at length from an unpublished letter from Metzger, Adorno says, "The market probably had its share in the formation of the category of musical quality, but what survived the market was not mere exchange value—whose blind authority is only fully established today—but always something more. The capacity to make distinctions of quality at all would not have spread at all but for the market system, and this capacity comes into its own only at the moment when it has freed itself of market mechanisms. Musical quality . . . has long since objectified itself" (166). [Trans.]

9. In his theory of jazz, Adorno decoded such phenomena psychoanalytically as the symbol of castration (see *Prisms*, trans. Samuel and Shierry Weber [Cambridge: MIT Press, 1981], 129). It suffices to study the entire context of the castration symbol in jazz to perceive the absurdity of transferring this isolated observation from one sphere to another. Function remains the sole criterion, as always.

Chance as Ideology

Konrad Boehmer

Common harps resound under every hand.

—*Karl Marx, doctoral dissertation*

When the American composer John Cage took the podium at the Darmstadt Summer Program for New Music in 1958 to lecture on and demonstrate the principle of indeterminacy, the absolute primacy of serial organization over musical form in Europe had already been broken. The link between serialism and indeterminacy, which had already been critically elucidated without Cage's contribution, had produced works such as Pierre Boulez's *Third Sonata* for piano (1957–1962) and Karlheinz Stockhausen's *Zeitmasse* for wind quintet (1957). Stockhausen had subjected the traditional serial conception of the parameter to a comprehensive analysis, criticizing the discrepancy between the determination of analogous parameters and at the same time sketching the outlines of a "new morphology" of musical time.[1]

In his lecture "Aléa," Boulez had already unambiguously and acidly repudiated the programmatic use of chance, laying bare the intellectual poverty of hoping to solve musical problems through this means while sketching the possibilities opened for musical thought through the integration of strict criteria of musical indeterminacy.[2] It may be assumed that the further development of the serial system might have succeeded without Cage's intervention; over the years, with his help, it has become increasingly confused.

Cage had the greatest success among composers of inferior quality, those who wanted to escape from the rigors of serial composition anyway but who—obeying the fashion of the times—did not dare return to the neutral idiom of neoclassicism. Through Cage, they not only justified the discovery of a dismaying simplicity in technical matters; they also legitimated these as "up-to-date" by means of handy philosophical props. And the lament that Cage has had a catastrophic effect on musical development, raised year after year in the press, is only a half-truth; equally so are the protests by individual composers that their aleatory conceptions were in no way influenced by Cage. In fact, composers of the first rank, such as Boulez, Luigi Nono, and Gottfried Michael Koenig, simply laughed at Cage's philosophy, and one cannot suspect that they have after all secretly made it their own in their work. Yet composers such as Stockhausen and Pousseur—however much they might personally deny it—have internalized the Cagean worldview with no benefit to their production. This is especially so in the case of Stockhausen, who until the *Groups for Three Orchestras* (1955–1956) wrote work on the highest level; his submission to ideological forms of indeterminacy was followed by a drastic drop in compositional quality, now evident.

For the success enjoyed between 1958 and 1961, first at Darmstadt, then in other European centers of advanced art, Cage can probably thank the auspicious moment at which he made his entrance. For although the breakthrough to principles of more comprehensive organization had already appeared on the serial horizon, these—and with them the theory of controlled indeterminacy—had barely been grasped; much less had they been productive of finished theories. In principle they could have led, through compositional deployment, to the transcendence of serialism's contradictions. Cage appeared, then, as deus ex machina. Given its obvious musical insufficiency, something no serially schooled composer could have confidence in as a formula for use was presented by Cage as a philosophical system free of contradiction, namely, chance. The nonchalance with which he delivered his theses must have been as fascinating as his lack of respect for serial doctrine. All of this created the impression that the exclusive use of chance absolved the author of all historical obligations, against which he had in fact already theoretically turned. And yet the ideology of absolute freedom, which no doubt dates back well into the nineteenth century, is itself the result of unresolved historical antagonisms.

Figure 2.1 John Cage and Karlheinz
Stockhausen, c. 1958. Courtesy John
Cage Trust.

Since nothing in Cage's works lends itself to analysis—chance pro-
ducing nothing that can sustain musical scrutiny—the Idea moves into
the foreground. This Idea, however, originates less in philosophical re-
flection than in the unacceptable contradictions of Cage's earlier oeuvre.
This early work is structurally alien to the principle of mediation, which
has been replaced with that of mere arrangement, the simple addition
of material. It already tends thereby toward the isolation of the musical
element. In traditional musical idioms, this isolation was often given form
by the ostinato-like repetition of rhythmic patterns or simple interval-
lic relationships. Cage's *Metamorphosis*, for example, is put together from
row fragments that are not subjected to variation: the cells of the row
become figures suitable for use as ostinatos, whose repetition, reminiscent
of folkloristic music, casts doubt on the necessity of employing rows at
all.[3] This additive procedure becomes a model for other works such as the
Trio (1936) or the *Quartet* (1935) for percussion, which string together
invariant rhythmic patterns with no attempt at differentiation.

As is frequently the case with American music of the first half of the twentieth century, which, for want of an independent tradition, tends to opt for reliance on American folkloristic or church music, this method has the quality of existing within a technical preserve.[4] In most cases the clichéd quality of such works overwhelms their compositional innovation, if these are at all significant.

In the *String Quartet* of 1936, patterns and clichés accumulate according to the principle of collage, a patchwork of empty phrases from various musical idioms, but without—as is often found in such cases with Stravinsky—such additive procedures having an ironic or critical function or even contributing to coherence.[5] Cage's scores up until 1938 or so are startling in their simplicity of compositional procedures; the absence of authentication for the score provides no evidence to the contrary. Whoever knows Cage as the author of totally indeterminate "experimental" music is not a little astonished that the rhythmic constellation of his earlier music is calculated rigidly with the bar lines—in the manner of an old-fashioned orchestra leader. Even works that borrow from Varèse, such as *Construction in Metal*, display this schematic quality to the point of paralyzing monotony.[6] Thus the integration of percussive sounds—the sine qua non of his musical emancipation—recedes behind simple rhythmic divisions, which, for the most part periodic, remain at the level of the most elementary interactions of changing tones within closed structural blocks. The rhythmic structure plays no part in the organization of the musical givens; to the contrary, it prevents any differentiated unfolding of the material, since it serves the simplest, unvaryingly schematic repetition. In the first *Construction* the metric scheme is 4–3–2–3–4; it is repeated untransformed sixteen times (a coda based on the scheme 2–3–4 is added). The revolutionary gesture ends up in schoolmasterish symmetry, which nevertheless behaves in a manner that is purely external to musical phrasing.

In fact Cage takes such schemata—which could only possess musical sense thanks to musical relationships (of which they are a component)—to be a quality, a thing in itself, and in the complete catalog of his works he makes special mention of the "rhythmic structure" of a number of works.[7] The metrical unit, which in the idiom of tonal music had a musico-linguistic and syntactic function, becomes an independent schema whose mechanical use conversely erodes the development of the phrase. Moreover, procedures for using variable meters are not developed;

to the contrary, identical rhythmic grouping predominates in most of the works. What is consistently carried to the level of the single note in Schoenberg's music, namely, a compositional critique of a conception of musical relationships that had become questionable, is with Cage merely the result of underdeveloped, unreflected compositional technique and should really not be termed "critique."

The disparate blocks or cells, which are coordinated from above, so to speak, result, through the failed emancipation of sound "in itself," in a false substantiality.

As for the principle of "preparation" of the piano strings, as employed by Cage beginning in 1938,[8] the isolation of sound is exchanged for the supposed increase in the substance of the tones now seen as compensation for the sacrificed order of connections.[9] This order, as Cage himself continually underscores, is the dictate of man over nature, the violence done by compositional systems devised by humans. The sounds must be freed from this enslavement: "Or, as before, one must give up the desire to control sound, clear one's mind of music, and set about discovering means to let sounds be themselves rather than vehicles for man-made theories or expressions of human sentiment."[10]

To all appearances, the seeds of later ideological confusion, which Cage built with unparalleled superficiality into an ideological system, can be found in the procedure of piano preparation. This isolation, made into a program, negates the basis of musical interrelationships in the case of the "prepared piano" by abolishing the principal of homogeneous scales in favor of the particularity of estranged single tones, so that the meaning that was previously found only in their configuration is projected into single tones. The abstract detail is thus legitimated as a system. Thanks to their timbres, alienated by means of metal or rubber elements, the single piano tones are removed from their functional context and made into a set of phenotypes such that each stands for itself—not ordered via a sound-color continuum that could mediate between it and the next estranged tone. The compositional procedure, however, does not reflect this peculiarity. The piano pieces go on orienting themselves according to just those homogeneous scales of the piano that the preparations have degraded to an epiphenomenon.[11] But for Cage an ideological justification is ready to hand. This tone, barred from any functional context, seems to him to stand for freedom. In a description of probabilistic processes in Earle Brown's *Indices*, Cage remarks,

The sounds of *Indices* are just sounds. Had bias not been introduced in the use of the tables of random numbers, the sounds would have not just been sounds but elements acting according to scientific theories of probability, elements acting in relationship due to the equal distribution of each one of those present—elements, that is to say, under the control of man.[12]

But the tables of chance operations are also schemata, designed by people using complicated techniques.

Although the critical doubt concerning established musical contexts—and along with this, the skepticism toward their compositional-technical foundations—is the impetus for all musical evolution, Cage would like to veer out of this historical trajectory in order to decree a far simpler one. The liquidation of sense and of relationships ends by reifying those very relationships, as though they are simply there and did not come into existence over time:

> Several other kinds of sounds have been distasteful to me: the works of Beethoven, Italian bel canto, jazz, and the vibraphone. I used Beethoven in the *William's Mix*, jazz in the *Imaginary Landscape Number V*, bel canto in the recent part for voice in the *Concert for Piano and Orchestra*. It remains for me to come to terms with the vibraphone. In other words, I find my taste for timbre lacking in necessity, and I discover, that in the proportion I give it up, I find I hear more and more accurately. Beethoven now is a surprise, as acceptable to my ear as a cowbell.[13]

No composer is obliged to feel affection for Beethoven. But his ideas remain questionable when he cannot distinguish between Beethoven and a cowbell and cannot refrain from imbecilic comments such as, "Is what's clear to me clear to you? . . . Are sounds just sounds or are they Beethoven? . . . People aren't sounds, are they?" Or, "We know now that sounds and noises are not just frequencies (pitches): that is why so much of European musical studies and even so much of modern music is no longer urgently necessary. It is pleasant if you happen to hear Beethoven or Chopin or whatever, but it isn't urgent to do so any more."[14]

It would be premature to conclude that Cage arranges his musical or theoretical events for the sake of destroying false bourgeois cultural ideals that he constructs criticism manifested in musical actions. If Adorno has

said that Cage's music is "a protest against the domination of nature," then one might reply that he constructs a nature ideology out of this, because in fact Cage has long since done so and in the very manner Adorno critically cautioned against: "The practical joke turns deadly where it appeals to an exotic, home-spun metaphysics, and aspires to precisely that affirmation it set out to denounce."[15] This affirmation is already inscribed at the core of Cage's enterprise, since his critique of musical relations, which he simply identifies with the domination of mankind over nature, fulfills itself in the liberation of "raw" sounds outside the entanglement of manmade systems.[16]

Heinz-Klaus Metzger finds this critique a praiseworthy surrogate for an attack on the principle of men's authority over men. But the idea of domination is not to be abstracted from the dominated, nor the oppressor simply revealed as anathema par excellence. Just as the criticism of domination of nature entails nothing that is not functionally bound up with the domination of men by one another, so Cage's compassion for enslaved nature reverses into the domination over men.[17] The reduction of musical context to the presentation of isolated sound phenomena—single sounds—liquidates musical sound, which possesses significance only through its contextual placement; it is thereby replaced with pre-musical natural material. In those works by Cage that are fully given over to chance, every sound, no matter where it comes from, is always the right one. The basic postulate of the unity of art and life shies away, however, from the challenge that for that unity to be realized, life must first become better than it is. On the contrary, here that critical character of art is totally purged. It becomes part of the worst general conditions and gets mixed up with the banalities of daily routine:

> When we separate music from life what we get is art (a compendium of masterpieces). With contemporary music, when it actually is contemporary, we have no time to make that separation (which protects us from living), and so contemporary music is not so much art as it is life and anyone making it no sooner finishes one of it [sic] than he begins making another just as people keep on washing dishes, brushing their teeth, getting sleepy, and so on.[18]

Even though dressed up as revolutionary, this isolation of sounds from one another—which is justified by the claim that only in this way can they be themselves—quickly reveals its reactionary side. Similarly,

Figure 2.2 John Cage, *Imaginary Landscape No. 5* (with Cage's instructions), 1952. © 1961. Used by permission of C. F. Peters Corporation on behalf of H. Henmar Press Inc.

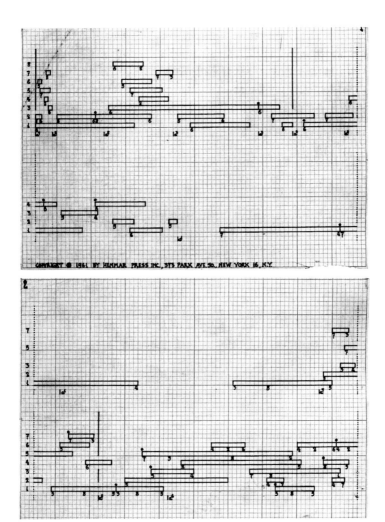

perhaps, to the savage who can only perceive the phenomenal but not the functional aspect of natural events, grasping them as particular and personifying them, Cage's liquidation of context is a regression into false myth. In the name of the nonsensical reproach that musical systems have forced musical material into a straitjacket that is incompatible with its freedom, qualities are attributed to whatever of this material that somehow survives its total isolation, although it cannot be determined how this quality arises.[19] This antagonism remains unresolved in Cage's

philosophy and his music. The theory makes things simple insofar as, rather than resolving this contradiction, it exalts it as nature, concealing this failure behind sheer subjectivity. Here Cage goes so far that one is tempted to compare the level of his philosophizing with Hermann Löns's literary production.[20] At least in terms of language and argumentation, they are strikingly similar:

> Hearing sounds which are just sounds immediately sets the theorizing mind to theorizing, and the emotions of human beings are continuously aroused by encounters with nature. Does not a mountain unintentionally evoke in us a sense of wonder? Otters along a stream a sense of mirth? Night in the woods a sense of fear? Do not falling rain and rising mists suggest the love binding heaven and earth? Is not decaying flesh loathsome? Does not the death of someone we love bring sorrow? And is there a greater hero than the least plant which grows? What is more angry than the flash of lightning and the sound of thunder? These responses to nature are mine and will not necessarily correspond with another's. Emotion takes place in the person who has it. And sounds, when allowed to be themselves, do not require that those who hear them do so unfeelingly. The opposite is what is meant by "response ability."[21]

Where the quality of the sounds manifests an increasingly semantic function—the use of, for example, thunder, car horn, or airplane engine—the demand to contemplate sounds by themselves is itself a banality. Where, however, the demand for an unmediated relation between pure object and human feeling results in the reduction of the "material" of art to the incidental noises of the environment—as though these were already essences—here theory relinquishes its claim to reflection and becomes a dumb ideology of nature.[22] Here, perhaps, we see the real reason Cage took the step into the manipulation of chance: the marriage of total isolation with the cult of unmediated nature. Meaning, which in musical sound emerges only out of the musical context, is expelled in Cage in order to pump these sounds up again as false subjects, as isolated, absolute egos. Although it declares freedom its standard, Cage's thesis—that the organization of sound according to chance frees the listener from the compulsion that the composed work imposes on him—reverses into naked, senseless terror, into the compulsion of the system of chance. Cage's

public, unaware of this, often responds with laughter. For in its totality, chance is a rigorous system. In its musical forms, it would have to be all the more subjected to Cage's systematic critique, since in the compulsive isolation of its elements, it prohibits human intervention toward that goal that remains for Cage a mere name: the founding of freedom.[23]

One recalls the ideologies generated within the history of liberalism or of anarchism, conceptions such as Stirner's "Ego" or some similar ideas in Bakunin. And considering the probably strong influence of the anarchist movement from the time of the American Depression, we clearly see that his originality is reduced to zero.[24] In the political sphere, this world-philosophical project had to surrender much earlier, above all in the context of fascist ideology, which referred to the unmediated emancipation of the individual with "strength," "virtue," and similar slogans.

The confusion between nature as the purely objective, and freedom, which in Cage's music assumes the shape of sheer arbitrariness, positions this author, at least according to his philosophy, in the proximity of those social ideologies.

Isolation and chance are correlates insofar as the first is a condition of the second, and conversely, the use of chance results in the isolation of the objects subjected to it. This cancels any idea of freedom, since a freedom that, as with Cage, refers to nothing is invalid according to its own concept. Marx critically illuminated this in his dissertation, and although they were written a century too early, one is almost inclined to regard his words as though formulated specifically for (or against) Cage. At least this demonstrates how little of the new is to be found in Cage's system: "Abstract singularity is the freedom *from* existence, not the freedom *in* existence. It is incapable of shining in the light of existence. But it is only in this element that it loses its character and assumes material form."[25]

Cage proceeds with unmistakable naiveté—hence the relevance of the above critique. In an interview titled "Experimental Music: Doctrine,"[26] which the composer holds with himself, we read: "Question: I have noticed that you write durations that are beyond the possibility of performance. Answer: Composing's one thing, performing's another, listening a third. What can they have to do with one another?"[27]

The confusion Cage sets up between consciousness and artistic material emerges even more clearly in the negation of consciousness: "The interpretation of imperfections in the paper upon which one is writing may provide a music free from one's memory and imagination . . . the

composer resembles the maker of a camera who allows someone else to take the picture."[28]

By means of a thoroughly dubious comparison, the musical composition is degraded to the level of the mere instrument of its own presentation. This is neither dialectical nor paradoxical but simply incompetent thinking, since the relationship between camera, photograph, and the world of objects cannot be compared to that between a work and its various realizations in performance. However, to ignore the relationships between objects is characteristic of Cage's logic. Only in this way can Beethoven and a cowbell be equated. In a double sense, Cage's thinking reveals a tendency to naked reification: the composition becomes a mere instrument (a camera), while its realization in sound becomes a mere object, a natural panorama perhaps, that could be recorded with a camera. But the two do not face each other. The camera photographs itself.

Despite this supposed radicality, the realizations of Cage's works, whose perpetual undissolved juxtaposition of material evokes monotony, have all too much of an artisanal bricolage. Luigi Nono has referred to the connection between Cage's ideology of freedom and arts-and-crafts decoration. He was also struck by Cage's inclination toward the Eastern philosophy that he so colorfully jumbles together. Nono writes that "one can make decorations out of anything, and it is quite simple to remove an element from its cultural context and place it in a new culture deprived of logic, robbed of its original significance." And, further, that "there is no functional difference between a hollow Indian prayer drum that serves in a European house as a trash can, and the Orientalism that serves European art by making its aestheticist concoctions more attractive."[29]

Another element reveals just how important this attraction is for Cage; while technically the result of chance procedures, it is converted, through aesthetic legitimation, into a prop for a worldview. In Cage's later works, extraordinarily long pauses appear throughout, between which single tones are most often inserted. But these are not simply the means to liquidate context; they are further reinterpreted as instances of freedom—although here too under the yoke of naked reification—becoming holes through which nature peers in. Of course, given Cage's insufficient insight, this is tautological, since the work itself has already been declared a piece of nature. However, insofar as the pauses must set off this direct nature from the sounds of the "composition"—when I do not hear the sounds of the work, car engines or perhaps crickets from

outside become audible—then the claim of the work to be "nature" becomes sheer coercion, the arrangements through chance methods merely provisional. And musical structure, which seems merely to happen to the author, becomes nothing more than a nakedly arbitrary object, a sort of leaded glass window, since to grasp this structure as a result of reflection has become suspect:

> For in this new music nothing takes place but sounds: those that are notated and those that are not. Those that are not notated appear in the written notes as silences, opening the doors of the music to the sounds that happen to be in the environment. This openness exists in the fields of modern sculpture and architecture.[30]

The tendency to reification is supported by an inclination toward the "spatialization" of musical ideas. Adorno has already diagnosed this aspect earlier within neoclassicism, to which Cage is linked not least because of his insensitivity to material, which is, then as now, declared to be "nature."[31]

The human capacity for reception stands opposed to the material itself as mere object. In another connection, Cage conceives of "a mind that has nothing to do," that, by virtue of its presumably unencumbered state, is finally supposed to be capable of an unconditioned perception of sounds that, again, simply are what they are: mere objects.

> What happens, for instance, to silence? That is, how does the mind's perception of it change? Formerly, silence was the time lapse between sounds, useful towards a variety of ends, among them that of tasteful arrangement, where by separating two sounds or two groups of sounds their differences or relationships might receive emphasis; or that of expressivity, where silences in a musical discourse might provide pause or punctuation; or again that of architecture, where the introduction or interruption of silence might give definition either to a predetermined structure or to an organically developing one. When none of these or other goals is present, silence becomes something else—not silence at all, but sounds, the ambient sounds. The nature of these is unpredictable and changing. These sounds (which are called silence only because they do not form part of a musical intention) may be depended upon to exist. The world teems with them and is, in fact, at no point free of them. He who has entered an

anechoic chamber, a room made as silent as technologically possible, has heard two sounds, one high, one low—the high the listener's nervous system in operation, the low his blood in circulation. There are, demonstrably, sounds to be heard and forever, given ears to hear. Where these ears are in connection with a mind that has nothing to do, that mind is free to enter into the act of listening, hearing each sound just as it is, not as a phenomenon more or less approximating a preconception.[32]

The notion that absolute silence cannot exist, supported by Cage with dubious examples, implies that musical pauses have been used up to now as demonstrations of physical silence. Cage mentions the syntactic use of pauses in earlier music. But he immediately affirms the obsolescence of musical articulation in order to be able to revalue these pauses as reservoirs of untouched sound presence. Environmental sounds, which become audible through pauses in the music ("which are called silence only because they do not form part of a musical intention"), thus become substance, claiming our attention because "the world is at no point free of them." In this way war, misery, and oppression collectively receive their reactionary justification: since they reign everywhere, they acquire a trans-historical scale, so that striving for their abolition is utopian from the start. Cage, who uses the term "freedom" unreflectively, surrenders to the rule of what seems to him to guarantee this freedom, namely, the contingencies of nature that are worthy of contemplation because they are not constituents of mental conceptions. In Marx's *German Ideology*, what Cage demands was termed "animal consciousness," by which Marx means a relationship of man to nature that has not yet been modified historically.[33]

Koenig has provided an unambiguous rejoinder to Cage's tendency to elevate his own incapacity for musical articulation to the status of the highest criterion of musical shape and to condemn any articulation as naked force. "The complexity of statistical events is, however, only apparent," Koenig writes. "It results from an ideological idea of liberty, as though the possibility, grasped by the subject, of writing a dense and realized text was externally imposed."[34] Conversely, the primacy of natural events over human actions is correctly represented by Cage as force. And when musicians reproduce this force rather than breaking through it, they turn the stage into a fairground booth, with false freedom as a ghastly spectacle. Anyone who has witnessed the performance of a Cage work

will have been struck by the embarrassment caused by pianists crawling under the piano, although there is nothing to be found there:

> [Cage's] chance procedures have their basis less in theoretical reflections than in the wish to eliminate the subjection of men to their equals. Such noble convictions remain, however, external to musical events, do not become language. The actions of his interpreters rather arouse the suspicion that freedom, when not articulated, but instead simply pictured, or one might say, "behaviorally initiated," is only realized in an infantile stage.[35]

As everywhere else, it is also a central element in Cage's reactionary philosophy that it elevates hybrid thought to the absolute. Even the most elementary historical facts cannot be grasped by this philosophy that thinks nothing of historicity to begin with; it has to transform them for its own purposes, as, for example, when Cage presumes that the principle of the integrated pause had migrated from the United States to Europe, as though he, rather than Webern, had established it as an example: "The silences of American experimental music and even its technical involvements with chance operations are being introduced into new European music. It will not be easy, however, for Europe to give up being Europe. It will, nevertheless, and must: for the world is one world now."[36] Elsewhere, it has been remarked regarding this author, whose apodictic tone has an embarrassing flavor, especially in Europe, that this last sentence would be well suited to a campaign speech by Goldwater.[37]

The sum of the short circuits that determine Cage's thought—manifested in his music, moreover, as tedium—result, in passages like the last cited, in a vicious circle. The claim to sheer objectivity, like that raised by the ideology of chance, expands into the claim that this objectivity, unreflected as it is in its barrenness, merits recognition as a binding system because it tolerates no contradictions. But it is pointless to oppose Cage's system with an equally closed theory, because in this context Cage's philosophy of the arbitrary only represents an extreme that takes itself for the whole, above all of history, and it is precisely for this reason that it hardens internal contradictions that can only be dissolved by the historical process itself. As surely as absolutized chance is external to musical form, so is its correlate, unreflected material, inadequate to the human capacity for the development of meaningful relations—the actual basis of freedom. Just

as it is pointless to submit to Cage's ideal, so is it futile to oppose him by damning every type of indeterminacy in musical method or process. In the end, no musical context can be produced through the naked verdict of absolute isolation. All the more decisively, then, the challenge must be made to coordinate chance—which is an expression of the situation at which musical thinking has arrived—with the musical material and thus allow it to emerge as functional within a comprehensive compositional method.

The pleonasms and antinomies that remain together in instrumental music without any possibility of mediation offer, it is true, nothing in the way of productive approaches. Where, as in the extreme case of Cage, they are merely solved with slogans—whether that of "interpretive freedom," "moment form," or "variable form"—they allow no insight into the structure of the instrumental work. It would be necessary to free chance from its confinement to macrotemporal processes, where it merely arranges sound objects, to bring it into a realm of effectiveness in which, to the contrary, it can be used to determine complex forms.

Notes

1. Karlheinz Stockhausen, *Schriften I,* ed. Dieter Schnebel (Cologne: DuMont Buchverlag, 1963), 99ff.

2. Pierre Boulez, *Aléa, Darmstädter Beiträge I* (Mainz: Schott, 1958), 44ff.

3. *Metamorphosis* (1938) for piano. Beginning in 1960, all of Cage's works, including earlier compositions, have been published by C. F. Peters, New York and Frankfurt. *Music for Wind Instruments* (1938) is similarly constructed.

4. One thinks of Charles Ives's *Third Symphony* (1905) or of the folkloristic pattern of his *Concord Sonata* (1910–1915), whose primitiveness is especially evident where the works try to keep pace with the spent relics of musical progress (unresolved dissonances, bitonal structures, mobile sections).

5. Unpublished score.

6. *Construction in Metal I* (1939), *Construction in Metal II* (1939), *Construction in Metal III* (1941). The above observations refer to the first *Construction*, which one has to compare with a piece like Varèse's *Ionisation* (1930–1931) in order to confirm the striking difference in compositional levels. In the integration of percussion sonorities, Cage remains far behind Varèse.

7. *John Cage*, ed. Robert Dunn (New York: C. F. Peters, 1962), 8, 15, 17, 38, etc.

8. The correct date is 1940. [Trans.]

9. *Bacchanale* (1940) for prepared piano.

10. John Cage, *Silence* (Middletown, Conn.: Wesleyan University Press, 1961), 10. All quotes are taken from the collection of Cage's writings, *Silence*, where they are easier to find than in the dispersed and often out-of-print first publications.

11. Cf. *Meditation* (1943), *Perilous Night* (1944), *Room* (1943), etc.

12. Cage, *Silence*, 37.

13. Ibid., 30ff.

14. Ibid., 41, 70.

15. Theodor W. Adorno, "Vers une musique informelle," in *Quasi una Fantasia*, trans. Rodney Livingstone (London: Verso, 1992), 315, 314 [translation modified].

16. Cage, *Silence*, 22, 37ff.

17. Assuming that the word "authority" even has any sense in this context. But the resistance nature offers to human activity is not grounded in subjective will. Its strength is rather the sign of the incomplete knowledge humans dispose over nature.

18. Cage, *Silence*, 44.

19. This reproach that becomes manifest in the later works of Cage reveals a simplistic conception of musical systems. For the imputation that they are external to the artistic material only represses that these systems, as objectifications of musical idioms, are themselves a part of historically changing forms taken by this material.

20. Hermann Löns (1866–1914) was an early twentieth-century German producer of trivial literature on nature and one of the favorite authors of the Nazi government. [Trans.]

21. Cage, *Silence*, 10.

22. The most striking model of this confusion between mind and nature is provided by Martin Heidegger's "Schöpferische Landschaft: Warum bleiben wir in der Provinz?," in *Nachlese zu Heidegger,* ed. Guido Schneeberger (Bern: Suhrkamp Verlag, 1962), 216ff.

23. "We must remember that 'freedom' becomes a deceptive emblem, a 'solemn attribute' of power, as soon as it freezes into an idea and one begins to defend 'freedom' instead of free men" (Maurice Merleau-Ponty, *Humanisme et terreur: Essai sur le problème communiste* [Paris: Gallimard, 1947], 18).

24. Max Stirner, *The Ego and Its Own* (Cambridge: Cambridge University Press, 1995); for a discussion of Bakunin's book *Staatlichkeit und Anarchie,* see Karl Marx and Friedrich Engels, *Werke*, vol. 6 (Berlin: Dietz Verlag, 1961), 270ff, and vol. 18 (1962), 331ff, 477ff, 599ff.

25. Karl Marx, "Die Differenz der demokritischen und epikureischen Naturphilosophie" (1841), in *Werke*, vol. 40 (1968), 163. When fascist ideology spoke of the emancipation of the individual, a false emancipation is meant. Individuals are therefore appealed to in their unmediated individuality, and strengthened only in order that they might adapt themselves all the more smoothly to the absolute primacy of the existing social system. Similarly, with Cage, the individual tone "as such" that he has conjured up is in the end punished with neglect and delivered over to chance operations.

26. Cage, *Silence*, 13–17. [This text is a fictional dialogue "between an uncompromising teacher and an unenlightened student" that was written by Cage and appeared in *The Score* 12 (June 1955): 65–68. Trans.].

27. Cage, *Silence*, 15.

28. Ibid., 10–11.

29. Luigi Nono, "Geschichte und Gegenwart in der Musik von heute," in *Darmstädter Beitrage III* (Mainz: Schott, 1959), 35, 45ff. [Nono's last sentence begins: "The collage method derives from imperialistic thinking." This is symptomatic of a fundamental organicism among the "hard-core serialists," and to their indifference to Dada, surrealism, and constructivism. In fact, Nono frequently employed collage techniques. Trans.]

30. Cage, *Silence*, 7ff.

31. Cf. Adorno, *Philosophy of Modern Music*, trans. Anne G. Mitchell and Wesley V. Blomster (New York: Seabury Press, 1980), 140–141, 174ff; and Paul Hindemith, *Unterweisung im Tonsatz*, part 1 (Mainz: Schott, 1937).

32. Cage, *Silence*, 22.

33. Karl Marx and Friedrich Engels, *The German Ideology* (New York: International Publishers, 1986), 51.

34. Gottfried Michael König, "Kommentar," *Die Reihe* 8 (Vienna: Universal Edition, 1962), 80.

35. Ibid., 80ff.

36. Cage, *Silence*, 75.

37. Konrad Boehmer, "Anathema in Musica," unpublished radio broadcast, Germany SFB 3, December 16, 1975.

Looking Myself in the Mouth

Yvonne Rainer

Sliding Out of Narrative and Lurching
Back In, Not Once but . . .
Is the "New Talkie" Something
to Chirp About?
From Fiction to Theory
(Kicking and Screaming)
Death of the Maiden, I Mean Author, I
Mean Artist . . . No, I Mean Character
A Revisionist Narrativization of/with
Myself as Subject (Still Kicking) via
John Cage's Ample Back

I. A Likely Story: What I Know and What I Think I Feel

She says, "Yes, I was talking with Joan Braderman about the subject in signifying practice, and she brought up the idea that everything is fiction except theory."

Hard as she tries to focus on this most intriguing idea, she finds herself distracted by the recognition of an annoying habit to which she reverts whenever discussing theory, namely, a tendency to transform theory into narrative by interpolating what she calls "concrete experience" in the form of a first-person pronoun and progressive verb, such as "Yes, I was talking with . . ." or "I've been reading this book by . . ." or, even worse, "Yesterday as I was walking down Broadway I was thinking . . ." The obvious motive might be to bolster or support her own argument

by referring to known and respected figures who have advanced similar arguments or to make an analogy that might illuminate the issue at hand. There is, however, another way to describe the phenomenon which points to either a conflict or a contradiction—depending on how one looks at it.

(Artist as Exemplary Sufferer)

(Artist as Self-Absorbed Individualist)

(Artist as Changer of the Subject)

She knows that the content of her thoughts consists entirely of what she's read, heard, spoken, dreamt, and thought about what she's read, heard, spoken, dreamt. She knows that thought is not something privileged, autonomous, originative, and that the formulation "Cogito ergo sum" is, to say the least, inaccurate. She knows too that her notion of "concrete experience" is an idealized, fictional site where contradictions can be resolved, "personhood" demonstrated, and desire fulfilled forever. Yet all the same the magical, seductive, narrative properties of "Yes, I was talking . . ." draw her with an inevitability that makes her slightly dizzy. She stands trembling between fascination and skepticism. She moves obstinately between the two.

"Yes, I am constructed in language," she thinks. "And no, I don't think I've ever really advocated a 'restored integrity of the self.'" She pauses, bites at a cuticle, and finally—in a burst of sheer exasperation—faces the camera squarely and blurts, "But when I say, 'Yes, I was thinking . . . ,' you'd just better believe me!"

Linguistically, the author is never more than the instance writing, just as *I* is nothing other than the instance saying *I*: language knows a 'subject', not a 'person', and this subject, empty outside of the very enunciation which defines it, suffices to make language 'hold together', suffices, that is to say, to exhaust it.

—*Roland Barthes*[1]

(Artist as Medium)

(Artist as Ventriloquist)

II. The Cagean Knot

In the late 1950s and early 1960s the ongoing modernist assault took as its targets certain assumptions by then codified in the institution of American modern dance: the necessity of musical accompaniment; the inadmissibility—and necessity of transformation—of everyday movement; the rigid and inviolable separations between humorous, tragic, dramatic, and lyrical forms; the existence of rules governing sequence climax and development of movement ("theme and variations"); and the relationship of movement to music, clichéd notions of coherence and unity, and exact conditions under which "dissonance" might replace "harmony" (as in "modern" themes of "alienation"). You heard a lot of Bartók at dance concerts in those days.

(Artist as Innovator)

The forerunners of this assault were Merce Cunningham and John Cage. In mutual determination they succeeded in opening a veritable Pandora's Box, an act that launched in due course a thousand dancers', composers', writers', and performance artists' ships, to say nothing of the swarms of salubriously nasty ideas it loosed upon an increasingly general populace, ideas that are apparent even today in Fluxus-like punk performances. I would venture to say that by now the "Cagean effect" is almost as endemic as the encounter group. I say "Cagean" and not "Cunninghamian" because it is Cage who has articulated and published the concepts that I shall be addressing here and that have been especially problematic in my own development. It is not my intention to force the lid shut on John's Box but rather to examine certain troubling implications of his ideas even as they continue to lend themselves to amplification in art making.

Only a man born with a sunny disposition could have said:

This play, however, is an affirmation of life, not an attempt to bring order out of chaos nor to suggest improvements on creation, but simply a way of waking up to the very life we're living which is so excellent once one gets one's mind and one's desires out of its way and lets it act of its own accord.[2]

(Artist as Consumer)

Let's not come down too heavily on the goofy naiveté of such an utter-
ance, on its evocation of J. J. Rousseau, on Cage's adherence to the mes-
sianic ideas of Bucky Fuller some years back, with their total ignoring of
worldwide struggles for liberation and the realities of imperialist politics,
on the suppression of the question, "*Whose* life is so excellent and at what
cost to others?" Let's focus on the means by which we will awaken to this
excellent life: by getting our minds and desires out of the way, by mak-
ing way for an art of indeterminacy to be practiced by everyone, an art
existing in the gap between life and art. All this and more has been stated
hundreds of times in more ways than one.

(Artist as Transgressor)

Who am I and what is my debt to John Cage? My early dances
(1960–1962) employed chance procedures or improvisation to deter-
mine sequences of choreographed movement phrases. At that point, for
some of us who performed at Judson Church in New York City, repeti-
tion, indeterminate sequencing, sequence arrived at by aleatory meth-
ods, and ordinary/untransformed movement were a slap in the face to
the old order, and, as we were dimly aware, reached straight back to the
surrealists via the expatriated Duchamp. Our own rationales were clear,
on-the-offensive, and confident. We were "opening up possibilities" and
"thwarting expectations and preconceptions." A frequent response to the
bafflement of the uninitiated was "Why not?" We were received with
horror and enthusiasm. I can't beguile myself into thinking that the world
has not been the same since.

What is John Cage's gift to some of us who make art? This: the relay-
ing of conceptual precedents for methods of nonhierarchical, indeter-
minate organization which can be used with a critical intelligence, that
is, selectively and productively, not, however, so we may awaken to this
excellent life; on the contrary, so we may the more readily awaken to the
ways in which we have been led to believe that this life is so excellent,
just, and right.

The reintroduction of selectivity and control, however, is totally an-
tithetical to the Cagean philosophy, and it is selectivity and control that
I have always intuitively—by this I mean "without question"—brought
to bear on Cagean devices in my own work. In the light of semiological
analysis I have found vindication of those intuitions. In the same light it
is possible to see Cage's decentering—or violation of the unity—of the
"speaking subject" as more apparent than real.

(Artist as Failed Primitive)

(Artist as Failed Intellectual)

Before going on I wish to say that it makes me mad that, as important a figure as he is to any discussion of American modernism, John Cage has not to my knowledge been examined within the framework of the various reworkings of Freudian and Marxist theory that have been accumulating with such impressive results over the past two decades. In France and England this is in part attributable to the fact that such theoretical writings have concentrated on literature and film to the exclusion of music. Not that the French—with their tendency to romanticize American "irrationalism"—could do him justice at this point. The English know little about him, and the Germans zeroed in on him too early to make use of French critical theory. I am ignorant of writings on him that may have appeared in other countries in which he has performed and lectured extensively, such as Sweden and Denmark. In America I tend to blame the avant-garde critical establishment for its neglect of this most influential man. Well, sometimes artists rush in where critics refuse to tread. In the noisy silence that surrounds the man, I shall produce a few semiotic chirps.

III. Five-Hundred-Pound Canary

What are the implications of the Cagean abdication of principles for assigning importance and significance? A method for making indeterminate, or randomizing, a sequence of signifiers produces a concomitant arbitrariness in the relation of signifier to signified, a situation characterized not by an effacement of signifiers by signified, as in *Gone with the Wind*, nor by a shifting relationship of signifier to signified whereby the signifier itself, or the act of signifying, by being foregrounded, becomes problematic, but by a denial and suppression of a relationship altogether.

What is this but an attempt to deny the very function of language and, by extension, the signifying subject, which is, according to Lacan's definition, dependent on and constructed through and in systems of signification, that is, language?

A *signifying practice* . . . is a complex process which assumes a (speaking) subject admitting of mutations, loss of infinitization, discernable in the modifications of his discourse but remaining irreducible to its

formality alone, since they refer back on the one hand to unconscious-instinctual processes and, on the other, to the socio-historical constraints under which the practice in question is carried on.

—*Julia Kristeva*[3]

The highest purpose is to have no purpose at all.

—*John Cage*

(Artist as Shaman)

(Artist as Visionary)

For Cage, either to problematize, that is, call into question, a "purposive" subject, or to grant admission to a "mutating," finite one, would have been to risk becoming reentangled in those hated measurements of genius and inspiration that particularly infested the world of music, and in those "ambiguities, hidden meanings (which require interpretation), ... silent purposes and obscure contents (which give rise to commentary)."[4] Cage's solution was to throw out the baby with the bathwater. In the absence of a signifying subject, "modifications of discourse" become untenable, as does the concept of an unconscious that manifests itself in the heterogeneity and contradictions of the subject as it is positioned in relationships of identity and difference by "socio-historical constraints," not the least of which is the patriarchal order itself. Trying to operate outside of these processes, a Cagean "nonsignifying practice" sees itself as existing in a realm of pure idea, anterior to language—without mind, without desire, without differentiation, without finitude. In a word, that realm of idealism that so much of our capricious, wavering, flawed, lurching twentieth-century art has similarly failed—while being so committed—to violate.

> Surrealism, unable to accord language a supreme place (language being a system and the aim of the movement being, romantically, a direct subversion of codes—itself moreover illusory: a code cannot be destroyed; only 'played off '), contributed to the desacralization of the image of the Author by ceaselessly recommending the abrupt disappointment of expectations of meaning.
>
> —*Roland Barthes*[5]

(Artist as Transcendental Ego)

From the standpoint of consumption, if meaning is constantly being subverted before a practice that refuses to make or break signs, if the avowed goal of a work is a succession of "nonsignifying signifiers," one is left with an impenetrable web of undifferentiated events set in motion by and referring back to the original flamboyant artist-gesture, in this case the abandonment of personal taste. The work thus places an audience in the "mindless" (sensual?) position of appreciating a manifestation of yet one more and excludes it from participation in the forming of the meanings of that manifestation just as surely as any monolithic, unassailable, and properly validated masterpiece. John Cage can now—and perhaps always could—be safely taught in any high school music appreciation course. His genius is beyond question, the product of that genius beyond ambiguity.

> What was it actually that made me choose music rather than painting? Just because they said nicer things about my music than they did about my paintings? But I don't have absolute pitch. I can't keep a tune. In fact, I have no talent for music. The last time I saw her, Aunt Phoebe said, "You're in the wrong profession."
>
> —*John Cage*[6]

(Artist as Misfit)

I was telling some of my students at the Whitney Independent Study Program that ten years ago I had been invited there to conduct a seminar. I had begun by playing a record of Billie Holiday singing "The Way You Look Tonight," repeatedly lifting and replacing the arm of the record player as, with increasing difficulty and embarrassment, I tried to learn the melody. I couldn't get it and had at length to give it up. At this point in the story Marty Winn said, "So they hired you!"

IV. Bang the Tale Slowly

> After I had been studying with him for two years, Schoenberg said, "In order to write music you must have a feeling for harmony." I then explained to him that I had no feeling for harmony. He then said that I would always encounter an obstacle, that it would be as

though I came to a wall through which I could not pass. I said, "In
that case I will devote my life to beating my head against that wall."

—John Cage[7]

I was just beginning to congratulate myself for having finally triumphed,
in *Journeys from Berlin/1971*, over the tyranny of narrative. I didn't need it
anymore, I told myself. The distinct parts of that film never come together
in a spatiotemporal continuity. From this point of view, narrative seemed
no longer to be an issue. If the film made any effort toward integrating the
separate "speakers," it was at the level of another kind of discourse, pro-
pelled not by narrative but by a heterogeneous interweaving of verbal texts
acting on or against or in relation to images. What a thrilling idea: to be
free of the compelling and detested domination of cinematic narrativity,
with its unseen, unspoken codes for arranging images and language with
a "coherence, integrity, fullness, and closure," so lacking in the imperfect
reality it purports to mirror.

On closer examination, however, it becomes clear that a particular
aspect of narrative, namely, character, is a consistent presence in *Journeys
from Berlin/1971* as it is—often by dint of its conspicuous absence—in
my three previous films. It was in fact a decisive factor in a move from
dance to film in the early '70s. It seems to me that I am going to be
banging my head against narrative for a long time to come.

> But once we have been alerted to the intimate relationship that
> Hegel suggests exists between law, historicality, and narrativity,
> we cannot but be struck by the frequency with which narrativity,
> whether of the fictional or the factual sort, presupposes the existence
> of a legal system against or on behalf of which the typical agents of a
> narrative account militate.

—Hayden White[8]

"Language knows a 'subject,' not a 'person,'" says Barthes. A central
presumption of narrativity is that "subject" may become synonymous
with "Authority of the Law" in an unseen leap that is implicit in every
instance of narrative discourse. In literature it has traditionally been the
author-conflated-with-narrator that has occupied this position of au-
thority. In mainstream cinema a more encompassing illusionism tends to

suppress the presence of the writer-director to a greater degree. As a consequence, authorial status is assumed exclusively by a "character," a designation which—with all of its implicit compounding of self-contained narrator, "person," "persona," and legal/psychological existence—blocks the intrusion of an anterior authorship, at once embodying the representation of, and unseen leap between, subject and legal system.

Godard was probably the first director working within the illusionist narrative film tradition to "meddle" with the integrity of this usually singular speaking position. He accomplished this by having a given character speak from different authorial positions, including that of performer, but also by introducing the presence—usually in voice-over—of another authorship, a commentator not sufficiently "filled in" to be a character, sufficiently "omniscient" to be a narrator, or identifiable with any conclusiveness as speaking the opinions of the director-writer himself, even when it is unquestionably the voice of the director that we hear. The tension attendant on this splitting of authorship among character, performer, commentator, and director-writer produces fissures and contradictions that the viewer must consciously register in order to "get" anything from the film.

Who speaks (in the narrative) is not *who writes* (in real life) and *who writes* is not who is.

—*Roland Barthes*

The thing that pushed me toward narrative and ultimately into cinema was "emotional life." I wished not exactly to "express" emotion, certainly not to mimic it, and I wasn't sure whether a recognizable social context would play a part. I knew little more than that its means of presentation would be largely language and that when spoken, it would be spoken by someone. Not that I hadn't used spoken texts before. In every case, however, either disjunction between movement and speech or the separation inherent in dance presentation between what is performed and the person performing it had prevented the speech from being received as "belonging to" the performer uttering it. On taking up film, I would perforce be dealing with an entirely different register of relationship between "spoken" and "speaker." The problem would be not so much in getting them together as tearing them apart.

I was not only entering a new medium but was jettisoning a whole lexicon of formalized movement and behavior, realizing instinctively that certain concessions to "lifelikeness" would have to be made. For the most part my speaking performers would be doing what people, or characters, so often do in "the movies": sit around, eat, walk down the street, ride bicycles, look at things, and so forth. If they danced in my early films, I gave them good reason by assigning them the occupation "dancer."

From the beginning I used a loose, paratactic, nondramatic construction, more narrative in feeling than fact. My primary "mission," as I see it now, was to avoid narrative contextualizing that would require synchronized, "naturalized" speech to continue for very long in any given series of shots. I could never quite satisfactorily account—publicly—for the necessity of my particular alternatives to conventional narrative films. I veered unsettlingly close to formalist generalizations ("It hasn't been done; it's there to do; it's another 'possibility'"), to the point of almost denying altogether that my enterprise had any significance as social criticism or that it was an "intervention" against illusionist cinema. Or I about-faced and took up the cudgels of the illusionist-cinema-produces-passive-viewer argument. I felt inadequate to the task of advancing a more pertinent argument to support my aversion to the "acting" and "acting out" required by the narratological character.

As recently as the summer of 1980 I find myself saying, in *Millennium Film Journal,*

> Previously I used whatever interested me. I was able to absorb and arrange most materials under some sliding rule of thumb governing formal juxtaposition. Everything was subsumed under the kinds of collage strategies that had characterized my dancing, and could even include a kind of mechanistic, or quasi-psychological narrative.[9]

Still laboring under long-standing Cagean habits of thought about what I'd done—and here I'm talking literally about doing one thing and describing it as another—I was willing to annex my labors to that segment of the surrealist tradition which, from Schwitters to Cage to Rauschenberg, has used "collage strategies" to equalize and suppress hierarchical differentiations of meaning. On another face of it, my work can be, and has been, read as a kind of reductivism coming out of '60s minimal art, a view which I myself held when I was making dances. It still seems that the refusal to invest my film performers with the full stature and

authority of characters shares at some level the same impulse that substituted "running" for "dancing" many years ago. What marks this refusal in the medium of film as not simply an obsolescent holdover from an earlier way of doing things is that from the very outset it was brought to bear against a full-blown institution and manifested itself in specific, pertinent, and contesting strategies.

Speaking of the medieval annals, an early form of European historiography, Hayden White writes that

> for the annalist, there is no need to claim the authority to narrate events since there is nothing problematical about their status as manifestations of a reality that is being contested. Since there is no "contest," there is nothing to narrativize. . . . It is necessary only to record them in the order that they come to notice, for since there is no contest, there is no story to tell.[10]

The implied narrator of the annalist's account is the "Lord," whose supreme authority has subsumed all human need to change "the order [in which things] come to notice." Here we can discover the story of John Cage come full circle. For all of John's Buddhist leanings and egalitarian espousals, for all of his objections to hierarchies and consequent seeming to operate in the space left by the absence of God, his ideas lead inevitably back to the "no contest" of White's early historian. We can't have it both ways: no desire and no God. To have no desire for "improvements on creation" is necessarily coequal to having no quarrel with—God-given—manifestations of reality. Any such dispassionate stance in turn obviates the necessity of "retelling" the way things have been given. The converse of this situation is a state of affairs that Cage—rightfully—most feared: we are surrounded by manifestations of reality that are not God-given but all fucked up by human society and that must be contested and reordered by a human "Narrativizing Authority," which, by so representing them, will impart to events an integrity and coherence cut to the measure of all-too-human desire.

Maybe I'm being simple-minded when I say the problem (not the solution) is clear: to track down the Narrativizing Authority where it currently lives and wallop the daylights out of it. And where does it now live? The battle zone is not a serene plane of indeterminacy outside of the overdeterminations of narrative, nor is it, as I put it in 1973, "somewhere between the excessive specificity of the story and the emotional

unspecificity of object-oriented permutations,"[11] thinking it would be something like steering between the narrativity of Scylla and the formalism of Charybdis.

(Is *who speaks* [in the essay] *The Artist*

[in real life] and is *The Artist who is?*)

In cinema the battleground is neither between nor outside. The battleground is narrativity itself, both its constructs/images and the means by which they are constructed: both its signs and its signifiers.

V. In the N.A.'s Lair

The reluctance to declare its codes characterizes bourgeois society and the mass culture issuing from it: both demand signs which do not look like signs.

—*Roland Barthes*[12]

By refusing to assign a 'secret', an ultimate meaning, to the text (and to the world as text), [writing] liberates what may be called an antitheological activity, an activity that is truly revolutionary since to refuse to fix meaning is, in the end, to refuse God and his hypostases—reason, science, law.

—*Roland Barthes*[13]

Arguing with Douglas Beer about Dan Walworth's film, *A House by the River: The Wrong Shape*, stirred up some thoughts. There are a number of clues in this film pointing to the instability of the narrative, I mean a fragility in the relationship of speech to speaker, action to actor. This instability in turn tells us that we are to listen to the verbal text, a historical critique of the bourgeois family, in its own right, at least not to judge it primarily and absolutely from the standpoint of its having emanated from the lips of a "bad actor" or a particular character, in this case a seventeen- or eighteen-year-old student. True, recognition of the character = "student" and situation = "presentation of paper" does affect our reception of the text. Whatever one's initial impulse, however, to discredit or be inattentive because "it's only a student's term paper" is quickly mitigated by a number of factors. In this kind of film the various representations of social

reality do not have, necessarily, equivalent relations to their referents with respect to meaning. The "classroom" is stable as a signified insofar as it consistently illustrates those parts of the text that deal with school. The "student," on the other hand, is not. What with the prolongation of the classroom shot, the formality of its fixed framing, and the density and duration of the student's reading, our "reading" of the performance moves back and forth from "character" to "agent-for-transmitting-a-text." The effect of this movement is to put both the representation and the verbal text into a precarious balance: the characterization constantly dissolves and reforms—the signifier-performer alternately exposed and covered over—and at the same time the unstable signified-"student" spills over as a kind of metaphor, rather than identity, informing the spoken text as being other than authorial, as being in a state of flux, in process, to-be-scrutinized by the artist-filmmaker and "audience-filmmaker." The audience, rather than moving from perception/recognition to identification/ repulsion now passes from recognition to critical attention.

Do I seem to be paraphrasing Brecht? Yes and no. I'm not mentioning knowledge/understanding. You can lead a horse to water; you cannot make it drink.

This text has been concerned with the necessity for problematizing a fixed relation of signifier to signified, the notion of a unified subject, and, specifically, within the codes of narrative film practice, the integrity of the narratological character. Any such problematizing, calling into question, or "playing off " of the terms of signification of necessity involves an "unfixing" of meaning, a venturing into ambiguity, an exposing of the signs that constitute and promulgate social inequities.

I have also analyzed the contradictions in John Cage's concepts of indeterminacy. It is important that Cage's efforts to *eliminate and suppress* meaning should in no way be confused with the refusal to *fix* meaning of which Barthes speaks. Cage's *refusal of meaning* is an abandonment, an appeal to a Higher Authority. The refusal that has been of more concern to me is a confrontation with—and within—authorial signifying codes. I wouldn't go so far as Barthes in calling such confrontation a revolutionary activity, at least not at this point in time. Nevertheless, insofar as it involves a certain amount of risk and struggle, it is an important and necessary activity.

A last paraphrase on the battleground of cinematic narrativity. As the character dies, it is not inconceivable that some members of the audience will come to their senses. And I don't mean Aristotle.

Notes

1. Roland Barthes, "The Death of the Author," in *Image-Music-Text*, trans. Stephen Heath (New York: Hill and Wang, 1977), 145.

2. John Cage, quoted in Richard Barnes, "Our Distinguished Dropout," in *John Cage*, ed. Richard Kostelanetz (New York: Praeger, 1970), 51.

3. Julia Kristeva, "The Subject in Signifying Practice," *Semiotext(e)*, no. 3 (1975): 19.

4. Michel Foucault, "What Is an Author?," *Screen* 20, no. 1 (Spring 1979): 17.

5. Barthes, "The Death of the Author," 144.

6. John Cage, *A Year from Monday* (Middletown, Conn.: Wesleyan University Press, 1967), 118.

7. Ibid., 114.

8. Hayden White, "The Value of Narrativity in the Representation of Reality," *Critical Inquiry* 7, no. 1 (Autumn 1980): 17.

9. Noël Carroll, "Interview with a Woman Who ... , " *Millennium Film Journal*, nos. 7–9 (Fall-Winter 1980–1981), 44.

10. White, "The Value of Narrativity in the Representation of Reality," 22.

11. Yvonne Rainer, *Work 1961–73* (Halifax: Press of the Nova Scotia College of Art and Design; New York: New York University Press, 1974), 244.

12. Roland Barthes, "Introduction to the Structural Analysis of Narratives," in *Image-Music-Text*, 116.

13. Barthes, "The Death of the Author," 147.

Cage and Asia: History and Sources

David W. Patterson

"What I do, I do not wish blamed on Zen . . ."

—*John Cage*[1]

John Cage and Asian Music

In determining the legitimate impact of Asian culture on John Cage's development, a clear distinction must be made between those influences that are purely musical and those that are philosophical in nature. As to the former, there is little if anything in Cage's music that suggests any kind of compelling interest in the musics of Asia, and even less that might constitute direct stylistic borrowing. Certainly in his early years, Cage had ample opportunity to be exposed to Asian music, whether in California, in New York while studying with Cowell (1934), or through longstanding friendships with others whose interest in this music was pronounced, such as Lou Harrison or sculptor Richard Lippold. Furthermore, during the 1940s it was popular among critics and sophisticated listeners to equate Cage's percussion ensemble works with the gamelan or interpret the prepared piano's delicate timbres as evidence of musical orientalism. Indeed, at one point Cage himself commented that his square-root method of rhythmic organization was in part "a structural idea not distant in concept from Hindu tala (except that tala has no beginning or ending, and is based on pulsation rather than phraseology)."[2] However, such comparisons, whether drawn by critics or Cage himself, are actually quite superficial, and no significant structural or procedural affinities between Cage's oeuvre and the music of Asia have been demonstrated to date.

The occasional "Asian" element in Cage's compositions was often little more than programmatic, as in the *Seven Haiku* (1951–1952) or *Ryoanji* (1983). An earlier and subtler example might be the *Sonatas and Interludes* for prepared piano (1946–1948), which, as Cage explained,

> were written when I … first became seriously aware of Oriental philosophy. After reading the work of Ananda K. Coomaraswamy, I decided to attempt the expression in music of the "permanent emotions" of Indian tradition: the heroic, the erotic, the wondrous, the mirthful, sorrow, fear, anger, the odious, and their common tendency toward tranquility. These pieces were the first product of that effort.[3]

These nine permanent emotions were also the programmatic basis for *Sixteen Dances* (1950–1951). In the case of either composition, though, the genuine relation of the *rasas* to the music is a murky issue; it is impossible, for example, to cross-match any one sonata with a discrete emotion (if in fact Cage's account is meant to be taken that literally at all). And while each of the *Sixteen Dances* identifies explicitly its connection to a single *rasa,* the nature of Cage's chance compositional procedures during this stylistic transition period all but precludes the possibility of extramusical "depiction"; instead, the *rasas* are concretely manifested only in the programmatic schemata of Cunningham's choreography.

In addition to the "permanent emotions," the notion of the seasons can also be read as an Asian-derived programmatic theme in Cage's works during the 1940s. His first orchestral score, *The Seasons* (1947) (which was also Cunningham's first ballet), was offered to audiences as "an attempt to express the traditional Indian view of the seasons as quiescence (winter), creation (spring), preservation (summer), and destruction (fall)."[4] Yet like the dubious musical relationship between the *rasas* and *Sixteen Dances,* any genuine affinity between the Indian concept of the seasons and the music that Cage composed for the ballet is stylistically intangible. Shortly after *The Seasons,* Cage related each of the movements of the *String Quartet in Four Parts* (1949–1950) to a particular season as well. However, in this case, his explicit program utterly westernizes the concept, summarizing the work's theme as:

> that of the seasons, but the first two movements are also concerned with place. Thus in the first movement the subject is Summer in France while that of the second is Fall in America. The third and

fourth are also concerned with musical subjects, Winter being expressed as a canon, Spring as a quodlibet.[5]

Ultimately, Cage must be categorized as an emphatically "Western" composer, particularly when compared to contemporaries such as Lou Harrison, Colin McPhee, Henry Cowell, or even Harry Partch. He never systematically explored preexistent, non-Western tuning systems, for example, and his overall attempts to integrate authentically "Asian" instruments into his compositions were typically confined to the small handful of instruments specified among the vast battery of devices found in the early percussion works and to a few of the later "number" pieces, such as *One*[9] (1991), *Two*[3] (1991), and *Two*[4] (1991), each of which calls for a *shō*. Even in a work such as *Haikai* (1986), written for gamelan ensemble, Cage deliberately disassociated the work from the musical style and performance practices standard to this ensemble, incorporating classically Cagean passages of silence into the musical texture and calling for the pot gongs to be turned upside down and played from their bottom edges. As he explained, "I wanted to make some use of the gamelan that, as far as I knew, hadn't been made. I think that if I'm good for anything, that's what I'm good for: finding some way of doing things other than the traditional way."[6]

John Cage and Asian Philosophy

While claims of any causal relation between Asian music and Cage's compositions are highly contentious, both his interest in and appropriation of terms and concepts from Asian philosophy and aesthetics, on the other hand, are indisputable, and such borrowings came to constitute a cornerstone of his rhetoric. Yet in appropriating terms and concepts from his sources, his borrowings were not so much faithful transcriptions of ideas as they were carefully constructed intellectual subversions. This is not to lend an insidious tone to Cage's attitude toward his materials but more objectively refers to a particular type of appropriation whereby the basic elements and unifying structure of an idea are maintained, though the intended effect is first undercut and then reversed (i.e., subverted) by a motivation contrary to the idea's original purpose. Of course, the notion of "subversion" could well apply to an even larger portion of Cage's activity during the 1940s, particularly in regard to the prepared piano, whose extraneous objects decisively thwarted the aesthetic function of the

premier instrument of the nineteenth century. In fact, one could say that Cage transformed his rhetorical sources much as he did the standard piano through his use of preparations—taking delight in the historical weight these sources derived from their traditions, yet then alienating them utterly from their original contexts, manipulating their internal arguments to sound to his taste and for his purposes.

The specific dating of Cage's earliest exposure to Asian texts is problematic, as is the identification of the texts themselves. Both Cage and Harrison have recalled the instance in the 1930s in which Harrison first showed the *I Ching* to Cage in San Francisco, although developmentally Cage was hardly at the point where it was of much interest.[7] Cage also made frequent reference to his attendance at a lecture entitled "Zen Buddhism and Dada" given by Nancy Wilson Ross at the Cornish School in Seattle, though this too seems an isolated instance of no obvious consequence.[8] Throughout the late 1930s, Cage's own musical rhetoric was consistently Western in its expression, and even during the war years his prose bore little overt sign of Asian influence. In 1944, for example, his mentality reflects that of the still-to-be-converted Westerner when he states, "Personality is a flimsy thing on which to build an art. (This does not mean that it should not enter into an art, for, indeed, that is what is meant by the word *style*.)"[9]

In August of 1942 Cage met dancer Jean Erdman, who along with Merce Cunningham, co-choreographed and premiered Cage's *Credo in Us* (1942) during the Martha Graham Company's summer tenure at the Bennington School of the Dance. Upon relocating permanently to New York City just a few weeks later, Cage and his wife, Xenia, received an offer of lodging from Erdman and her husband, the mythologist Joseph Campbell, and for several months thereafter Erdman, Campbell, Cage, and Xenia fit snugly into a four-room apartment on Greenwich Village's Waverly Place. This environment, and more specifically the exchanges between Cage and Campbell that occurred therein, provides a point of departure for the study of Cage's encounters with concepts derived from Asian texts. The relationship between the two men was, of course, hardly one of teacher-student. On the other hand, it is difficult to dismiss as mere coincidence the parallels between Campbell's intellectual interests and those topics that would soon come to fascinate Cage. From these sources, as well as from selected texts by medieval Christian mystics, Cage shaped his first genuine "collection" of appropriations. Among his writings from this decade, the influence of these sources on his own rhetoric

is especially evident in "The East in the West,"[10] the "Vassar Lecture," also known as "A Composer's Confessions,"[11] "Defense of Satie,"[12] and "Forerunners of Modern Music."[13]

South Asian Sources: Ananda Coomaraswamy

The war years, then, became a seminal period in which Cage first actively enhanced his own knowledge of Asian philosophy and aesthetics, and while seldom articulated in Cage scholarship to date, his initial frame of reference was not East Asian but South Asian. Cage's studies may well have begun with his reading of Ananda Coomaraswamy's 1934 publication entitled *The Transformation of Nature in Art*,[14] a set of essays that derives a general theory of art not only from the examination of Indian and Chinese treatises, but through the writings of the fourteenth-century German mystic Meister Eckhart as well. Cage discovered Coomaraswamy directly through Campbell, who had worked with Indologist Heinrich Zimmer at Columbia University and was himself steeped in Indian artistic and aesthetic studies during the early 1940s, overseeing the completion of several of Zimmer's unfinished volumes.

Cage's first extant reference to Coomaraswamy appears in the 1946 article entitled "The East in the West," in which he remarks, "There is, I believe, a similarity also between Western medieval music and Oriental. In other fields than music, Dr. Ananda K. Coomaraswamy has discussed such a relation."[15] However modest the citation, "The East in the West" signals the new role of Asia in Cage's creative thought and anticipates what would become his extensive use of Asian concepts and terms in his own aesthetic rhetoric. Over the years, his references to Coomaraswamy were both frequent and redundant, citing the importance of *The Transformation of Nature in Art* to his aesthetic development. When asked for additional information on the subject, he typically contributed a reference to a single concept contained within this text: "Art is the imitation of Nature in her manner of operation."[16]

In fact, many of Cage's aesthetic statements from this period could well be derived from or at least heavily influenced by the aesthetic set forth by Coomaraswamy. Yet Cage was seldom direct in acknowledging Coomaraswamy's work, making it difficult at times to distinguish conclusively those coincidental instances of aesthetic parallelism from genuine appropriations. For example, Coomaraswamy invokes the term "impersonality" to refer to the proper manner in which one is to execute tasks

artistically. In this context, self-expression, equated with "aesthetic exhibitionism," or "the substitution of the player for the play," is interpreted as an artistic vice, and Coomaraswamy continually warns of its degenerate nature. At the very least, the appearance of the artist's person in any work is intrusive; at worst, it is a glaring indication of defective workmanship. In several instances throughout his writings, Coomaraswamy explains the necessity of artistic impersonality through the example of Indian dramatic art and dance:

> As to the Indian drama, the theme is exhibited by means of gestures, speech, costume, and natural adaptation of the actor for the part; and of these four, the first three are highly conventional in any case, while with regard to the fourth not only is the appearance of the actor formally modified by make-up or even a mask, but Indian treatises constantly emphasize that the actor should not be carried away by the emotions he represents, but should rather be the ever-conscious master of the puppet show performed by his own body on stage. The exhibition of his own emotions would not be art.[17]

Cage concurred wholeheartedly with Coomaraswamy on this point, though in his own particular expression of the idea, he framed his position as the antithesis to nineteenth-century European attitudes. In the 1952 "Juilliard Lecture," he compares these two opposing attitudes, reinforcing his own position with references to the autonomy of sound, a central facet to his own aesthetic:

> The most that can be accomplished by no matter what musical idea is to show how intelligent the composer was who had it . . . the most that can be accomplished by the musical expression of feeling is to show how emotional the composer was who had it. If anyone wants to get a feeling of how emotional a composer proved himself to be, he has to confuse himself to the same final extent that the composer did and imagine that sounds are not sounds at all but are Beethoven and that men are not men but are sounds. Any child will tell us: this is simply not the case. To realize this, one has to put a stop to studying music. That is to say, one has to stop all the thinking that separates music from living.[18]

Likewise, the needless duality between art and life is a prominent theme in the work of either Coomaraswamy or Cage. To Coomaraswamy,

every action executed is linked inherently to an aesthetic process, whether an act of religion, philosophy, cooking, planting, teaching, sculpting, etc., and therefore must be considered "artistic." In Coomaraswamy's view, "the artist is not a special kind of man, but every man is a special kind of artist," and one's particular "art" is simply determined by individual nature, as he noted:

> Indian literature provides us with numerous lists of the eighteen or more professional arts *(silpa)* and the sixty-four avocational arts *(kala);* and these embrace every kind of skilled activity, from music, painting, and weaving to horsemanship, cookery, and the practice of magic, without distinction of rank, all being equally of angelic origin.[19]

Further, he contended, the modern (i.e., post-Renaissance) Western definition of art had alienated mankind from the experience of life as art. "All alike have lost," he lamented, "in that art being now a luxury, no longer the normal type of activity, all men are compelled to live in squalor and disorder and have become so inured to this that they are unaware of it."[20]

Cage's adoption of Coomaraswamy's attitudes toward art as life and of all persons as "artists" is nothing short of categorical, and the reader already somewhat familiar with Cage can acknowledge readily the status of these concepts as mainstays in his aesthetic for the rest of his life: "Art's obscured the difference between art and life. Now let life obscure the difference between life and art."[21] In his earliest expressions of this idea, the very language he chooses is clearly derived from Coomaraswamy; in a 1950 rebuttal of criticisms leveled against Satie, his rhetorical plagiarism is flagrant:

> *Art is a way of life.* It is for all the world like taking a bus, picking flowers, making love, sweeping the floor, getting bitten by a monkey, reading a book, etc., ad infinitum. . . . Art when it is art as Satie lived it and made it is not separate from life (nor is dishwashing when it is done in this spirit).[22]

Armed with the essential themes and terms of Coomaraswamy's aesthetic—the challenge to limited Western conceptions of "art," the technique of juxtaposing examples of works of "art" with works of life (and the ultimate equation of the two), etc.—Cage often modified these materials to make specific claims for contemporary music as to its function and value not only *in* life but *as* life. His contentions are made clear

in the 1958 essay "Composition as Process," in which he takes aim at the very same Western conception of "art" to which Coomaraswamy objects so strenuously:

> When we separate music from life what we get is art (a compendium of masterpieces). With contemporary music, when it is actually contemporary, we have no time to make that separation (which protects us from living), and so contemporary music is not so much art as it is life and any one making it no sooner finishes one of it than he begins making another just as people keep on washing dishes, brushing their teeth, getting sleepy, and so on. Very frequently no one knows that contemporary music is or could be art. He simply thinks it is irritating. Irritating one way or another, that is to say keeping us from ossifying. For anyone of us contemporary music is or could be a way of living.[23]

Despite such affinities, however, it is imperative to acknowledge outright that Cage and Coomaraswamy are hardly kindred spirits, aesthetically speaking. In fact, from certain standpoints, it is hard to imagine two philosophic attitudes less sympathetic with one another, yet these divergences illuminate the nature of Cages appropriative subversions. To Coomaraswamy, for instance, art was an act of communication, and communication mandated a language that all spoke and understood—tradition. "Originality" was a foolish egoism; consequently, he openly loathed modern art, admonishing, "New songs, yes; but never new kinds of music, for these may destroy our whole civilization. It is the irrational impulses that yearn for innovation."[24]

Several of Cage's remarks strongly suggest that he was well aware of the limits of his aesthetic alliance with Coomaraswamy, and though he never named him explicitly as an intellectual detractor, many of his statements from this period seem to respond directly to Coomaraswamy's objections to contemporary art. In contrast to Coomaraswamy's insistence upon adherence to tradition for instance, Cage contended that it was pointless for contemporary artists to hold fast to the Western tradition, since the tradition itself was both dysfunctional and in an advanced state of deterioration:

> We are still at the point where most musicians are clinging to the complicated torn-up competitive remnants of tradition, and,

furthermore, a tradition that was always a tradition of breaking with tradition, and furthermore, a tradition that in its ideas of counterpoint and harmony was out of step not only with its own but with all other traditions.[25]

Ultimately, therefore, the manner in which Cage incorporated Coomaraswamy into his own aesthetic became typical of the way in which he approached later sources as well, appreciating their philosophic or aesthetic tenets on a highly selective basis, then recontextualizing, reconfiguring, and in some cases transgressing the intentions and ideals of their original authors.

South Asian Sources: *The Gospel of Sri Ramakrishna*

In April 1948, Cage told a Vassar audience of his recent completion of "eighteen months of studying oriental and medieval Christian philosophy and mysticism."[26] This study, however, revolved not so much around the work of Coomaraswamy as it did *The Gospel of Sri Ramakrishna*,[27] a volume recording the life and lessons of an Indian mystic of the late nineteenth and early twentieth centuries. This text came to Cage in 1946, shortly after the twenty-five-year-old Geeta Sarabhai arrived in New York from India. Sarabhai had just finished eight years of study of Hindustani singing, drumming, and music theory. Concerned over the ever-increasing threat that western music posed to the propagation of traditional Indian music, she made the trip intending to study this music in order to better comprehend and confront this creeping cultural invasion. One of the first friendships she established in New York was with the artist Isamu Noguchi, who, upon hearing of her plans, led her to Cage's door:

> John very readily offered to teach me what he had learnt from Schoenberg. When I inquired from him what I would have to pay for the lessons . . . he replied that if I taught him Indian music there would be no question of payment. I was overjoyed.[28]

Contrary to the original agreement, Sarabhai did not teach Cage as much about Indian music as she did the general philosophy surrounding this art, and for the next five months the two met three or four times a week, their meetings often followed by dinner and general conversation about Indian and Western cultures. Their aesthetic perspectives easily

complemented each other. Cage had already repudiated the idea of music
as self-expression, just as Sarabhai had learned from her own teacher in
India that music was "not the activity of the (conscious) mind but is
given to one or comes to one in those spaces in time when one is willing
to remain open to receive it."[29] She and Cage also concurred that the real
purpose of music was "to integrate and center one's personality or being,
to bring it to a state of repose or tranquillity and that communication, as
understood in the west, is not its true and prime function."[30] Based on his
exchanges with Sarabhai, Cage repeatedly quoted "the traditional reason
for making a piece of music in India: 'to season and sober the mind thus
making it susceptible to divine influences,'"[31] a statement that, in at least
one instance, he allied with the concept of art as life:

> We learned from Oriental thought that those divine influences are,
> in fact, the environment in which we are. A sober and quiet mind
> is one in which the ego does not obstruct the fluency of the things
> that come in through the senses and up through our dreams. Our
> business in living is to become fluent with the life we are living, and
> art can help this.[32]

Before returning to India in the latter part of December, Sarabhai
gave Cage a copy of *The Gospel of Sri Ramakrishna*. Cage's study of this
text constitutes the second phase of his South Asian studies, and his own
recollections of spending the next year reading this material[33] are verified
by the reminiscences of friends and colleagues who recount his voracious
consumption, some describing chance meetings with Cage on the street
in ensuing months, the book securely tucked under his arm.[34]

Because of the Indian philosophical origins it shares with *The Trans-
formation of Nature in Art*, *The Gospel of Sri Ramakrishna* includes many
conceptual parallels with Coomaraswamy's writings and therefore could
be considered at least an auxiliary source in Cage's aesthetic develop-
ment. Unlike *The Transformation of Nature in Art*, however, *The Gospel of
Sri Ramakrishna* is not a volume on aesthetics; consequently, its relation
to Cage's artistic thought is relatively tangential. Still, this publication
was essential to him, providing inspiration as well as general relief from
the tensions surrounding his more personal transitions of the mid-1940s,
including his separation and ultimate divorce from Xenia. Cage's own
acknowledgments of the text are not aesthetic but consistently personal
in nature, describing it as "a gift from India, which took the place of

psychoanalysis."[35] Not surprisingly, then, many of Cage's appropriations from Sri Ramakrishna are more generically spiritual than aesthetic in their thrust, as his references from this source often demonstrate:

> Ramakrishna spent an afternoon explaining that everything is God. Afterward, one of his disciples entered the evening traffic in a euphoric state and barely escaped being crushed to death by an elephant. He ran back to his teacher and asked, "Why do you say everything's God when just now I was nearly killed by an elephant?" Ramakrishna said, "Tell me what happened." When the disciple got to the point where he heard the voice of the elephant's driver warning him several times to get out of the way, Ramakrishna interrupted, "That voice was God's voice."[36]

East Asian Borrowings: Sources and Issues

Artistically and aesthetically, Cage's most striking transformations occurred in the early 1950s. Compositionally, three works in particular stand as points of arrival: *Music of Changes* (1951), *4′33″* (1952), and the multimedia *Black Mountain Piece* (1952). The explanatory prose that accompanied this new compositional agenda also took an equally noteworthy turn in these years, and although Cage never entirely abandoned his metaphors from South Asia and medieval Europe, they were all but eclipsed in the 1950s by the sudden influx of terms, concepts, and metaphors drawn from distinctly East Asian sources, and in particular from Taoism, Buddhism, and, in specific instances, Zen. As the conceptual and philosophic cousins to the thought of Coomaraswamy and Sri Ramakrishna, these traditions supplied Cage with a new terminology that was both sympathetic to his previous South Asian studies and pregnant with the potential to illuminate his new agenda of compositional indeterminacy. His appropriations of terms and concepts from these sources were far more explicit than those from previous sources, and he applied them vigorously to his own aesthetic statements. The "Lecture on Nothing,"[37] "Lecture on Something,"[38] and the "Juilliard Lecture"[39] are the earliest products of this new rhetoric. East Asian philosophy continued to play a predominant role in Cage's aesthetic language throughout the 1950s—whether in brief statements such as "Manifesto"[40] or "Robert Rauschenberg,"[41] larger essays such as "Experimental Music: Doctrine"[42] and "Composition as Process,"[43] or spoken performance works such as "45′ for a Speaker"[44] and "Indeterminacy."[45]

It is entirely reasonable to assume that Cage's aesthetic appetite for Buddhism and Taoism was at least being whetted during the 1940s concurrently with his readings of Coomaraswamy and Sri Ramakrishna. But if East Asian philosophy was, in fact, seeping into Cage's psyche during the 1940s, his subsequent rhetorical appropriations did not seep into his prose during this same period as much as they simply appeared in 1950, as demonstrated by the rhetorical lurch between "Forerunners of Modern Music"[46] and "Lecture on Nothing."[47] "Forerunners," for example, is Cage's last essay of the 1940s and still bears the clear imprint of his studies of South Asian philosophy and Christian mysticism. It opens with a description of music as an art involving the reconciliation of dualities, another notion specifically associated with Cage's aesthetic of the 1940s and the philosophies of Coomaraswamy and Sri Ramakrishna: "Music is edifying for from time to time it sets the soul in operation. The soul is the gatherer-together of the disparate elements (Meister Eckhart), and its work fills one with peace and love."[48]

Written only a few months after "Forerunners," the "Lecture on Nothing" is rooted in a startlingly new and well-developed rhetoric, opening with the seemingly paradoxical remark, "I am here and there is nothing to say." Ultimately, the use of paradox became central to Cage's rhetorical strategy of this period, reappearing, for instance, as the opening gambit in the "Juilliard Lecture":

> In the course of a lecture last winter on Zen Buddhism, Dr. Suzuki said: "Before studying Zen, men are men and mountains are mountains. While studying Zen things become confused: one doesn't know exactly what is what and which is which. After studying Zen, men are men and mountains are mountains." After the lecture the question was asked: "Dr. Suzuki, what is the difference between men are men and mountains are mountains before studying Zen and men are men and mountains are mountains after studying Zen?" Suzuki answered: "Just the same, only somewhat as though you had your feet a little off the ground."[49]

Cage's network of East Asian rhetorical appropriations is elaborate, and the conceptual richness of the traditions from which he borrowed makes these appropriations some of the most provocative to be found in his prose. Their individual instances can be both overt and subtle; the use of the paradox, for instance, is itself indicative of Cage's new mimicry of

Buddhistic (and in particular, Zen) methods of instruction. At times, it is necessary to distinguish more specifically those East Asian appropriations that affected Cage's approach to music conceptually (i.e., aesthetically) from those that affected his technical approach to composition; the *I Ching* was the essential primary mechanism by which Cage generated his compositions from 1951 onward, and yet its texts and terms were never a particularly noticeable part of his aesthetic vocabulary. In any event, just as in the case of his appropriations from South Asian aesthetics and philosophy, Cage's rhetorical borrowings from East Asia do not constitute the wholesale adoption of an agenda but are actually quite specific and idiosyncratic, limited to a fairly extensive yet relatively definable set of terms.

With a few exceptions, documentation of Cage's earliest East Asian source readings is elusive, and the most essential source of information—Cage's library itself—was sold off book by book in the economically lean 1950s.[50] His rhetorical borrowings provide a clue only on occasion, for in many cases, these are so basic as to defy association with any single textual source, as in the case of the reference below, in which Cage melds the biography of the Buddha with his own:[51]

> But no ivory tower exists, for there is no possibility of keeping the Prince forever within the Palace Walls. He will, willy nilly, one day get out and seeing that there are sickness and death (tittering and talking) become the Buddha. Besides at my house, you hear the boat sounds, the traffic sounds, the neighbors quarreling, the children playing and screaming in the hall, and on top of it all the pedals of the piano squeak. There is no getting away from life.[52]

In other instances, however, Cage actually identities his textual model, explicitly citing works from the respective canons of Buddhism and Taoism (such as Huang Po's *Doctrine of Universal Mind*[53] and the writings of Kwang-tse in general) as well as contemporary publications by Western authors, such as Blyth's *Haiku*[54] and *Zen in English Literature*.[55]

The works of Reginald Horace Blyth, for example, are similar to those of Coomaraswamy in their frequent use of diverse cultural cross-references, reinforcing observations on East Asian poetry and philosophy with examples from Western literary sources spanning the late Renaissance to the nineteenth-century transcendentalists. Cage's first published acknowledgment of Blyth—or, for that matter, of any of his East Asian

source readings—appears in a 1950 apologia of Satie; the parenthetical reference to Beethoven is Cage's own:

> If we glance at R. H. Blyth's book on *Haiku* (the Japanese poetic structure of five, seven, and five syllables), we read (p. 272): "Haiku thus makes the greatest demand upon our internal poverty. Shakespeare (cf. Beethoven) pours out his universal soul, and we are abased before his omniscience and overflowing power. Haiku require of us that our soul should find its own infinity within the limits of some finite thing."[56]

Cage also cited Blyth's *Zen in English Literature and Oriental Classics* on a handful of occasions,[57] and, in at least one subtler instance, implied this work through his choice of literary examples:

> No matter how rigorously controlled or conventional the structure, method, and materials of a composition are, that composition will come to life if the form is not controlled but free and original. One may cite as examples the sonnets of Shakespeare and the *haikus* of Basho.[58]

The year 1950 marks not only the new East Asian rhetoric of the "Lecture on Nothing" and Cage's first overt citation of Blyth but also his first extant reference to Daisetz Teitaro Suzuki, a Japanese scholar of East Asian philosophy.[59] In the latter part of this same year, Suzuki himself (by then eighty years old) arrived in New York, and within a few years, reaction to his English publications and public and university lectures transformed Buddhism, and in particular the relatively esoteric school of *Ch'an*, or in Japanese, *Zen*, into a full-blown New York fad. As one observer noted:

> Ultra-modern painting, music, dance, and poetry are acclaimed as expressions of Zen. Zen is invoked to substantiate the validity of the latest theories in psychology, psychotherapy, philosophy, semantics, mysticism, free-thinking, and what-have-you. It is the magic password at smart cocktail parties and bohemian get-togethers alike.[60]

In terms of Cage's development, the figure of Suzuki poses some historical difficulties. In his own recollections of the 1940s, Cage often

cited Suzuki's lectures at Columbia University as one of the early cata-
lysts of his East Asian studies. Yet his historical memory was character-
istically sketchy; at times he recalled attending Suzuki's lectures for two
years;[61] at others, he claimed it was three.[62] His dating of these lectures
was also variable, ranging from 1945–1947[63] to 1949–1951.[64] But even
a cursory investigation into Suzuki's lectures proves that these could not
possibly have been events that spurred Cage's East Asian studies, since
Suzuki did not even arrive in New York until the late summer of 1950;
moreover, he only first lectured publicly at Columbia in March 1951 and
was not employed by Columbia until spring 1952, when he taught his
first course. Although this redating corrects a popular misconception, it
also creates a historic vacuum, for unfortunately this spurious citation to
Suzuki's lectures has been the predominant (and often only) historical
reference to Cage's early East Asian studies, and no new information on
this period has yet surfaced that might fill the void. There are also no
extant records at Columbia University that can confirm Cage's actual
attendance at Suzuki's lectures, although accounts from fellow auditors
verify his presence at least in the spring and fall of 1952.[65] Further, there
are very few materials that elaborate on Suzuki's lectures themselves, and,
oddly, there are almost no official university records that document Su-
zuki's stay at Columbia. Consequently, there seems to be almost "nothing
to say" about these essential events related to Cage's studies of East Asian
philosophy. Still, the published reminiscences of former students and
colleagues at least provide scattered glimpses into Suzuki's pedagogy, re-
counting how he emphasized "the fact that Zen thought is, in opposition
to the Western rational way of thinking, an irrational, non-rational way of
thinking"[66] or "took the Hua-yen or Kegon doctrines of the *Avatamsaka
Sutra* as the starting point of his Columbia seminars."[67]

Even after investigating the chronological details of Suzuki's Colum-
bia lectures, his particular role in Cage's aesthetic development is a frus-
tratingly speculative issue. Surprisingly, Cage did not cite any of Suzuki's
English publications in his own prose of the 1950s, leaving a considerable
body of literature open for consideration. Moreover, Cage's published
remarks on Suzuki are primarily anecdotal, seldom indicating the impact
that Suzuki's actual writings or lectures may have had, as illustrated by the
related references below:

There was an international conference of philosophers in Hawaii
on the subject of Reality. For three days Daisetz Teitaro Suzuki said

nothing. Finally the chairman turned to him and asked. "Dr. Suzuki, would you say this table around which we are sitting is real?" Suzuki raised his head and said Yes. The chairman asked in what sense Suzuki thought the table was real. Suzuki said, "In every sense."[68]

In order to fulfill all our commitments, we need more ears and eyes than we had originally. Besides, the old ones are wearing out. In what sense am I losing my ear for music? In every sense.[69]

On more than one occasion, Cage himself elevated Suzuki to a position of considerable prominence:

I think I am actually an elitist. I didn't study music with just anybody; I studied with Schoenberg. I didn't study Zen with just anybody; I studied with Suzuki. I've always gone, insofar as I could, to the president of the company.[70]

Still, the pairing of Suzuki with Schoenberg seems an obvious overstatement, and at times Cage countered his own testimonials with reminiscences of the anonymous, passive—and sometimes, be confessed, napping[71]—audience of as many as three hundred in attendance at Suzuki's lectures, or ascribed only a symbolic significance to his Columbia studies:

Suzuki was not very talkative. He would frequently say nothing that you could put your finger on. Now and then he would. When I say now and then I mean one Friday or another, but on any given day, nothing that you could remember would remain.[72]

In the long run, therefore, it is tremendously difficult to gauge the proper weight that Suzuki is to be afforded in Cage's aesthetic development.

Unlike Coomaraswamy or Sri Ramakrishna, who were sources of inspiration peculiar to Cage, Suzuki was a figurehead to a fair number of creative artists of the 1950s. Yet it bears note that Suzuki was not always pleased with the ramifications of his success, and like Coomaraswamy, he could well be classified an unwilling adoptee of the Western avant-garde. By the late 1950s, in fact, he deemed it necessary to distance his work publicly from its artistic reverberations in the United States in the brief article, "Zen in the Modern World":

Zen is at present evoking unexpected echoes in various fields of Western culture: music, painting, literature, semantics, religious philosophy, and psychoanalysis. But as it is in many cases grossly misrepresented or misinterpreted, I undertake here to explain most briefly, as far as language permits, what Zen aims at and what significance it has in the modern world, hoping that Zen will be saved from being too absurdly caricatured.[73]

While Suzuki's critique focuses exclusively on the appropriation of Zen by the "Beat" authors, one can nonetheless infer a great deal about his attitude toward Cage's artistic applications of East Asian philosophic concepts as well:

I can say this about the "Beat Generation": they have probably not yet tapped the headspring of creativity. They are struggling, rather superficially, against "democracy," bourgeois conformity, economic respectability, conventional middle-class consciousness, and other cognate virtues and vices of mediocrity. Because they are still "rootless," as Simone Weil would condemn them, they find themselves floundering in the mud in their own search for "the only way through into truth (which) is by way of one's own annihilation; through dwelling a long time in a state of extreme and total humiliation." They have not yet quite passed through their experiences of humiliation and affliction and, I may add, revelation.[74]

Unlike the highly speculative relationship between Cage's aesthetic and Suzuki's work, Cage's borrowings from the slim ninth-century Chinese Zen text *Doctrine of Universal Mind*, attributed to Huang Po, are far more evident and are occasionally reinforced by historical information, such as accounts of Cage's late-night reading of this text at North Carolina's Black Mountain College in the summer of 1952. Among Cage's writings, the brief "Manifesto"[75] is one of his most obvious adaptations of Huang Po, lifting the rhetorical motif of "accomplishing nothing" directly from this source:

It is by not allowing wrong thinking to take place that you will realize Bodhi [Truth; Enlightenment]; and, at the moment of realization, you will be but realizing the Buddha who has always existed in your own mind. Kalpas [aeons] of striving will prove to have been

so much wasted effort, just as, when the warrior found the pearl, he merely discovered what had been on his forehead all the time, and just as his finding of it was not dependent on his efforts to find it elsewhere. Therefore the Buddha said: "I obtained nothing from complete, unexcelled Enlightenment."[76]

Written in response to a request for a manifesto on music, 1952: instantaneous and unpredictable, nothing is accomplished by writing a piece of music, nothing is accomplished by hearing a piece of music, nothing is accomplished by playing a piece of music. Our ears are now in excellent condition.[77]

In the essay "Experimental Music: Doctrine," Cage not only borrowed individual rhetorical figures from Huang Po but openly copied the text's formal substructures, parodying its master–student question-and-answer (or in Zen terminology, *mondo*) sections. At an even deeper level, other passages from this mock *mondo* include recastings of actual passages from Huang Po's original:

Question: When I spoke to your Reverence, just now, in what way was I mistaken?
Answer: You are the one who does not understand what is said to him. What is all this about being mistaken?[78]

Question: But, seriously, if this is what music is, I could write it as well as you.
Answer: Have I said anything that would lead you to think I thought you were stupid?[79]

Less frequently credited than Buddhist sources, the texts of Taoism contributed to Cage's aesthetic vocabulary of the 1950s as well. Cage's borrowings from Kwang-tse, for example, were often quite overt, making direct reference to several parables.[80] One such parable depicts Chaos, a Taoist concept roughly analogous to what Coomaraswamy might call a primordial Ultimate Reality:

The Four Mists of Chaos, the North, the East, the West, and the South, went to visit Chaos himself. He treated them all very kindly and when they were thinking of leaving, they consulted among

themselves how they might repay his hospitality. Since they had noticed that he had no holes in his body, as they each had (eyes, nose, mouth, ears, etc.), they decided each day to provide him with an opening. At the end of seven days, Kwang-tse tells us, Chaos died.[81]

Cage referred to this particular story in subsequent essays and lectures in apparent appreciation of both its interpretation of Chaos as a dynamic, natural entity as well as its contention that purposeful (i.e., intentional) action is deleterious to this greater essential state. The story also provided Cage with a motivic reference, as is seen in one of the best-known passages from his writings, where it is combined with the idea of "purposelessness" (itself an appropriation from Huang Po):

> And what is the purpose of writing music? One is, of course, not dealing with purposes but dealing with sounds. Or the answer must take the form of a paradox: a purposeful purposelessness or a purposeless play. This play, however, is an affirmation of life—*not all attempt to bring order out of chaos nor to suggest improvements in creation*, but simply a way of waking up to the very life we're living, which is so excellent once one gets one's mind and one's desires out of its way and lets it act of its own accord.[82]

In addition to Kwang-tse, Cage was no doubt familiar with the *Tao Te Ching,* although its importance as a distinct source of rhetorical appropriations is relatively peripheral. In explaining the purpose of *Imaginary Landscape No. 4* (1951), for example, Cage states:

> When I wrote the *Imaginary Landscape* for twelve radios, it was not for the purpose of shock or as a joke but rather to increase the unpredictability already inherent in the situation through the tossing of coins. Chance, to be precise, is a leap, provides a leap out of reach of one's own grasp of oneself. Once done, forgotten.[83]

Following its more obviously provocative allusions to chance operations and the *I Ching*, the concluding sentence of this passage may be passed over too quickly as a mere cadential figure. However, it may also be considered a motivic reference that draws upon a prominent concept in Taoist literature, as the *Tao Te Ching* explicitly illustrates:

...Therefore the sage goes about doing nothing, teaching no-talking.
The ten thousand things rise and fall without cease,
Creating, yet not possessing,
Working, yet not taking credit.
Work is *done, then forgotten.*
Therefore it lasts forever.

—*Lao-tse*[84]

Conclusions

In his writings, Cage never abandoned any of his previous sources entirely;
instead his pool of sources increased additively, and an undergrowth of
the rhetorical borrowings that had been prominent in earlier periods is
often detectable beneath the layers of his more recent appropriations. In
the 1960s he propelled many of the notions originally expressed through
South or East Asian terminology through an entirely different set of terms.
As usual, his sources were based outside the field of music—and, for that
matter, outside of the arts altogether. These post-1960 appropriations also
signaled a noteworthy turn in Cage's aesthetic motivations, for while the
sources from which he derived his metaphors during the 1940s and 1950s
ultimately centered upon "God" (in its most abstract sense) in some as-
pects, the sources from which he co-opted his metaphors from the 1960s
until his death—namely, the social philosophy of Marshall McLuhan, the
writings of Henry David Thoreau and anarchist theory in general—are
unified in their focus on man. During the 1960s, for instance, it was not
the Buddha's enlightenment that served as a metaphor for musical works
deliberately designed without a single, central focus, but the futurist lingo
of McLuhan: "Nowadays everything happens at once and our souls are
conveniently electronic (omni-attentive)."[85] Yet while this shift in empha-
sis marks a fundamental change of attitude, it does not so much disrupt the
continuity of his aesthetic thought as much as it simply represents its next
stage. Moreover, based upon the ideological affinities that Zen and Taoism
share with anarchic political theory, one could comfortably suggest that
East Asian philosophy was a logical precursor to Cage's subsequent interest
in social theorists.

The depth to which Cage may have ever personally accepted the
principles of any Asian philosophic tradition is, for the purposes of this
essay, a matter of disinterest. He regularly attended Suzuki's Columbia

University lectures in the 1950s; he read a fair amount of South Asian aesthetics and East Asian philosophy. He did not affiliate himself officially with any Buddhist temples or other organizations; nor did he sit *zazen* (the traditional seated form of Zen meditation), contending that just about anything else could serve as a perfectly acceptable substitute: "Distractions? Interruptions? Welcome them. They give you the chance to know whether you're disciplined. That way you needn't bother about sitting cross-legged in the lotus position."[86] Similarly, in surveying his use of excerpts from Asian sources during the 1940s and 1950s, it becomes apparent that Cage's aesthetic was never any more consistently Hindu or Taoist than he himself ever was, that his works composed through chance operations are no more authentically "Buddhist" than his percussion works are "Balinese." Indeed, from the 1960s onward, Cage's personal intersections with Asia and Asian composers were more frequent—he visited Japan on several occasions, meeting with Suzuki in the early 1960s; he was and continues to be venerated in Japanese New Music circles. However, these later biographical details seem more surface than substance. In truth, and as the preceding pages have attempted to document, the most elemental facet of Cage's contact with Asian culture is the way in which he studied, absorbed, and sifted through a variety of texts during the 1940s and 1950s, extracting with single-minded discrimination only those malleable ideas that could be used metaphorically to illuminate the artistic themes that were always the focus of his writings or reshaped to reinforce the tenets of his own modernist agenda.

Notes

1. John Cage, "Preface to *Indeterminacy*" (1959), in *John Cage, Writer: Previously Uncollected Pieces*, ed. Richard Kostelanetz (New York: Limelight Editions, 1993), 79.

2. John Cage, "A Few Ideas about Music and Film" (1951), in ibid., 63.

3. John Cage, ["On Earlier Pieces"] (1958), in *John Cage: An Anthology*, ed. Richard Kostelanetz (New York: Da Capo Press, 1991), 129.

4. John Cage, "Notes on Compositions," in *John Cage, Writer*, 11.

5. Ibid., 51.

6. John Cage, interview with Miguel Frasconi, *Balungan* 3, no. 2 (October 1988): 20.

7. John Cage, "Tokyo Lecture and Three Mesostics" (1986), in *John Cage, Writer*, 177.

8. Cage, "Preface to *Indeterminacy*," 78–79.

9. John Cage, "Grace and Clarity" (1944), in Cage, *Silence* (Middletown, Conn.: Wesleyan University Press, 1961), 90.

10. John Cage, "The East in the West" (1946), in *John Cage, Writer*, 21–25.

11. John Cage, "A Composer's Confessions" (1948), in ibid., 27–44.

12. John Cage, "Defense of Satie" (1948), in *John Cage: An Anthology*, 77–84.

13. John Cage, "Forerunners of Modern Music" (1949), in Cage, *Silence*, 62–66.

14. Ananda K. Coomaraswamy, *The Transformation of Nature in Art* (New York: Dover, 1934).

15. Cage, "The East in the West," 24.

16. This statement makes several appearances in Cage's prose, and may be found in Cage, *Silence*, 100.

17. Coomaraswamy, *The Transformation of Nature in Art*, 14.

18. John Cage, "Juilliard Lecture" (1952), in Cage, *A Year from Monday* (Middletown, Conn.: Wesleyan University Press, 1967), 97.

19. Coomaraswamy, *The Transformation of Nature in Art*, 9.

20. Ibid., 65.

21. John Cage, "Diary: How to Improve the World (You Will Only Make Matters Worse) 1965," in Cage, *A Year from Monday*, 19.

22. John Cage, "More Satie" (1950), in *John Cage: An Anthology*, 93 (Cage's italics).

23. John Cage, "Composition as Process" (1958), in Cage, *Silence*, 44–45.

24. Ananda K. Coomaraswamy, "Why Exhibit Works of Art?," *Studies in Comparative Literature* 5, no. 3 (1971): 176.

25. John Cage, "Lecture on Something" (c. 1951–1952), in Cage, *Silence*, 144.

26. Cage, "A Composer's Confessions," 41.

27. Mahendranath Gupta, *The Gospel of Sri Ramakrishna*, trans. with an introduction by Swami Nikhilananda (New York: Ramakrishna-Vivekananda Center, 1942).

28. Geeta Sarabhai Mayor, letter to David Patterson, 1993.

29. Ibid.

30. Ibid.

31. Cage, "A Composer's Confessions," 41. See also Cage, "45′ for a Speaker" (1954), in Cage, *Silence*, 158; and Cage, ["Memoir"] (1966), in *John Cage: An Anthology*, 77.

32. Cage, ["Memoir"], 77.

33. Cage, *Silence*, 127.

34. Lou Harrison, interview with David Patterson, September 29, 1993; Richard Lippold, interview with David Patterson, December 7, 1993.

35. "List no. 2" (1961), in *John Cage: An Anthology*, 138–139. See also Cage, *Silence*, 127.

36. Cage, *A Year from Monday*, 111. Additional citations from Sri Ramakrishna may be found in Cage, "Forerunners of Modern Music," 63; Cage, "Composition as Process," 45; John Cage, "History of Experimental Music in the United States" (1959), in Cage, *Silence*, 67–68; John Cage, "Indeterminacy," in Cage, *Silence*, 272; John Cage, "Lecture on Commitment" (1961), in Cage, *A Year from Monday*, 117–118; John Cage, "How to Pass, Kick, Fall, and Run" (1965), in Cage, *A Year from Monday*, 136.

37. John Cage, "Lecture on Nothing" (c. 1949–1950), in Cage, *Silence*, 109–126.

38. Cage, "Lecture on Something," 128–145.

39. Cage, "Juilliard Lecture," 95–111.

40. John Cage, ["Manifesto"] (1952), in Cage, *Silence*, xii.

41. John Cage, ["Robert Rauschenberg"] (1953), in *John Cage: An Anthology*, 111–112.

42. John Cage, "Experimental Music: Doctrine" (1955), in Cage, *Silence*, 13–17.

43. Cage, "Composition as Process," 18–56.

44. Cage, "45′ for a Speaker," 146–192.

45. Cage, "Indeterminacy," 260–273.

46. Cage, "Forerunners of Modern Music," 62–66.

47. Cage, "Lecture on Nothing," 109–126.

48. Cage, "Forerunners of Modern Music," 62. This theme is reemphasized in another passage of the essay, which Cage entitled "Refrain": "Activity involving in a single process the many, turning them, even though some seem to be opposite, toward oneness, contributes to good way of life."

49. Cage, "Juilliard Lecture," 95–96. This story is also one of several independent anecdotes found in Cage, *Silence*, 88.

50. Earle Brown, interview with David Patterson, November 13, 1992.

51. Other such references include those in Cage, *Silence*, 85, 93, 273; and Cage, *A Year from Monday*, 135.

52. Cage, "Lecture on Something," 135.

53. Huang Po, *Doctrine of Universal Mind,* trans. Chu Ch'an (John Blofeld) (London: Buddhist Society, 1947).

54. Reginald Horace Blyth, *Haiku*, 4 vols. (Tokyo: Hokuseido, 1950–1952).

55. Reginald Horace Blyth, *Zen in English Literature and Oriental Classics* (Tokyo: Hokuseido, 1942).

56. John Cage, "Satie Controversy" (1950), in *John Cage: An Anthology*, 90.

57. See, for example, Cage, "Lecture on Something," 143.

58. Cage, "Composition as Process," 35.

59. "Suzuki's works on Zen Buddhism are about to be published." Letter from John Cage to Pierre Boulez, January 17, 1950. See *The Boulez-Cage Correspondence*, ed. Jean-Jacques Nattiez, trans. Robert Samuels (Cambridge: Cambridge University Press, 1993), 50.

60. Ruth Fuller Sasaki, quoted in Rick Fields, *How the Swans Came to the Lake: A Narrative History of Buddhism in America* (Boston: Shambhala Publications, 1992), 205. Sasaki was the wife of Zen teacher Sokeian Sasaki, who founded the First Zen Institute in New York City. She herself oversaw the translation of several Zen texts and was the first foreigner to be ordained a Zen priest in Japan.

61. John Cage and Laurie Anderson, "Taking Chances: John Cage and Laurie Anderson" (interview), *Tricycle: The Buddhist Review* (1992): 54.

62. See, for example, *John Cage: An Anthology*, 23.

63. See, for example, "Biographical Chronology," in *A John Cage Reader*, ed. Peter Gena, Jonathan Brent, and Don Gillespie (New York: C. F. Peters, 1982), 186.

64. Cage and Anderson, "Taking Chances," 53.

65. Verification in the latter semester comes from Earle Brown, who recounts how he and Cage quit early each Friday afternoon while working on the arduous cut-and-splice

assemblage of *Williams Mix* to attend Suzuki's lectures. Brown, interview with David Patterson, November 13, 1992.

66. Torataro Shimomura, "D. T. Suzuki's Place in the History of Human Thought," in *A Zen Life: D. T. Suzuki Remembered*, ed. Masao Abe (New York: Weatherhill, 1986), 66.

67. Fields, *How the Swans Came to the Lake*, 197.

68. Cage, *A Year from Monday*, 35.

69. Cage, "Lecture on Commitment," 112. For other anecdotal references to Suzuki, see for instance Cage, *Silence*, 32, 40, 67, 193, 262, 266; and Cage, *A Year from Monday*, 67–68.

70. William Duckworth, "Anything I Say Will Be Misunderstood: An Interview with John Cage," in Richard Fleming and William Duckworth, eds., *John Cage at Seventy-Five* (Lewisburg, Pa.: Bucknell University Press, 1989), 27.

71. Cage, "Indeterminacy," 262.

72. Cage and Anderson, "Taking Chances," 54.

73. Daisetz Taitaro Suzuki, "Zen in the Modern World," *Japan Quarterly* 5, no. 4 (1958): 452.

74. Ibid., 453. The internal quotation derives from Simone Weil, *La personne et la sacré* (Paris: Gallimard, 1957), as excerpted in Richard Rees, *Brave Men: A Study of D. H. Lawrence and Simone Weil* (London: Gollancz, 1958), 45.

75. Cage, ["Manifesto"].

76. Huang Po, *Doctrine of Universal Mind*, 25.

77. Cage, ["Manifesto"], xii. This manifesto reappears in edited form as part of the text for "Experimental Music: Doctrine," 17: "Why don't you realize as I do that nothing is accomplished by writing, playing or listening to music?"

78. Huang Po, *Doctrine of Universal Mind*, 41.

79. Cage, "Experimental Music: Doctrine," 17.

80. See, for example, "Kwang-tse points out that a beautiful woman . . ." in Cage, *A Year from Monday*, 136; and on the succeeding page, "A Chinaman (Kwang-tse tells) went to sleep. . . ."

81. Cage, "How to Pass, Kick, Fall, and Run," 137. This story also appears in the 1959 recording of *Indeterminacy: New Aspect of Musical Form in Instrumental and Electronic Music*.

82. John Cage, "Experimental Music" (1957), in Cage, *Silence*, 12 (italics mine).

83. Cage, "45' for a Speaker," 162–163.

84. Lao-tse, *Tao Tê Ching*, trans. Gia-Fu Feng and Jane English (New York: Vintage Books, 1972), second section (italics mine). It is noteworthy that "The Ten Thousand Things" was Cage's private name for the series of pieces with unwieldy durational titles, including *26'1.1499" for a string player* (1953) and *34'46.776" for a pianist* (1954). See James Pritchett, *The Music of John Cage* (Cambridge: Cambridge University Press, 1993), 95–104.

85. John Cage, ["Letter to the Editor of the Village Voice"] (1966), in *John Cage: An Anthology*, 167.

86. Cage, "Diary: How to Improve the World," 11.

John Cage and the Architecture of Silence

Branden W. Joseph

In 1961 Gyorgy Kepes invited John Cage to contribute an article to the book *Module, Proportion, Symmetry, Rhythm,* part of the series he was editing under the collective title *Vision and Value.* When the anthology appeared, Kepes pitched Cage's article "Rhythm Etc." as "a personal statement on the creative power and use of the module, rhythm, and proportion,"[1] although Kepes knew full well that Cage—sounding the only discordant voice in the collection—had expressly opposed the aesthetic value of any of the aforementioned principles.

When preparing "Rhythm Etc.," Cage correctly surmised that what united the themes of Kepes's book was an interest in Le Corbusier's proportional measuring device, the Modulor, and it was against this that Cage directed his critique. Cage was, not surprisingly, annoyed at what he called the "farfetched analogy to music of previous times" that ran through Le Corbusier's book on the Modulor.[2] More significantly, however, as an instrument of visual and architectonic harmony, the Modulor was diametrically opposed to Cage's own artistic project, a project premised on the rejection of harmony as a legitimate basis for musical composition. Cage saw harmony as an outdated and abstract ordering principle that served to regulate the otherwise continuous field of sound,[3] and he sought in his own work to substitute for harmony different structures, such as the "rhythmic structures" he created based solely on lengths of time.[4]

If Cage hoped definitively to end the reign of musical harmony, Le Corbusier proposed to extend it by using the Modulor as a means of propagating harmonic proportion throughout the realms of the visual

Figure 5.1 Paul Williams, Gatehill
Cooperative Community, upper
square, c. 1956. Western facade of
Williams-Cage House at lower left.

and architectonic. As Le Corbusier envisioned it, the Modulor would play
a role at every building site as a proportional scale that would "serve as a
rule for the whole project, a norm offering an endless series of different
combinations and proportions," which, "different and varied as they are,
will be united in harmony."[5]

Cage responded to Le Corbusier's project with unequivocal con-
demnation and exposed what he saw as the authoritarian implications
of the Modulor. As Cage stated, "once the measurements are made (not
in rubber but in some inflexible material), the proper relationships de-
termined . . . , a police force is in order."[6] As proof, Cage cited a passage
from Le Corbusier's own text: "Concord between men and machines,
sensitivity and mathematics, a harvest of prodigious harmonies reaped
from numbers: the grid of proportions. This art . . . will be acquired by
the effort of men of good will, but it will be contested and attacked. . . . *It
must be proclaimed by law.*"[7]

To this decree, Cage replied succinctly, "Art this is called. Its shape is that of tyranny."[8] However, against the impending threat of Le Corbusier's "reign of harmony,"[9] Cage did not immediately counterpoise the example of his own music; instead he referred to the alternative of a vitreous architecture. "Unless we find some way to get out we're lost," he warned, and then, "the more glass I say, the better."[10]

Although never mentioned by name, an important intermediary who facilitated the debate between Cage and Le Corbusier was the architect Paul Williams. Williams studied for some years at the Harvard School of Architecture and MIT but was, more importantly, a student and resident architect at Black Mountain College where, in 1949, he and John Cage met.[11] It was from Williams that Cage borrowed the copy of *The Modulor* that he studied to prepare "Rhythm Etc."[12] Moreover, it was one of Williams's buildings that Cage had in mind when alluding to an antiauthoritarian architecture of glass. This building, in fact, was none other than John Cage's home.

Since the summer of 1954, Cage had lived at the Gatehill Cooperative Community in Stony Point, New York, an experiment in communal living organized to function, in part, as a successor to that aspect of Black Mountain College.[13] Located in Gatehill's upper square, Cage's apartment occupied the western quarter of a duplex that he shared with Paul Williams and the rest of the architect's family. Like the other buildings surrounding the upper square, the Williams-Cage House evinces a high modernist formal sensibility closely akin to that of Marcel Breuer's contemporary domestic architecture. Supported by a weighty central core and barely perceptible wooden columns, the rectangular mass of the house rests, on one side, against the upper slope of a densely forested hillside, while the opposite end of the structure stretches out at some distance above the ground. The main structure's sense of lightness, which is accentuated by its exceedingly thin lines and windows that run from floor to ceiling, makes the building appear almost to perch atop the site. Contrasting with the building's sylvan environment, the frame is clad in panels of prefabricated, industrial materials, ranging in texture from corrugated aluminum to fiberglass and asbestos.

Separated from the remainder of the building by a free stone wall that John Cage and Vera Williams built by hand, Cage's living quarters, with the exception of a small bath and kitchenette, consisted originally of a single room, the western and southern walls of which were made up almost entirely of vertically sectioned glass windows. While the southern

Figure 5.2 Le Corbusier,
the Modulor, c. 1946.

view looks out onto the other buildings at Gatehill, the western wall
faces directly onto the steeply climbing hillside. This wall is the most
striking aspect of the building, for Williams designed it to slide open,
coming to rest in a large wooden frame that stands next to the building
as an extension of the facade. It was to this feature that Cage referred
when he wrote in "Rhythm Etc.": "Not only the windows, this year, even
though they're small, will open: one whole wall slides away when I have
the strength or assistance to push it. And what do I enter?" Cage asked,

Figure 5.3 Paul Williams, Williams-
Cage House, south facade, c. 1956.

once more taking a swipe at Le Corbusier. "Not proportion. The clutter of the unkempt forest."[14]

While such a specific reference to the Williams-Cage House is unique to Cage's polemic against Le Corbusier, it nonetheless forms part of a larger discursive figuration of glass and glass architecture that surfaces repeatedly throughout Cage's statements and writings. Far from being simply a convenient metaphor, what I would like to argue is that this architectural trope is of particular importance for understanding the specificity of the neo-avant-garde artistic project that Cage pursued throughout the 1950s.

The earliest reference to glass architecture that can be found in Cage's writings occurs in the "Juilliard Lecture" of 1952. There Cage stated with regard to contemporary music, "It acts in such a way that one can 'hear through' a piece of music just as one can see through some modern buildings or see though a wire sculpture by Richard Lippold or the glass of Marcel Duchamp."[15] It is not insignificant that this first

reference appeared in 1952, for that year marks the composition of Cage's most famous work, *4′33″*: the manifesto presentation of his definition of silence as the presence of ambient and unintentional noise rather than the complete absence of sound. Indeed, the passage quoted from the "Juilliard Lecture" might well refer to *4′33″*, for, as originally composed, the work consisted solely of an empty time structure of three silent movements through which any sounds emanating from the environment could flow.

Over the years, Cage would more explicitly relate his understanding of silence to the material properties of glass. In a lecture entitled "Experimental Music," given in Chicago in 1957, Cage stated:

> For in this new music nothing takes place but sounds: those that are notated and those that are not. Those that are not notated appear in the written music as silences, opening the doors of the music to the sounds that happen to be in the environment. This openness exists in the fields of modern sculpture and architecture. The glass houses of Mies van der Rohe reflect their environment, presenting to the eye images of clouds, trees, or grass, according to the situation. And while looking at the constructions in wire of the sculptor Richard Lippold, it is inevitable that one will see other things, and people too, if they happen to be there at the same time, through the network of wires. There is no such thing as an empty space or an empty time. There is always something to see, something to hear. In fact, try as we may to make silence, we cannot.[16]

In the way that it subtly interrelates the conceptions of vision and hearing, space and time, and music, sculpture, and architecture, this passage proves much richer and more complex than that in the "Juilliard Lecture." Moreover, in this passage Cage makes a distinction between two modes of openness operating among the constellation of individuals grouped around the notion of transparency. Whereas one looks, as before, through the wire mesh of Lippold's sculptures, in Mies van der Rohe's architecture the observation of the environment is to be understood as a result of the reflections cast across the glass surfaces of the building. In this reformulation of transparency in terms of reflection, Cage returned to what was undoubtedly one of the primary sources of his interpretation—the discussion of architectural space presented by László Moholy-Nagy in the

book *The New Vision*, the importance of which Cage stressed on more than one occasion.[17]

As defined in *The New Vision*, truly spatial relations—as opposed to volumetric ones—were only achieved by modern architecture through the mutual interpenetration of the interior and exterior of the building.[18] While Moholy-Nagy did reference the physical openness and flow of space in certain modernist buildings, he repeatedly presented his concept of architectural space as a consequence of the play of external reflections. This idea he articulated most clearly in the caption placed below Lux Feininger's photograph of the glass curtain wall of Gropius's Dessau Bauhaus. "Fenestrations," Moholy wrote, "produced the inward and outward reflections of the windows. It is no longer possible to keep apart the inside and outside. The mass of the wall, at which all the 'outside' previously stopped, is now dissolved and lets the surroundings flow into the building."[19] In Cage's writing, this formulation of the reflection on the outside of the building forms a complimentary pair with the effect of transparency from the inside as a means of visually opening up the building's structure to the environment. It was the relation of the inside to the outside (and not the reverse) that Cage took as the operative part of Moholy-Nagy's definition of architectural space.

Cage's reading would have been supported by Moholy-Nagy's text, which described the end limit of spatial relations as the complete dissolution of architecture into its environment. At the end of *The New Vision* Moholy-Nagy speculated that

> a white house with great glass windows surrounded by trees becomes almost transparent when the sun shines. The white walls act as projection screens on which shadows multiply the trees, and the glass plates become mirrors in which the trees are repeated. A perfect transparency is the result; the house becomes part of nature.[20]

In "Rhythm Etc.," Cage would echo Moholy-Nagy's understanding of a glass building's ability to dematerialize. In apparent reference to Mies's Farnsworth House in Plano, Illinois, Cage stated, "If, as is the case when I look at that building near Chicago, I have the impression it's not there even though I see it taking up space, then module or no module, it's O.K."[21]

Cage's interpretation of Miesian architecture contrasts sharply with a reading such as that of K. Michael Hays, who has theorized Mies's work

in relation to the aesthetic strategies of the historical avant-garde. According to Hays, beginning with the skyscraper projects of the 1920s, Mies eschewed any prioritization of an internal formal logic from which the building's meaning could be derived and figured its signification instead through a mimetic immersion into the urban context. Reflecting the chaos of metropolitan existence across their surfaces, the vitreous facades of Mies's buildings overtly register the disorder and anxieties of modern urban society. In comparing Mies's skyscraper projects to Kurt Schwitters's *Merz-Column*, Hays argues, "Both share an antagonism toward a priori and reasoned order. Both plunge into the chaos of the metropolis to seek another order within it through a systematic use of the unexpected, the aleatory, the inexplicable."[22] Yet, in order for one of Mies's buildings to function as a cognitive mechanism or what Hays, following Adorno, calls an "exact fantasy" of reality[23]—that is, in order for it to assume a critical rather than merely superstructural function in relation to society—the Dadaist montage of fragmentary appearances that materialize across its glass surfaces must be understood as part of a dialectical relationship formed with the relative autonomy of the building from its cultural as well as physical environment. A necessary condition of the building's oppositional stance, it is this ability to tear a disjunctive cleft out of the continuous surface of reality that Hays, following Tafuri, has termed the "implacable silence" of Miesian architecture.[24]

Cage's understanding of Mies differs from that of Hays most starkly in that it rejects the notions of relative autonomy and critical distance that Hays posits as indispensable. For Cage, any silence in Miesian architecture would not negate the environment but would open the building up to an interpenetration with its surroundings along the lines of Cage's own definition of silence. Indeed, Cage figures the transparency of Mies's glass buildings as a metaphor for his own goal of eradicating harmonic music's alienation from the plane of everyday existence. Following the allusion made to the transparency of the Farnsworth House in "Rhythm Etc.," Cage added, "It must be that eventually we will have a music the relationship of which to what takes place before and after ('no' music) is exact, so that one will have the experience that no experience was had, a dematerialization (not of facts) of intentions."[25]

By abrogating any notion of critical distance, Cage opened himself up to a series of attacks by Theodor Adorno. In articles written at the beginning of the 1960s, Adorno criticized Cage's interest in allowing sounds to be just sounds[26] and reiterated what he saw as the

compositional necessity to subjectively form musical materials into functioning relations.[27] In the article "Vers une musique informelle" of 1961, Adorno wrote:

> But the hypothesis that the note "exists" rather than "functions" is either ideological or else a misplaced positivism. Cage, for example, perhaps because of his involvement with Zen Buddhism, appears to ascribe metaphysical powers to the note once it has been liberated from all supposed superstructural baggage.[28]

In imputing to Cage an attitude that fluctuated between pure immediacy and the ascription of metaphysical powers, Adorno located him at exactly the same "crossroads of magic and positivism" that he criticized Walter Benjamin for occupying nearly a quarter of a century earlier.[29] And Adorno's advice to Cage was much the same as that once offered to Benjamin: in a word, "more dialectics."[30]

For Adorno, the failure to form one's material dialectically—whether as critic or composer—was symptomatic of no less than a capitulation to the ego-annihilating forces of instrumental reason and culture industry.[31] "Composers tend to react to [the anthropology of the present age]," Adorno stated, "by renouncing any control of their music by their ego. They prefer to drift and to refrain from intervening, in the hope that, as in Cage's *bon mot*, it will be not Webern speaking, but the music itself. Their aim is to transform psychological ego weakness into aesthetic strength."[32] As Adorno viewed it, a Cagean aesthetic ultimately amounted to little more than an ineffectual revival of Dadaism.[33] "In contrast to its Dadaist grandparents," Adorno cautioned, "it degenerates at once into culture, and it cannot remain unaffected by this."[34]

In this last assessment, Adorno's judgment of Cage is typical of those who would view the composer as a victim of the historical neutralization of avant-garde aesthetics. Typical, but unjust, for Cage clearly understood the failure and co-optation that was the general fate of the earlier avant-garde movements. As he explained in his preface to "Indeterminacy" of 1959, "There is a connection possible between the two, but neither Dada nor Zen are fixed tangibles. They change; and in quite different ways in different places and times, they invigorate actions. What was Dada in the twenties is now, with the exception of the work of Marcel Duchamp, just art."[35] To this brief but insightful synopsis of the theory of the avant-garde, Cage added, still referring, in part, to the important exception of

Duchamp, "I often point out that Dada nowadays has a space, an emptiness, in it that Dada formerly lacked."[36] In another article published the same year, Cage made it clear that this notion of space was the same as that he attributed to modern architecture.[37] This fact is significant, for it indicates that behind Cage's aim of collapsing art into life was not a renewed faith in the transgressive facticity of the unassisted readymade but instead an investigation into the modalities of transparency that brought Duchamp closer to Mies van der Rohe. In other words, the Dadaist forebear of the Cagean project was not the *Bottle Rack* but *The Bride Stripped Bare by Her Bachelors, Even* (*The Large Glass*).

Because of its transparency, Duchamp's *Large Glass* served for Cage as the model of an artwork with no determinate focal point or center of interest. "Looking at the *Large Glass*," Cage explained,

> the thing that I like so much is that I can focus my attention wherever I wish. It helps me to blur the distinction between art and life and produces a kind of silence in the work itself. There is nothing in it that requires me to look in one place or another or, in fact, requires me to look at all. I can look through it to the world beyond.[38]

Beginning with the concept of silence exemplified by *4'33"*, Cage would seek ways of attaining a similar modality of unfocused perception in music. One manner in which Cage approached this goal may be seen in another composition of 1952, *Music for Carillon I*—also known as *Graph*.[39] The score for the piece consists of twenty-four 3-by-10-inch sections of quadrille graph paper onto which Cage added an array of points, the locations of which were determined by chance operations. Read from left to right, each of the inch-wide horizontal segments is equivalent to one second of performance time, while the vertical axis corresponds in a relatively indeterminate manner to the disposition of high, middle, and low tones.

As opposed to a traditional harmonic structure, the graph that serves as the "structure" of *Music for Carillon I* does not divide or regulate the continuum of pitch-time in any way but instead leaves its expanse completely intact.[40] There is, for example, no necessity of lining up the points of the score with the abscissas and ordinates of the grid in order for them to be readable. Rather, while it is only through the presence of the graph that these random markings can be translated into music, the structure of *Music for Carillon I* remains as though on a different level from

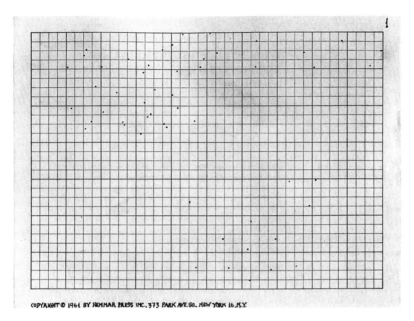

Figure 5.4 John Cage, *Music for Carillon I (Graph)*, 1952. © 1961. First page, showing two 3-by-10-inch sections (one above the other). Used by permission of C. F. Peters Corporation on behalf of Henmar Press, Inc.

the graphic representation of the sound plane. Although in actuality the points are laid onto the quadrille paper, one might see the graph—from the other side, as it were—as a window through which the separate space of the sonic continuum can be viewed.[41]

Music for Carillon I does not consist merely of musical material left in an untransformed state of residual facticity. By allowing chance to determine the location of the points, Cage deliberately "composed" the work in such a manner as to avoid any result that could be related to harmony or any other form of consciously created musical continuity. The "aggregates" or "constellations" into which Cage's musical materials fall are thereby characterized by incidental rather than exclusive relationships. Lacking any determinate continuity on which to focus, the listener must then await "no matter what eventuality" and not simply those sounds integrally related to the music as composition.[42] This openness to

"no matter what" allows the listener to unfocus her attention and "hear through" the piece, accepting as equally proper any sound and even the environmental or unintentional noises that occur during performance.

More specifically, the structure of *Music for Carillon I* functions to map out the space in which the points are situated, providing thereby the coordinates by which that space may be read and hence performed. That the graph acts as a map of pitch–time coordinates rather than as a traditional musical scale is made clear by the fact that the vertical axis is elastic in the sense that it may be recalibrated for instruments of differing octave ranges. Thus the different sonic identities of the points in any given musical realization will depend on the proportion of space between them rather than upon their location in relation to the lines of the graph. In the "Juilliard Lecture," Cage explained this notion of space as constitutive of difference through the example of leaves on a tree. "Any other leaf of the same tree," he wrote, "if it were the same as another leaf, it would be a coincidence from which each leaf would be free because of its own unique position in space."[43]

In all of Cage's later point-drawing scores, different means of mapping space similarly allow for the musical realization of the constitutive difference between points. The unique acoustic result of each piece is determined solely by means of the particular structure through which the randomly located points are viewed. (As Cage wrote in "45′ for a Speaker," "Spots are spots and skill's needed to turn them to the point of practicality.")[44] Through subsequent scores such as *Variations I* and *Variations II*, Cage further developed his ideas of transparent structure and spatial differentiation. In these scores, Cage's "structures" literally take the form of transparencies, separate from but laid atop different spatial arrays of points. In *Variations II* of 1961, the structure has become six separate transparencies, each of which is printed with a single line. Once the lines have been randomly arrayed on top of the points, the acoustic identity of a sound is determined by measuring the distances from a point to each of the six different lines in order to yield values corresponding respectively to the parameters of frequency, amplitude, timbre, duration, time of occurrence, and number of sounds. Here, not only pitch and time, but all aspects of a sound's identity are determined by measurements made with reference to a transparent mapping. As each throw of the transparencies completely alters the configuration of the structure, the fixed intervals of harmonic structure have completely given way in favor of an infinite

Figure 5.5 John Cage, one
configuration of *Variations II*, 1961.
© 1961. Used by permission of
C. F. Peters Corporation on behalf
of Henmar Press, Inc.

series of "intermittent aggregates" for which there is no underlying pro-
portional rule.[45]

Although Cage's aesthetic is clearly predicated on more than a mis-
placed trust in the supposedly transgressive nature of readymade material,
nothing so far refutes the most damning aspect of Adorno's judgment:
that the failure of Cage's compositions to attain an autonomy, however
relative, from social conditions betrays an incapacity to achieve the dis-
tance necessary for a critical practice. Likewise, lacking any negativity
vis-à-vis the urban context, Cage's understanding of Miesian architecture
would appear to strip it of any criticality. It would be mistaken, however,
to argue that Cage's interpretation of Mies was motivated by an uncriti-
cal acceptance of modern urban existence. (Cage speaks, for example, of
his "disgust" at walking through Times Square.)[46] If Cage had no inter-
est in forming aesthetic devices to reveal the structures of an otherwise
indecipherable chaos of modernity, it is because, for Cage, the aversion to

the city and to the commercial culture engendered there was motivated
not by a surfeit of irrationality but by a dearth of it. For from his stand-
point in midcentury America, what Cage could understand better than
his Dadaist predecessors on the Continent was that there was already a
strict logic to the form of modern existence: one that had little to do
with chaos but instead had everything to do with repetition.[47] This reali-
zation brings him closer to the position that Horkheimer and Adorno
had arrived at during their years in California. As they stated in the open-
ing lines of the culture industry chapter of *Dialectic of Enlightenment*, "The
sociological theory that [the developments of modernity] have led to
cultural chaos is disproved every day; for culture now impresses the same
stamp on everything. Films, radio and magazines make up a system which
is uniform as a whole and in every part."[48]

That repetition encompasses more than the identical return of the
selfsame was one of the lessons Cage credited Arnold Schoenberg with
teaching him. "Everything," Cage recalls Schoenberg saying, "is repeti-
tion. A variation, that is, is repetition, some things changed and others
not."[49] In this, Cage could have agreed with Adorno, who noted: "In
serial music this dialectic is taken to extremes. Absolutely nothing may
be repeated and, as the derivative of One thing, absolutely everything
is repetition."[50] Where Cage could not have agreed was when Adorno
concluded that "the task of [contemporary] music would be to rethink
this dialectic and incorporate it into its own organizational structure."[51]
Cage did not view atonal serialism as presenting a viable alternate with
which to structure a contemporary music: as he stated, for the project of
constructing a wholly new music, "The twelve-tone row offers bricks
but no plan."[52] With this, Cage distanced himself from Schoenberg and
thus from Adorno as well; because, for Cage, the problematic of repeti-
tion and variation in serial music was ultimately no different from that of
harmonic structure: serialism replaced counterpoint, but both presumed
an underlying model to which they implicitly referred.[53]

Cage stated repeatedly that the evolution of harmony, including the
questioning and disintegration it experienced under atonality, was in-
tegrally linked to the development of Western commercialism.[54] If, as
Adorno emphasized, life in commodity culture becomes objectively
more repetitive and conformist, society's connection to harmony, as Cage
viewed it, must nonetheless be understood through the manner in which
that conformity is subjectively lived as individualism. With the develop-
ment of capitalism came the replacement of actual differences by a system

of "accidental differentiation" and "pseudo-individualization."[55] While the individual's desire for difference is catered to by means of the "personalization" of products, this personalization only distinguishes mass-produced objects from one another by means of minute distinctions, such as those of color and available accessories. By substituting for actual difference only so many declensions from an a priori model or type, the extent and range of difference is effectively circumscribed—even if that model is purely ideal and inductively produced by the unfolding of the series. Apparent opposition to the series is defined as merely a negative relation to the series as such, in just the same way, as Cage pointed out, that atonality is forced to evade the presence of tonal harmony.[56] Far from being opposed to it, serial differentiation is the necessary alibi of social conformity.[57]

Looking back from his standpoint in the twentieth century, Cage saw the advent of harmonic music and the dynamic of repetition and variation as reproducing (if not preceding) as culture the same logic of model and series that would come to pervade society with the commodity form.[58] But, while the system of serial differentiation ideologically accommodates people into the realm of commodity production, the traditional musical work, according to Cage, operates as ideological at still another level. Because the variations of the series are inevitably related through the intermediary of a harmonic structure to the role of an existential author, the individual subject is placed firmly at the center of the system. "The thing that's so offensive about the series," Cage explained, "is the notion that it is the principle from which all happenings flow (it would be perfectly acceptable for a series to enter into a field situation). But the prediction of series equals harmony equals mind of man (unchanged, used as obstacle, not as fluent component open at both ends)!"[59] By apparently replacing an individual at the center of the socio-economic system, the traditional musical work functions to relieve, if only temporarily, the anxieties experienced by the subject decentered by the developments of capitalism. "Masterpieces and geniuses go together," Cage observed, "and when by running from one to the other we make life safer than it actually is we're apt never to know the dangers of contemporary music."[60]

With this, we have returned to Cage's argument with Le Corbusier. For the Modulor—as proportional harmonizer of the world's buildings and merchandise was presented by Le Corbusier as no less than the ur-model of multinational capitalism. "The 'Modulor' would," he dreamt,

"one day claim to be the means of unification for manufactured articles in all countries."[61] Far from representing a procedural innovation, Le Corbusier's Modulor acted to increase the efficiency of commodity production precisely by centralizing and intensifying capitalism's dynamic of model and series. By adopting the Modulor as standard, or so Le Corbusier advanced, one would be able to derive from it a variety of proportional schemes that would fulfill every individual's desire. "Ingenuity and good taste will make use of them at will," Le Corbusier said, "finding arrangements to satisfy every temperament and every fancy, and to meet every purely rational need."[62]

It was Le Corbusier's complicity with the logic of capitalism that motivated Cage's subtle but perceptive criticism: "Don't tell me it's a question of mass production," he wrote in "Rhythm Etc." "Is it not rather that they want to establish, if not the rules of the game, at least what it is that one uses to play with when he starts playing?"[63]

Thus Le Corbusier's analogy to music turns out not to have been so farfetched after all, for his project aimed to fulfill exactly the same role that traditional harmonic music had come to play: responding to the anxiety caused by the decentering of the individual by the system of mass production. It was for this reason that Le Corbusier continually

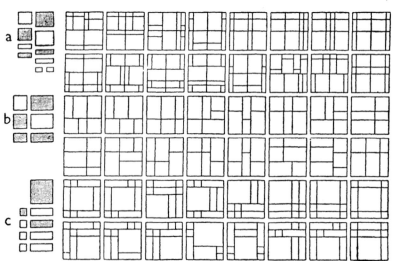

Figure 5.6 Le Corbusier, table from *The Modulor* showing possible combinations of harmonious proportions, 1948.

railed against the arbitrariness of industrial standards, and it motivated his repeated claim that the Modulor was superior because it was "based upon the human scale."[64]

By now we can understand how Cage could have viewed Le Corbusier's system as tyrannical. For were a single person actually able to dictate the form and extent of the allowable variations of commodity production, he would indeed be a tyrant, personally delineating the range and scope of subjective as well as objective differentiation.[65] We may now also be able to understand why, in "Rhythm Etc.," Cage would have posited his home at Gatehill as antithetical to Le Corbusier's project. For it may be argued that Cage viewed the Gatehill community as an instantiation of an oppositional aesthetics.

The siting of the Williams-Cage House, at a tangent to a hillside in the midst of a huge expanse of woodland, is important, because a certain notion of nature, understood as an immeasurably complex realm of un-regulated differentiation, ultimately served as the paradigm and justification of Cagean aesthetics.[66] Such a proximity to nature was integral to Cage's understanding of Mies as well; for in Cage's descriptions, Mies's glass buildings reflect clouds, trees or grass, but never images of the city.[67] However, while Cage viewed through one wall of his apartment the un-developed, forested hillside, through the other he saw the proto-urban configuration of the neighboring houses. There, around the pebbled clearing of the upper square, was manifest the logic of prefabrication and mass production that Paul Williams had incorporated into his thoroughly modern, post-Bauhaus-style buildings. Looking out from Cage's apartment, these two views were not juxtaposed to form opposed pairs such as nature/culture, rural/urban, or freedom/regulation.[68] Instead, the natural expanse that surrounds the settlement relativizes the realm of serial difference marked out by the buildings, situating them within the wider field of what Cage saw as nature's more radical sense of differentiation.

Yet even this formulation is not exact, for the settlement is not simply surrounded by nature; it is infiltrated and interpenetrated by it as well. No window in the upper square fails to reflect the surrounding trees and hillside, and from within the buildings each glance readily traverses the interior to arrive at views of the outlying natural realm. This dynamic occurs nowhere so much as in Cage's apartment, where the high proportion of glass causes the interior and exterior to interpenetrate almost completely. Furthermore, by designing the entire western wall to slide off the facade of the building into the adjacent frame, Williams literally

opened the structure up to nature and in the process transformed a glass wall à la Mies van der Rohe into the *Large Glass* of Marcel Duchamp. Freed of any attachment to the interior of the building, the wall becomes a mechanism of pure exteriority, mimetically dissolving into the environment via the interrelated play of transparency and reflection.

A paradigm of critical distance such as that posed by Frankfurt School aesthetics ultimately presupposes a relatively autonomous subject who will realize the structure of capitalist society once it has been presented without obscuring transformations. In the Cagean paradigm, on the other hand, given the lack of any possible autonomous or semi-autonomous space of critical distantiation, the subjective transformation takes place on the level of perception rather than cognition.[69] *Pace* Adorno, Cagean enlightenment had nothing to do with the ascription of metaphysical powers; rather, it was defined as the achievement of a mode of perception in which attention was unfocused, and the attachment to transcendent models and the limited play of repetition and variation they engendered could be undermined. To this end, the goal of Cage's oppositional aesthetic was not to understand the regulatory structures at

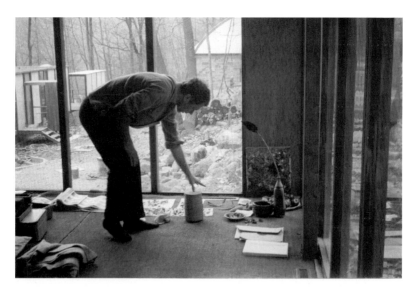

Figure 5.7 Interior view of Cage apartment with Merce Cunningham, November 1956. Photo: Valenti Chassin. Courtesy John Cage Trust.

the base of the social formation but rather to forget them.[70] Through the amnesic removal of the overarching model, a reorientation of perception toward the experience of differentiation would serve as a means of opposing the serialized logic of the commodity. As Cage explained in conversation with Daniel Charles,

> In contemporary civilization where everything is standardized and where everything is repeated, the whole point is to forget in the space between an object and its duplication. If we didn't have this power of forgetfulness, if art today didn't help us to forget, we would be submerged, drowned under those avalanches of rigorously identical objects.[71]

Only after this form of enlightenment had been achieved could Cage return to the city and view it and its inhabitants without disgust. "We go into a crowd," he explained,

> with a sharp awareness of the idiosyncrasies of each person in it, even if they're marching, and we along with them. We see, to put it coldly, differences between two things that are the same. This enables us to go anywhere alone or with others and any ordinarily too large number of others. We could take a vacation in a hotel room on Times Square.[72]

That Cage's oppositional aesthetic is not predicated on a relative autonomy from the phenomena to be critiqued problematizes the Frankfurt School ideal of Oedipally mature individuals who somehow hold their own against the dictates of consumer culture.[73] For Cage, the cognitive capacities of consciousness and the controlling force of the ego act to inhibit the experience of differentiation; the mind plays the role of a model from which only a limited series of ideas about the world can be derived. In contrast, Cage's differential perception, in which the last vestiges of a monadic humanism have been abolished, leads to the possibility of independent, or what Cage termed "experimental," actions, that is, actions not circumscribed by the inherent teleology of serialized and conformist modes of behavior. An experimental action, Cage explained, "is simply an action the outcome of which is not foreseen."[74]

It does not move in terms of approximations and errors as "in-
formed" action by its nature must, for no mental images of what
would happen were set up beforehand; it sees things directly as they
are: impermanently involved in an infinite play of interpenetrations.[75]

It is through the experimental pursuit of the nonidentical that Cage's
project reveals itself as an anti-ideological one, meant to evade the situa-
tion Adorno described as "the totality of mass culture [that] culminates in
the demand that no one can be any different from itself."[76]

In a manner analogous to that in which in his scores he had em-
ployed space to undermine musical continuity, Cage described ex-
perimental actions as a function of spatial separation. In the article
"Composition as Process: II. Indeterminacy" of 1958, Cage explained,

There is the possibility when people are crowded together that they
will act like sheep rather than nobly. That is why separation in space
is spoken of as facilitating independent action on the part of each
performer. Sounds will then arise from actions, which will then arise
from their own centers rather than as motor or psychological effects
of other actions and sounds in the environment.[77]

If, in the above description, Cage's musicians no longer resemble the reg-
imented automatons of the culture industry, neither do they approximate
the autonomous, centered subjects of classical thinking. Instead, just as the
music they perform breaks free of the limitations of "European harmony,"
Cage's musicians attain liberation from society's ideologically premodeled
norms of consciousness and behavior, but only through the complete im-
mersion into a radically multiplicitous perception of the world, a turning
of the mind "in the direction of no matter what eventuality."[78] Interest-
ingly, at the end of "Composition as Process II," Cage once again turned
explicitly to the topic of architecture, noting that for the successful per-
formance of such experimental music, "The conventional architecture
is often not suitable." Rather, Cage would go on to propose, "What is
required perhaps is an architecture like Mies van der Rohe's School of
Architecture at the Illinois Institute of Technology."[79]

Cage's project does recall the goals of the historical avant-garde: to refor-
mulate perception as a means of anticipating life beyond the boundaries
of commodity capitalism. However, rather than being limited to a merely

ineffectual revival of Dada, Cage's neo-avant-garde project marks a thorough reformulation of avant-garde aesthetics in light of the historical circumstances of the postwar era. In the face of a revolutionary hope of proletarian mass subjectivity falsely realized as the debilitating norms of a bourgeois mass culture, Cage attempted to actualize an anticipatory form of existence that would be the prerequisite for a new form of sociability, a perception of difference intended to destabilize the overriding social logic of repetition by interpenetrating, infiltrating, burrowing under and hollowing out that logic until it simply fell apart under the strain. Only then could the anarchic society of which Cage dreamed become a reality.

Although this aim would motivate virtually all of Cage's subsequent work, the means by which he would pursue it changed radically in the 1960s. In many ways, the article "Rhythm Etc." marked the end of the period I have been describing and the beginning of that transition. By 1961 Cage had already begun to reformulate his ideas of space, structure, and transparency.[80] Like the project of the historical avant-garde—like all avant-garde projects so far—Cage's neo-avant-garde project would ultimately fail in its most revolutionary ambitions, in part because he did not see that capital did not share Le Corbusier's anxiety at the dissolution of the model or standard but would itself embrace an ever more differentiated mode of commodity production. A radical increase in differentiation alone would not be able to counteract the new forms of decentralized power that have emerged within the most recent stages of capitalist society.[81]

Yet Cage, so perceptive on other counts, seems largely to have ignored such developments, and he kept his optimistic faith in an architecture of glass long after it would appear to be outdated. In "Overpopulation and Art," a piece he was writing at the time of his death in 1992, Cage could still state:

> we live in glass hOuses
> our Vitric surroundings
> transparEnt
> Reflective
> Putting images
> Outside
> in sPace of what's inside
> oUr homes
> everything's as muLtiplied
> As we are[82]

Notes

I would like to thank both Vera B. Williams and Merce Williams for generously sharing their time and knowledge as well as material on Paul Williams's architecture from their personal archives. I would also like to thank Laura Kuhn of the John Cage Trust for her assistance in tracking down information and visual materials relating to this topic, and the PhD students at the School of Architecture, Princeton University, at whose conference, Hypotheses 2, this paper was initially presented. Work on this article was supported, in part, by a fellowship from the Center for Advanced Study in the Visual Arts from the National Gallery of Art, Washington, D.C.

1. *Module, Proportion, Symmetry, Rhythm*, ed. Gyorgy Kepes (New York: George Braziller, 1966), book jacket. Cage tells the story of being commissioned by Kepes in the introduction to "Rhythm Etc.," in John Cage, *A Year from Monday* (Middletown, Conn.: Wesleyan University Press, 1967), 120.

2. Cage, "Rhythm Etc.," 124.

3. "Harmony, so-called, is a forced abstract vertical relation which blots out the spontaneous transmitting nature of each of the sounds forced into it. It is artificial and unrealistic" (John Cage, "45' for a Speaker," in Cage, *Silence* [Middletown, Conn.: Wesleyan University Press, 1961], 152).

4. Cage has discussed his interest in "rhythmic structures" throughout his own writings. See especially "Defense of Satie," in *John Cage: An Anthology*, ed. Richard Kostelanetz (New York: Da Capo, 1970), 77–84; and "Lecture on Nothing," in Cage, *Silence*, 109–126. For a discussion of the subject, see James Pritchett, *The Music of John Cage* (Cambridge: Cambridge University Press, 1993); and Paul Griffiths, *Cage* (London: Oxford University Press, 1981), chap. 2, "Rhythmic Systems," 7–20.

5. Le Corbusier, *The Modulor*, trans. Peter de Francia and Anna Bostok (Cambridge: Harvard University Press, 1955), 37.

6. Cage, "Rhythm Etc.," 125–126.

7. Le Corbusier, quoted in ibid., 126 (ellipses and italics are Cage's).

8. Ibid.

9. Le Corbusier, *The Modulor*, 54.

10. Cage, "Rhythm Etc.," 126.

11. Mary Emma Harris, *The Arts at Black Mountain College* (Cambridge: MIT Press, 1987), 177. Information on the life of Paul Williams has been confirmed through conversations with Vera B. Williams during the preparation of this article.

12. Cage states in the introduction to "Rhythm Etc.": "Living next door to an amateur architect who was deeply impressed by Le Corbusier, it dawned on me that the words might have come from Le Corbusier's book, *The Modulor*. I ran next door, picked up the book, opened it" (120). That Cage was undoubtedly referring to Paul Williams was confirmed by Vera Williams in conversation, March 27, 1996.

13. Harris, *The Arts at Black Mountain College*, 156; Calvin Tomkins, *The Bride and the Bachelors* (New York: Penguin, 1968), 121–122.

14. Cage, "Rhythm Etc.," 126.

15. John Cage, "Juilliard Lecture," in Cage, *A Year from Monday*, 102.

16. John Cage, "Experimental Music," in Cage, *Silence*, 7–8.

17. Cage stated that Moholy-Nagy's book was extremely influential to his thinking from the 1930s on and that reading it was what attracted him to teach at Moholy-Nagy's Chicago Institute of Design in 1941. See *John Cage Talking to Hans G. Helms on Music and Politics* (Munich: S-Press Tapes, 1975). Cage also mentions *The New Vision* in *Musicage: Cage Muses on Words, Art, Music*, ed. Joan Retallack (Hanover, N.H.: Wesleyan University Press/University Press of New England, 1996), 87. It is of interest to note that Cage had spent the summer of 1938 teaching at Mills College in the company of both Kepes and Moholy-Nagy (Tomkins, *The Bride and the Bachelors*, 89).

18. In order to include the work of his friend, the sculptor Richard Lippold, Cage had to fudge Moholy-Nagy's definition of space somewhat, for Moholy-Nagy strictly differentiated architectural and sculptural space. In his evaluation of Lippold's constructivist sculptures, Cage would seem to have been following Moholy-Nagy's consideration of the Eiffel Tower, which remained sculpture, although it occupied the "border line between architecture and sculpture" (Moholy-Nagy, *The New Vision* [New York: George Wittenborn, 1947], 61).

19. Ibid., 62. It should be noted that Moholy-Nagy directly mentions Mies van der Rohe, among others, in the sentence in which this figure is referenced.

20. Ibid., 63–64.

21. Cage, "Rhythm Etc.," 128.

22. K. Michael Hays, *Modernism and the Posthumanist Subject* (Cambridge: MIT Press, 1992), 192. Hays has developed this reading of Mies through "Critical Architecture: Between Culture and Form," *Perspecta* 21 (1984), 14–29; *Modernism and the Posthumanist Subject*; and "Odysseus and the Oarsmen, or, Mies's Abstraction Once Again," in *The Presence of Mies*, ed. Detlef Mertins (New York: Princeton Architectural Press, 1994), 235–248.

23. Hays, *Modernism and the Posthumanist Subject*, 192.

24. "Mies's achievement was to open up a clearing of implacable silence in the chaos of the nervous metropolis; this clearing is a radical critique, not only of the established spatial order of the city and the established logic of classical composition, but also of the inhabiting *nervenleben*. It is the extreme depth of silence in this clearing—silence as an architectural form all its own—that is the architectural meaning of this project" (Hays, "Critical Architecture," 22). Hays states that "the Barcelona Pavilion tears a cleft in the continuous surface of reality" ("Critical Architecture," 25). On Mies's silence, see also Manfredo Tafuri, *Architecture and Utopia* (Cambridge: MIT Press, 1976), 148; and the passages on Mies van der Rohe in Manfredo Tafuri and Francesco Dal Co, *Modern Architecture* (New York: Abrams, 1979), 151–157, 335–342.

25. Cage, "Rhythm Etc.," 128.

26. This is a general idea in Cage's thought; see, for example, "History of Experimental Music in the United States," in Cage, *Silence*, 70.

27. Theodor W. Adorno, "Vers une musique informelle" (1961), in *Quasi una fantasia: Essays on Modern Music*, trans. Rodney Livingstone (London: Verso, 1992), 301–302, 307. See also Theodor W. Adorno, "Avant-Garde" in *Introduction to the Sociology of Music* (1962), trans. E. B. Ashton (New York: Continuum, 1976), 180–181. On the necessity of critical distance, see Theodor W. Adorno, "Music and New Music" (1960), in *Quasi una fantasia*, 256–257, 265. Cf. Peter Bürger: "For the (relative) freedom of art vis-a-vis the praxis of life is ... the condition that must be fulfilled if there is to be a critical cognition of reality. An art no

longer distinct from the praxis of life but wholly absorbed in it will lose the capacity to criticize it along with its distance" (*Theory of the Avant-Garde* [Minneapolis: University of Minnesota Press, 1984], 50).

28. Adorno, "Vers une musique informelle," 287.

29. Adorno to Benjamin, November 10, 1938, in *Aesthetics and Politics*, ed. Ronald Taylor (London: Verso, 1977), 129. Robert Hullot-Kentor has commented on the connection between Adorno's late writings on music and his debate with Benjamin in the 1930s in "Popular Music and Adorno's 'The Aging of the New Music,'" *Telos* 77 (Fall 1988): 90–94.

30. Adorno to Benjamin, March 18, 1936, in *Aesthetics and Politics*, 124.

31. On the relation of Adorno's critique of Benjamin to his subsequent critique of the place of subjectivity under culture industry, see Susan Buck-Morss, *The Origin of Negative Dialectics* (New York: Free Press, 1977), 171.

32. Adorno, "Vers une musique informelle," 283.

33. Ibid., 314–316. In this, Adorno's critique approaches that of Peter Bürger in *Theory of the Avant-Garde.*

34. Adorno, "Vers une musique informelle," 316.

35. John Cage, "Preface to *Indeterminacy*," in *John Cage, Writer: Previously Uncollected Pieces*, ed. Richard Kostelanetz (New York: Limelight Editions, 1993), 79. Cage will repeat, with only slight alterations, this and the following statement in the preface to *Silence* of 1961 (Cage, *Silence*, xi).

36. Cage, "Preface to *Indeterminacy*," 79.

37. "Implicit here, it seems to me, are principles familiar from modern painting and architecture: collage and space. What makes this action like Dada are the underlying philosophical views and the collage like actions. But what makes this action unlike Dada is the space in it" (Cage, "History of Experimental Music in the United States," 69–70).

38. Quoted in Moira and William Roth, "John Cage on Marcel Duchamp," *Art in America* 61 (November-December 1973): 78.

39. In the following discussion of Cage's scores, I have relied on the information and analysis provided in Pritchett, *The Music of John Cage*, especially 92–95 and 134–137. It is interesting to note that although *Music for Carillon I* was written in October 1952, it was revised for publication and copyrighted in March 1961, the year Cage began writing "Rhythm Etc."

40. As Cage stated in "History of Experimental Music in the United States," "All this can be summed up by saying each aspect of sound (frequency, amplitude, timbre, duration) is to be seen as a continuum, not as a series of discrete steps favored by conventions (Occidental or Oriental)" (70–71).

41. Visual tropes, such as Cage's analogy of structure to an empty glass, can be found in "Lecture on Nothing," in addition to the statement "But life without structure is unseen. Pure life expresses itself within and through structure" (113).

42. This form of listening is discussed throughout Cage's writings. See, for example, "Composition as Process: II. Indeterminacy," in Cage, *Silence*, 35–40.

43. Cage, "Juilliard Lecture," 99. As with many of Cage's pieces from the early 1950s, the implications present in *Music for Carillon I* go beyond its concrete realization. By designating the instrument, Cage limited (in a manner he would soon realize was unnecessary) the

possibilities of the piece to the sounds that could be played on a carillon. Nevertheless, in the above analysis I have purposely emphasized the implications inherent in the score.

44. Cage, *Silence*, 161.

45. The classification of aggregates can be found in Cage, "45' for a Speaker," 163.

46. Cage's aversion to Times Square can be inferred from his statement "Nevertheless, I do go to town now and then and I do pass through Times Square, with which for many years I was unable to make my peace. With the help, however, of some American paintings, Bob Rauschenberg's particularly, I can pass through Times Square without disgust" ("[Letter to Paul Henry Lang]," in *John Cage: An Anthology*, 117–118).

47. For Cage's aversion to the repetition in modern society, see statements made in "Defense of Satie," 79, and "Composition in Process," in Cage, *Silence*, 21.

48. Max Horkheimer and Theodor W. Adorno, *Dialectic of Enlightenment*, trans. John Cumming (New York: Continuum, 1972), 120.

49. John Cage, "Mosaic," in Cage, *A Year from Monday*, 48. Cage expressly juxtaposes Schoenberg's idea of repetition with his own idea of differentiation by reference to the differences between leaves on a tree in *Conversing with Cage*, ed. Richard Kostelanetz (New York: Limelight, 1987), 222.

50. Adorno, "Vers une musique informelle," 284 n. 7.

51. Ibid.

52. John Cage, "Forerunners of Modern Music," in Cage, *Silence*, 64 n. 8. On Cage's idea that serialism does not represent a new structure, see "Forerunners," 63–64 and n. 7. In "Mosaic," Cage explicitly calls Schoenberg's structures neoclassical (45).

53. Cage, "Forerunners," 63 n. 75.

54. John Cage, "The East in the West," in *John Cage, Writer*, 25: "Because of its ability to enlarge sound and thus to impress an audience, [harmony] has become in our time the tool of Western commercialism"; and Cage, "Defense of Satie": "It is interesting to note that harmonic structure in music arises as Western materialism arises, disintegrating at the time that materialism comes to be questioned, and that the solution of rhythmic structure, traditional to the Orient, is arrived at with us just at the time that we profoundly sense our need for that other tradition of the Orient: peace of mind, self-knowledge" (84). In "Forerunners," Cage stated that atonality represented the denial of harmony as a structure, but only led to "an ambiguous state of tonal affairs" (63).

55. For a discussion of "accidental differentiation" and "pseudo-individualization" as they apply both to commodities and to commodified music, see, respectively, Theodor W. Adorno, "On the Fetish Character in Music and the Regression of Listening" (1938), in *The Culture Industry*, ed. J. M. Bernstein (London: Routledge, 1991), 35; and "On Popular Music," *Studies in Philosophy and Social Sciences* 9 (1941): 25. In *La société de consommation* (Paris: Denoël, 1970), Jean Baudrillard analyzes much the same aspect of commercial culture in terms of the interplay of "model" and "series," a discussion that resonates perhaps more closely with Cage's position in "Rhythm Etc."

56. John Cage, "A Composer's Confessions," in *John Cage, Writer*, 31.

57. Adorno, "On Popular Music," 24. See also Jean Baudrillard, *The System of Objects* (1968), trans. James Benedict (London: Verso, 1996), 141.

58. On the anticipatory function of music, see Jacques Attali, *Noise: The Political Economy of Music* (Minneapolis: University of Minnesota Press, 1985).

59. John Cage, "Seriously Comma," in Cage, *A Year from Monday*, 28.

60. John Cage, "Composition as Process: III. Communication," in Cage, *Silence*, 46. By contrast, contemporary music was understood by Cage to fill the role of "bumping into things, knocking others over and in general adding to the disorder that characterizes life (if it is opposed to art) rather than adding to the order and stabilized truth, beauty, and power that characterize a masterpiece (if it is opposed to life)" (46). See also Cage, "Mosaic": "We're chucking this idea too (even though Schoenberg had it): that music enables one to live in a dream world removed from the situation one is actually in" (44).

61. Le Corbusier, *The Modulor*, 56.

62. Ibid., p. 90.

63. Cage, "Rhythm Etc.," 123.

64. Le Corbusier, *The Modulor*, 113 and passim.

65. "The social inflexibility," Cage noted, "follows from the initial conception of proportion" ("Rhythm Etc.," 126). Cage's reading of Le Corbusier's text would have been encouraged by lines such as "music rules all things, it dominates; or, more precisely, harmony does that. Harmony, reigning over all things, regulating all the things of our lives, is the spontaneous, indefatigable and tenacious quest of man animated by a single force: the sense of the divine, and pursuing one aim: to make a paradise on earth" (Le Corbusier, *The Modulor*, 74).

66. This reading of nature runs throughout Cage's writings. See "[Letter to Paul Henry Lang]," 117–118; "Experimental Music," 9–10; and Pritchett, *The Music of John Cage,* 147.

67. In this, Cage is again close to Moholy-Nagy, who postulated in the quotation from *The New Vision* cited above that "the white house with great glass windows" would dissolve into nature.

68. On Cage's opinion that "there is no need to cautiously proceed in dualistic terms," see "Composition as Process: III. Communication," 47.

69. On the shift from cognition to perception, see "Experimental Music: Doctrine," in Cage, *Silence*, 15; and "Where Are We Going? and What Are We Doing?," in ibid., 204–205.

70. This was articulated in a note by Duchamp that Cage would come to quote often: "to reach the Impossibility of sufficient *visual* memory to transfer from one like object to another *memory* imprint" (John Cage, "Jasper Johns: Stories and Ideas," in Cage, *A Year from Monday*, 79). For the complete Duchamp passage, see *The Writings of Marcel Duchamp*, ed. Michel Sanouillet and Elmer Peterson (New York: Da Capo, 1973), 31:

> Identifying
> *To lose* the *possibility* of *recognizing* 2 *similar objects*—2 colors, 2 laces, 2 hats, 2 forms whatsoever, to reach the Impossibility of sufficient *visual* memory to transfer from one like object to another the *memory* imprint.
> —Same possibility with sounds; with brain facts.

71. John Cage, *For the Birds* (Boston: Marion Boyars, 1981), 80. See also the statement Cage makes about the future of standardization in relation to architecture in "Questions," *Perspecta* 11 (1967): 71.

72. Cage, "Where Are We Going? And What Are We Doing?," 238. It should be noted that Cage did eventually move out of Stony Point and back to Manhattan.

73. Cf. Theodor W. Adorno, "Culture Industry Reconsidered," trans. Anson G. Rabinbach, in *The Culture Industry*, 92: "It [the culture industry] impedes the development of

autonomous independent individuals who judge and decide consciously for themselves. These, however; would be the precondition for a democratic society which needs adults who have come of age in order to sustain itself and develop."

74. Cage, "History of Experimental Music in the United States," 69.

75. Cage, "Experimental Music: Doctrine," 15.

76. Theodor W. Adorno, "The Schema of Mass Culture," in *The Culture Industry*, 79. See also *Dialectic of Enlightenment*, 123, 127.

77. Cage, "Composition as Process: II. Indeterminacy," 39.

78. Ibid.

79. Ibid., 40.

80. This Cage explained by means of an architectural metaphor: "The thing that was irrelevant to the structures we formerly made, and this was what kept us breathing, was what took place within them. Their emptiness we took for what it was—a place where anything could happen. That was one of the reasons we were able when circumstances became inviting (changes in consciousness, etc.) to go outside, where breathing is child's play: no walls, not even glass ones which, though we could see through them, killed the birds while they were flying" ("Rhythm Etc.," 122). Cf. the discussion of the changes in Cage's aesthetic in the 1960s in Pritchett, *The Music of John Cage*, 138–161.

81. For a discussion of emergent forms of social control, see Gilles Deleuze, "Control and Becoming," and "Postscript on Control Societies," in Deleuze, *Negotiations, 1972–1990*, trans. Martin Joughin (New York: Columbia University Press, 1995), 169–182.

82. In *John Cage: Composed in America*, ed. Marjorie Perloff and Charles Junkerman (Chicago: University of Chicago Press, 1994), 16–17.

Post-Cagean Aesthetics and the Event Score

Liz Kotz

Around 1960, in New York City, a new type of work began to appear that consisted of short, instruction-like texts proposing one or more actions. Frequently referred to under the rubric of "event" scores or "word pieces," they represent one response to the work of John Cage.

Composition 1960 #10
 to Bob Morris

Draw a straight line
and follow it.

October 1960

—*La Monte Young*

WORD EVENT

• Exit

Spring, 1961

—*George Brecht*

VOICE PIECE FOR SOPRANO
to Simone Morris

Scream.
1. against the wind
2. against the wall
3. against the sky

y.o. 1961 autumn

—*Yoko Ono*

Made by artists active in New York's interdisciplinary neo-avant-garde, these pieces came out of an expanded sense of "music" and an expanded sense of medium. Many of La Monte Young's early compositions were performed live at downtown venues, including the now legendary Chambers Street series he organized at Yoko Ono's downtown loft in December 1960 through June 1961.[1] Several of Young's scores, including *Composition 1960 #10*, were subsequently printed in *An Anthology of Chance Operations* (1961/1963),[2] the influential compendium of new art that Young published with the assistance of the poet Jackson Mac Low and designer George Maciunas—a publication that Maciunas would take as a model when he assembled his own avant-garde movement and publication, to be called Fluxus.

George Brecht, who engaged in perhaps the most systematic work with the short, enigmatic texts he called "event scores," initially wrote them as performance instructions and began mailing them to friends and receptive acquaintances; on a couple of occasions he also displayed handwritten scores in gallery settings.[3] In *Water Yam* (1963), about fifty of the texts were assembled as small printed cards in a box, the first of an envisioned series of Fluxus editions Maciunas had planned, offering artists' "collected works" in a cheap, widely available form. Many of Ono's texts initially took the form of instructions for paintings she exhibited at Maciunas's AG Gallery in July 1961. She subsequently displayed these instructions at the Sogetsu Art Center in Tokyo in May 1962, in the form of hand-lettered sheets—carefully calligraphed in Japanese by her husband Toshi Ichiyanagi, a composer and former student of Cage's.[4] Ono quickly expanded the idea to produce many short instruction-like and meditative texts, which she privately published in 1964 as the book *Grapefruit*, during a two-year stay in Japan. Reissued in 1971 by Simon and Schuster in the wake of Ono's marriage to John Lennon, *Grapefruit* would bring the form to wider, if quizzical, audiences, and into something resembling popular culture.[5]

What are these texts? They can be read (have been read) under a number of rubrics: music scores, visual art, poetic texts, performance instructions, or proposals for some kind of action or procedure. Most often, when they are read at all, these "short form" scores are seen as tools for something else, scripts for a performance or project or musical piece which is the "real" art—even as commentators note the extent to which, for both Brecht and Ono, this work frequently shifts away from realizable directions toward an activity that takes place mostly internally,

in the act of reading or observing. This conceptual ambiguity derives from the use of the text as score, inseparably both writing/printed object and performance/realization. This peculiar type of event notation arguably derives from Cage's work of the 1950s, appearing in its most condensed form in his landmark composition *4'33"* (1952), which directs the performer to remain silent during three "movements" of chance-determined durations. Replacing conventional musical notation with a condensed set of typewritten numbers and words, *4'33"* (in its first published version) effectively inaugurates the model of the score as an independent graphic/textual object, inseparably *words to be read* and *actions to be performed*. While this model was initiated by Cage, it was left to others to develop in a series of projects from 1959 to 1962.[6]

In their direct invitation to enactment and performed response, these event scores could seem almost absurd literalizations of 1960s critical claims for reading as an "activity of production"—except that the concrete, operational dimension of such scores engages an overt *transitivity*, a potential acting on materials, completely counter to the self-enclosed activity of the irreducibly plural text proposed by Roland Barthes in his 1967 call for a kind of writing, "intransitive" and "performative," in which "only language acts, 'performs,' and not me."[7] Taking music as a model for a renovated textuality, Umberto Eco's poetics of the "open work" explicitly modeled radical literary practices on the experiments with "open form" by Luciano Berio, Henri Pousseur, and other postwar European composers.[8] As Barthes would subsequently propose in "From Work to Text" (1971), "We know today that post-serial music has radically altered the role of the 'interpreter,' who is called on to be in some sense the co-author of the score, completing it rather than giving it 'expression.' The Text is very much a score of this new kind: it asks of the reader a practical collaboration."[9]

However resonant, these models of newly activated "textuality" risk a certain circularity, since the very postserial compositions they cite as aesthetic precedents were partly historical products of the European reception of Cage's aleatory and indeterminate strategies, which themselves hinge on a peculiar relation to writing.[10] The theoretical impasse confronting both musicology and theater studies regarding the relative status of the written score or script—long held to be the privileged locus of the "work"—and its various performances, seen as secondary, suggests the enormous difficulty of reading the relays among author, performer, text, reader, and audience. A more adequate analysis can perhaps

I

TACET

II

TACET

III

TACET

NOTE: The title of this work is the total length in minutes and
seconds of its performance. At Woodstock, N.Y., August 29, 1952,
the title was 4' 33" and the three parts were 33", 2' 40", and 1'
20". It was performed by David Tudor, pianist, who indicated the
beginnings of parts by closing, the endings by opening, the key-
board lid. However, the work may be performed by an instrument-
alist or combination of instrumentalists and last any length of
time.

FOR IRWIN KREMEN JOHN CAGE

Figure 6.1 John Cage, typewritten
score for 4′33″, 1952. First published
version. © 1960. Used by permission
of C. F. Peters Corporation on behalf
of Henmar Press Inc.

begin by specifying the particular modes of performance, enactment, and
realization made possible in different linguistic/literary materials, as these
circulate in specific material forms and contexts. As Eco was well aware,
the "practical intervention" of the instrumentalist or actor is quite dif-
ferent from that of "an interpreter in the sense of a consumer"—even as
he proceeds to assimilate them.[11]

In the case of these event scores, their condensed and enigmatic form may have facilitated their rapid circulation between performance, publication, and exhibition formats: small, strange, and belonging to no definable genre, they could go anywhere. Their reproduction, in the various broadsheets and "little magazines" of the time, had a provocative leveling effect: reproduced in the space of the page, all (typed/typographic) words become simply writing, "print." Apparent differences between autonomous works of word art or poetry, instrumental forms of performance instruction, program note or score, or even critical essays and diagrams, are rendered indistinct. This potential mutability and transposability is intrinsic to language as a material, particularly when dislodged from certain kinds of institutional containers.[12] In its unorthodox design and extreme heterogeneity of format, material, and genre, *An Anthology* provided a key site for this textual indeterminacy and interpenetration—one that structurally replicates, in printed form, the productive collisions between dance, music, sculpture, poetry, lecture, and so forth, that occurred in performance and event-based programs of the time.

To complicate this already ambiguous dual structure—inseparably both language and performance—intrinsic to the notion of the text as score, we must factor in a third mode: the relation of these texts to object production. From the manipulation of everyday materials as props and sound-generating devices in Young's early compositions to the sculptural production undertaken by Brecht, Ono, and others, many of these early word pieces could take object form or produce a material residue: material objects potentially presented for exhibition, just as the scores themselves could be (and were) exhibited. Working with an implicitly tripartite structure that allows them to be realized as language, object, and performance, certain of these event scores anticipate subsequent projects, by artists like Robert Morris and Joseph Kosuth, that explicitly investigate the tripartite structure of the sign (and which engage the photographic and overtly reproductive dimensions repressed in the earlier work).[13] By setting up chains of substitutions (but also bifurcations, hesitations, and unravelings) among word, sign, object, action, and so forth—all contained within a single word—a perplexing little text like Brecht's *Exit* opens onto the enigmatic abyss of the semiotic, opening a door to the entry of linguistic structures and material into visual art of the 1960s.

How might such a sparse, focused practice emerge from or alongside such programmatic cacophony? And why would it occur under the

guise of music? Here, the complex renegotiation of Dada and collage legacies that occurs in the late 1950s is perhaps crucial. Among the materials collected in *An Anthology* are all manner of neo-Dadaist concrete poetry, sound poetry, chance compositions, and simultaneities—many of which could be performed live. Event scores, however, were rarely read aloud—the linguistic performativity they propose is closer to that of the iterability of the sign than to that of an overtly oral (and more conventionally literary) performance poetics. Rather than pulverizing language into sonorous fragments, the scores focus on the instructions themselves as poetic material. This alternate poetics, of deeply prosaic everyday statements, comprised of short, simple, vernacular words presented in the quasi-instrumental forms of lists and instructions, emerged in the postwar era as a countermodel to the earlier avant-garde practices of asyntacticality, musicality, and semiotic disruption.[14] Yet this poetics by no means represents a simple departure from or rejection of collage aesthetics, but, as we shall see, a complex transformation of its semiotic engagement, one that pursues the logic of the fragment to unprecedented levels of isolation, focus, and reduction.

Physically modest and de-skilled, these scores represent an artistic practice driven by but also counter to the recording and reproductive technologies that would increasingly restructure sound and language in the postwar era. The very project of semiotics is both an effect and motor of this process, in which language, sound, image, and time become objects of decomposition, quantification, recombination, and analysis (an earlier phase of which is already evident in the breakdown of representation and sign in cubism and Dada). Yet the diverse techniques and technologies generated during the Second World War—from cybernetics and information theory to the perfection of magnetic audiotape—markedly intensified this process, reducing complex information to transmissible series of binary digits, and proliferating indexical signs whose distance from syntax potentially reduces signification to "the mute presence of an uncoded event."[15] Under the pervasive pressure of (mechanical, electronic, later digital) technologies of recording, reproduction, and transmission, the perceptual conditions of explicitly temporal and repeatable media (phonograph, film, later audiotape and videotape) came increasingly to inflect apparently static materials (objects, images, and printed text) in the postwar era, while also turning the previously ephemeral into a kind of object. Given its structural reliance on continual reenactment and its deep historical implication in systems of inscription, language is

a special case, a kind of model, of which the event score is but one example. To better understand this process, it will help to reconstruct some of the historical context of postwar music which gave rise to this radically reconfigured use of the score.

The Cage Class: Models of Experimental Music in the 1950s

In a critical essay on the interdisciplinary avant-garde of the early 1960s, Henry Flynt protests that "Fluxus, as it is remembered today, grew out of an art of insignificant and silly gestures mainly due to George Brecht."[16] He may be right. Brecht's event scores were eagerly embraced by Maciunas, who adopted them as a sort of signature form for Fluxus performance.[17] Brecht's myriad game- or kit-type objects (themselves crucial reinterpretations of Marcel Duchamp's "readymade" aesthetic) were subsequently adapted, semistandardized, and proliferated in Maciunas's endless FluxBoxes and early Fluxus editions.[18] Even Brecht's single-page broadsheet *VTRE* (1963) turned into the Fluxus newspaper *ccVTRE*. It is not surprising then that when Brecht's role is historically acknowledged, it is almost always within the context of Fluxus—a critical approach, however, which unfortunately tends to homogenize Fluxus production, flatten Brecht's work into a preconceived notion of performance, and neglect the possible reception or impact of his work outside of Fluxus. Never a commercially successful artist, Brecht left the United States permanently in 1965 to live in Europe. Although he participated in a number of solo and group shows in the 1960s, his last one-person exhibition in the U.S. was a 1973 retrospective at the Onnasch Gallery in New York.

Brecht's work with language appears to have come directly out of his involvement in Cage's class on experimental composition at the New School, which he attended from June 1958 to August 1959.[19] Until that time, Brecht's art production had mostly consisted of paintings and drawings made according to some version of chance procedures—drawings based on charts of random numbers and paintings made through dripping paint onto canvases, all fully pictorial in orientation.[20] In his addendum to *Chance Imagery*, Brecht states that, although he was aware of Cage's work since 1951, his model for chance operations during the 1950s came primarily from the work of Jackson Pollock.[21] As the title suggests, Brecht's initial goal was to use chance methods to generate what he termed "affective images." And, according to New School classmate Dick Higgins, at the time of entering Cage's class, Brecht still

described himself as "you might say, a painter."[22] Living in New Jersey, where he worked as a research chemist, Brecht often attended the class with Allan Kaprow, whom he knew through Robert Watts.

According to Higgins's accounts of the class in *Jefferson's Birthday/ Postface* (1964), Brecht and Cage shared certain concerns that largely escaped the rest of the class:

> The usual format of our sessions would be that, before the class began, Cage and George Brecht would get into a conversation, usually about "spiritual virtuosity," instead of the virtuosity of technique, physique, etc. . . . The best thing that happened in Cage's class was the sense he gave that "anything goes," at least potentially. Only George Brecht seemed to share Cage's fascination with the various theories of impersonality, anonymity and the life of processes outside their perceivers, makers or anyone else.[23]

As Higgins's somewhat mocking tone suggests, Brecht's miniaturized, highly self-effacing compositions shared Cage's philosophical interests in strategies of desubjectivization and self-restraint at a time when many of the other class members—especially Kaprow, Higgins, and Al Hansen—were drawn to the more expressionistic "anything goes" aesthetic that often came to characterize happenings. Yet Higgins goes on to state that Cage's real gift was to allow each member of the class to pursue his own project and sensibility, adding that "In the same way, Brecht picked up from Cage an understanding of his own love of complete anonymity, simplicity and non-involvement with what he does."[24]

Most accounts of 1950s experimental music note the extreme divergence between the chance-generated and indeterminate work of Cage and his colleagues (Christian Wolff, Morton Feldman, Earle Brown) and the hyperrationalized project of integral serialism characteristic of postwar European composers like Pierre Boulez and Karlheinz Stockhausen. And indeed, despite their shared claim to the legacy of Anton Webern, the compositional strategies and resulting works of the two circles initially appear completely opposed. In a 1959 talk, "Program Notes," Cage himself outlined these "two divergent directions characterizing advanced contemporary music, both stemming from the works of Anton Webern." Among European composers, he notes, "Webern's later music . . . suggested the application of serial methods to other aspects of sound than frequency. Thus concerning himself not only with the

ordering of pitch but with the control, too, of diverse characteristics of amplitude and duration, Stockhausen assumes a responsibility toward the problem of unification of disparate elements." But, Cage proposes, an opposite, antisystematic reading also lies at the very source of serialist models: "Webern's music also suggests the autonomy of sound in time-space and the possibility of making a music not dependent upon linear continuity means. The American works, setting out from this essentially non-dualistic point, proceed variously."[25]

Thus it may come as some surprise, when reading Brecht's *Notebooks* of his 1958–1959 attendance in Cage's New School class, that the initial lessons breaking down the properties of sound employ a vocabulary that could have come straight out of *Die Reihe*, the influential German music journal edited by Herbert Eimert and Stockhausen: "Dimensions of Sound: Frequency, Duration, Amplitude, Overtone-structure, Morphology." In his careful, precise notes, presumably following Cage's directives, Brecht graphs out each as a quantitatively mapped, continuous *field*— "frequency field" (hi/low), "duration field" (long/short), and so forth. *"Note trend towards continuity,"* he records, *"vs. classical treatment."* The next page notes, "'Events in sound-space.' (J.C.)," and in many of the exercises that follow, Brecht continues to carefully diagram phenomena in precise mathematical notation.[26]

Needless to say, this is not the picture of Cage's class we have received from the far more free-form, anecdotal accounts of Al Hansen or Dick Higgins. Trained as a chemist, Brecht may have been one of the few participants equipped to engage with the more technical aspects of Cage's discussion of music. According to Bruce Altshuler, Cage in a late 1980s interview recalled that "the impetus for the New School class was aroused by his recent work at the new music festival in Darmstadt, Germany, and ... he felt that he should make these ideas available in America."[27] Thus the models we find elaborated in Brecht's notebooks are not so much Cage's own compositional methods as notes for a shared project of the scientific breakdown of sound properties into quantifiable spectra—strategies that date, in one form or another, to the early nineteenth century and that were systematically researched and disseminated by *Die Reihe*. Brecht's notes record Cage's mention of it, and many American musicians (and artists, including Dan Graham and Sol LeWitt) read the journal during the 1960s.[28]

Die Reihe's project for a scientifically grounded practice of electronic music is laid out in an early introduction by Eimert, the artistic director

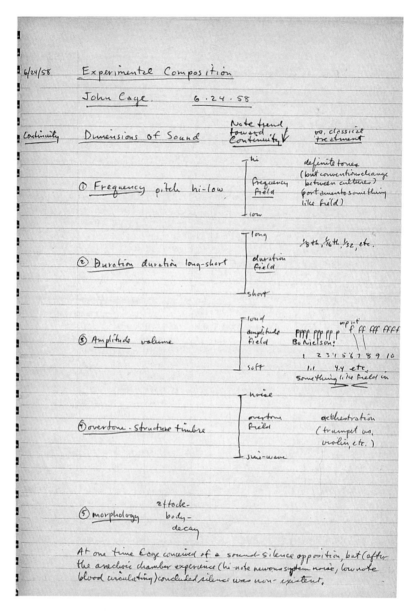

Figure 6.2 George Brecht,
Notebooks, vol. 1, "Experimental
Composition," June 24, 1958. Gilbert
& Lila Silverman Fluxus Collection,
Museum of Modern Art, New York.

of Cologne Radio. With Werner Meyer-Eppler and other postwar German academics and artists drawn to new, instrumentalized American models of communications, acoustics, and information theory, Eimert was engaged in research on the psychology of perception and the physics of sound, as well as in the development of new electronic sound technologies for which Cologne Radio was an important sponsor.[29] In the essay "What Is Electronic Music?" published in the inaugural issue of *Die Reihe* (1955), Eimert outlines a program for positivist research into sound as the basis for new musical composition, calling for "the disruption by electronic means, of the sound world as we have known it," and for the use of the technologies of broadcasting (tape recorder, loudspeaker, etc.) "transformed into a compositional means."[30]

The analytic capacities made possible by these new technologies, such as the analysis of frequencies and overtone curves, provide not just new material for composition but the model for the very ways of conceiving of sound and its (artistic) organization: "New ways of generating sound stipulate new compositional ideas; these may only be derived from sound itself which in its turn must be derived from the general 'material.'"[31] Naturally, such fundamentally restructured sound properties also required radically reconfigured notions of the score. "The multiplicity of forms of electronic elements far exceeds the possibilities of graphic notation," Eimert argues, proposing a new mathematically notated method: "Thus 'scores' of electronic compositions resemble precise acoustical diagrams with their coordinates, frequencies (cycles per second), intensity levels (measured in decibels) and time (cm. p.s.)."[32]

Passages from Brecht's *Notebooks* suggest that he actively read texts and scores by Boulez, Stockhausen, and other composers, adapting them to his own concerns. Perhaps via composer Richard Maxfield (an occasional New School substitute while Cage was away),[33] Brecht notes perceptual phenomena like the "relationality of pitch and amplitude" and their proportional relation to the experiential time of duration—concerns previously articulated by Stockhausen in essays in *Die Reihe*. While preparing an early version of *The Cabinet* (July 1958), an assemblage featuring lights and sounds, Brecht's notes read "minimal perceptible levels for duration, pitch, amplitude." For *Confetti Music* (July 1958), in which card colors determine source (gong, prepared guitar, gamelan, etc.), Brecht notes that "each sound [has] natural duration depending on source and amplitude," and proposes an indexical model of sound production: "Each sound becomes a *projection of the record of a state* (like an

abstract expressionist painting). The cards represent a *record of a more or less momentary state*."[34] In a notebook draft for an unpublished essay, Brecht compares Stockhausen's *Piano Piece no.* 11 with Earle Brown's *4 Systems* on the basis of what he terms "a scale of *situation participation*": "the extent to which the sound structure of the piece . . . partakes of the situation in which it occurs, as opposed to its arising from some pre-existent structure (score notation/symbolism/ arrangement)."[35]

However incongruous they may appear in relation to his rather low-tech rearrangeable assemblages, Brecht's recurrent recourse to quantitative models is not merely a period style. Not unlike some of Cage's quixotic efforts to combine art and technology in the 1930s and 1940s, Brecht repeatedly sought to bring scientific concepts into dialogue with artistic practice, referring to his work of the period as "research."[36] Working as a chemist at Johnson & Johnson, Brecht was moderately active as a scientific inventor—a calling reminiscent of Cage's less-than-successful inventor father.[37] In the 1960 report "Innovational Research," which he initially proposed to Johnson & Johnson as "a suggested prototype for an innovational research program," he cites scientific theorist H. G. Barnett's idea of innovation as "an arbitrary range of recombinations at one end of a continuous series," as well as Ernst Cassirer on naming as "process of concentration and condensation."[38]

Like Cagean "indifference," modeled on a recording apparatus it overtly disavows, Brecht's work represses the pivotal role of these more technicist models. Except for occasional references to his pre-Cagean work with probability, random number tables, and statistical models of chance in the 1950s, later statements by Brecht never mention them—in contrast, for instance, to Young's obsessive experiments since the 1960s with just intonation, producing works whose very titles comprise lengthy mathematical calculations of their precise harmonic frequencies. Brecht's own rhetoric instead stresses the liberatory, antitechnological, and anti-instrumental nature of his project—to a sometimes absurd degree. Yet the very conceptual apparatus he adopts, moving from "sound-silence opposition" to "model of field/continuity,"[39] is itself a product of the remapping of sound via recording technologies and quantitative analysis—for example, the musical dissolution of pitch, from a series of discrete, articulated notes along a scale, into frequency, which operates as a continuity, defined quantitatively. As theorists from Jacques Attali to Friedrich Kittler have argued, this fundamental rupture in the nature of sound is only comprehensible under the pressure of recorded sound.[40]

As Kittler notes, "The phonograph does not hear as do ears that have been trained immediately to filter voices, words, and sounds out of noise. Articulateness becomes a second-order exception in a spectrum of noise."[41] The perceptual availability of this spectrum (of sound outside the coded domains of "music" or "speech"), Kittler implicitly argues, is a product of modern recording technologies, emphasizing precisely the extent to which sound recording, in bypassing traditional methods of "alphabetic storage" (e.g., the musical score, written notation), permitted new, nonlinearized and nonlinguistic models of sound and, by extension, musical temporality. Prior to this nineteenth-century innovation, Kittler insists, the representation of temporal experience depended on the "symbolic bottleneck" of the letter: "Texts and scores: Europe had no other means of storing time."[42]

Thus the very conjoining of written text and musical score in Cagean practice—and so important in postwar poetry as well—is paradoxically predicated on the dissolution of what had previously linked them: a shared dependence on the letter. Musical notation, as used in the West, had relied on the (tempered) duodecimal harmonic system, itself a series of discrete notes, arranged in linear sequence by meter. It is against the enormous constraints of this system that radical twentieth-century musicians would turn to the disruptive acoustic potential of "noise," to the world of sound resting outside the parameters of "music"—from the "liberation of dissonance" in Schoenberg to a host of experiments with microtones, nonmusical instruments, and unconventional, nonmetric time structures by composers from Alois Hába to Edgar Varèse.

Yet for the musical score to become available as a generalized time structure or event score, it would have to be unhinged not only from *sound* as a system of discrete notes but also from *time* as a graphically plotted system of rhythmic measure. In experimental musics of the 1950s, these notational properties would be gradually replaced by the new positivities of quantitative science: pitch as frequency (vibrations per second) and time as mechanical time, clock time. No longer mere supplemental annotation, language enters the space of a musical score voided of its internal linguistic structure. Comprised of verbal performance instructions—"tacet"—organized in predetermined time brackets, *4′33″* employs the score as a kind of *temporal container*, one that can potentially be filled with any material. Such a structural shift necessarily entailed new forms of notation, and indeed Cage was famous throughout the 1950s for his experimentation with unconventional and graphic scores. Yet the

conceptual simplicity of *4′33″*, which made it such a compelling model
to other artists, rests on its use of conventional typewritten language and
numbers as notation—public, vernacular forms—unlike the graphic eso-
tericism of many of Cage's subsequent works, in which programmatic
indeterminacy would generate almost entirely arbitrary relations between
score and performance (and whose mannerist anti-conventionality
verged on something like a private language).

What Is an Event?

> What are the conditions that make an event possible? Events are pro-
> duced in a chaos, in a chaotic multiplicity, but only under conditions
> that a sort of screen intervenes.
>
> —*Gilles Deleuze, The Fold: Leibniz and the Baroque*[43]

Brecht's initial performance scores of 1959–1960, referred to as "card
events," consisted of small, printed instructions, outlining detailed proce-
dures for a variety of loosely synchronized actions: raising and lowering
the volume of radios, changing the tuning, and so forth, for indetermi-
nate durations based on natural processes such as the burning of a candle
(*Candle Piece for Radios*, Summer 1959); or turning on and off various
lights and signals; sounding horns, sirens, or bells; opening or closing
doors, windows, or engine hoods, and so on (*Motor Vehicle Sundown Event*,
Spring/Summer 1960). In their complex orchestration of simultaneous
acts and chance interactions, these pieces structurally resemble Dadaist
"simultaneities" of the early twentieth century: diffuse, multifocal, and
chaotic, they are extensions of collage aesthetics.

By sometime around spring 1961, this has been pared down to small,
enigmatic fragments such as *Two Durations* and *Event*.

How do we account for this shift, which represents the emergence of
the event out of a wider Cagean practice? "Cage," Brecht recalls, "was the
great liberator for me. . . . But at the same time, he remained a musician, a
composer. . . . I wanted to make music that wouldn't only be for the ears.
Music isn't just what you hear or what you listen to, but everything that
happens. . . . *Events are an extension of music*.[44] Kaprow recalls that "'events'
was a word that Cage was using—borrowing from science, from phys-
ics"[45]—although in Cage's work the individual sonic events, the "sounds
in themselves," remain embedded in a larger musical composition and an
acoustic model.

MOTOR
VEHICLE
SUNDOWN
(EVENT)

(TO JOHN CAGE)
SPRING/SUMMER 1960
G. BRECHT

Any number of motor vehicles are arranged outdoors.

There are at least as many sets of instruction cards as vehicles.

All instruction card sets are shuffled collectively, and 22 cards are distributed to the single performer per vehicle.

At sundown (relatively dark, open area incident light 2 foot-candles or less) the performers leave a central location, simultaneously counting out (at an agreed-upon rate) a pre-arranged duration 1 1/2 times the maximum required for any performer to reach, and seat himself in, his vehicle. At the end of this count each performer starts the engine of his vehicle and subsequently acts according to the directions on his instruction cards, read consecutively as dealt. (An equivalent pause is to be substituted for an instruction referring to non-available equipment.) Having acted on all instructions, each performer turns off the engine of his vehicle and remains seated until all vehicles have ceased running.

A single value from each parenthetical series of values is to be chosen, by chance, for each card. Parenthetical numerals indicate duration in counts (at an agreed-upon rate). Special lights (8) means truck-body, safety, signal, warning lights, signs, displays, etc. Special equipment (22) means carousels, ladders, fire-hoses with truck-contained pumps and water supply, etc.

INSTRUCTION CARDS (44 per set):

1. Head lights (high beam, low beam) on (1-5). off.
2. Parking lights on (1-11), off.
3. Foot-brake lights on (1-3), off.
4. (Right, left) directional signals on (1-7), off.
5. Inside light on (1-5), off.
6. Glove-compartment light on. Open (or close) glove compartment (quickly, with moderate speed, slowly).
7. Spot-lamp on (1-11), move (vertically, horizontally, randomly), (quickly, with moderate speed, slowly), off.
8. Special lights on (1-9), off.
9. Sound horn (1-11).
10. Sound siren (1-15).
11. Sound bell(s) (1-7).
12. Accelerate motor (1-3).
13. Wind-shield wipers on (1-5), off.
14. Radio on, maximum volume, (1-7), off. Change tuning.
15. Strike hand on dashboard.
16. Strike a window with knuckles.
17. Fold a seat or seat-back (quickly, with moderate speed, slowly). Replace.
18. Open (or close) a window (quickly, with moderate speed, slowly).
19. Open (or close) a door (quickly, with moderate speed, slowly).
20. Open (or close) engine-hood, opening and closing vehicle door, if necessary.
21. Trunk light on. Open (or close) trunk lid (if a car), rear-panel (if a truck or station-wagon), or equivalent. Trunk light off.
22. Operate special equipment (1-15), off.
23-44. Pause (1-13).

Figure 6.3 George Brecht,
Motor Vehicle Sundown (Event), 1960.

Along with its complex vernacular resonances, the term *event* has a number of quite precise meanings in scientific, philosophical, and historical discourses. The problematic often emerges in the wake of structural models and reconfigured temporalities, from the reconceptualization of the event undertaken in Annales School histories of the long duration, to the efforts of philosophers such as Gilles Deleuze and Michel Foucault to articulate modes of individuation as events rather than essences, as "incorporeal transformations" or "statements" that are both singular and repeatable. Arguing against the commonsense, mass-media idea of an event, Deleuze pinpoints two qualities that are relevant in this context: "Even a short or instantaneous event is something going on," and "events always involve periods when nothing happens."[46]

In scientific discourses that Brecht would almost certainly have been familiar with, mundane phenomena such as turning on a light or lighting a match represent almost generic examples of physical "events." In physics, an event is precisely "a point taken from three-dimensions to four-dimensions."[47] Because the concept addresses perceptual problems articulated in relativity theory that occur as phenomena move closer to

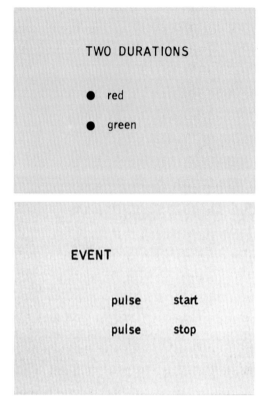

Figure 6.4 George Brecht, *Two Durations* and *Event*, c. 1961.

the speed of light, in an introductory course on physics, for instance, "a light bulb goes on" would be a typical event. In addition, information theory, statistics, and probability theory all rely on a generalized concept of the event as an unspecified occurrence. In Brecht's work, the event form works like a little device for cutting into the perceptual flow of this "everything that happens."

As they took shape in 1960–1961, Brecht's events represented both an extension and a focusing of the Cagean project—an extension because not only sound and hearing but "everything that happens" provides potential materials, and a focusing because singularity, rather than multiplicity or simultaneity, was the result. The programmatic chaos Cage provided was tremendously generative for Brecht and other artists who

would take the discrete or individual unit as the goal, rather than the overall, dispersed field of chance encounters that, in Cage's work, is still the transparent "screen" through which to see.[48]

What did this chaos consist of? Tasklike exercises employing mundane objects found at home or bought at the dime store—playing cards, whistles, toys—formed an ongoing part of Cage's class, where students were expected to present new pieces each week for (low cost, low preparation, generally unrehearsed) classroom enactment. Many of these nonmusical materials also entered Cage's more theatrical compositions, such as *Water Music* (1952), which includes the sounds of water being poured from one vessel to another. As Jan van der Marck argues in a 1974 article on Brecht's work, "Instead of being preparations for increasingly complex compositions, as undoubtedly Cage meant for them to be, such exercises became for Brecht ends in themselves," in effect "isolating event-structures from Cage's programmed performances."[49]

More improvisatory activities, using props, obstacles, sound, and speech to generate movement, were also used in Bay Area choreographer Ann Halprin's Dancer's Workshop, which Trisha Brown, Simone Forti, Robert Morris, Yvonne Rainer, Terry Riley, and La Monte Young all participated in during the summer of 1960.[50] In a manner parallel to Brecht's relationship with Cage, Forti's early use of task structures was adapted from her work with Halprin. Rainer recounts that "Halprin had a tremendous flair for the dramatic. Her emphasis was on using tasks to generate movement, which were then transformed into dance. *Simone simply kept the exercises themselves, as complete pieces.*"[51] Several of Forti's accounts of everyday movement in her "dance reports," "dance constructions," and "instructions" were published in *An Anthology*, including the following:

INSTRUCTIONS FOR A DANCE:

One man is told that he must lie on the floor during the entire piece.

The other man is told that during the piece he must tie the first man to the wall.

Although undated, the Forti piece was included in her May 1961 program at Young's Chambers Street series.[52] Dance historian Sally Banes reports that Forti's early rule pieces emerged from Robert Dunn's 1960–1961 composition class, where she worked with Cage's scores.[53] Both

Forti and Brecht knew Young's early text scores and may have known of each other's work, possibly through Young or the dancer Jimmy Waring (for whom Brecht had done sets).[54] More important than trying to disentangle instances of historical influence, however, is the larger sense that, at the same moment, a number of very different figures were drawing similar clues from certain environments and then taking them to very different ends:

THREE TELEPHONE EVENTS

- When the telephone rings, it is allowed to continue ringing, until it stops.
- When the telephone rings, the receiver is lifted, then replaced.
- When the telephone rings, it is answered.

George Brecht, Spring, 1961

While Brecht's lengthy "performance note," "Each event comprises all occurrences within its duration," inscribes his practice in an explicitly Cagean frame, Forti's visceral, potentially violent piece is structured by a level of conflict systematically excluded from Cage's project. This aggressive, bodily dimension also surfaces in Young's use of sustained tones played at intense volumes, which would allow listeners, in Young's words, "to get inside of a sound"—to develop a visceral, bodily relationship to sound through immersion over extended periods of time. In Henry Flynt's analysis, the goal of this immersion in "constant sound" was "the production of an altered state through narrowed attention and perceptual fatigue or saturation,"[55] drawing the listener into the work through the sheer force of structured sensation. In a role reminiscent of Cage's early work as a percussionist for dance groups, Young and the composer Terry Riley worked as musical codirectors for Halprin in 1959–1960. At this time, Young began to compose influential pieces such as his *Poem for Chairs, Tables, Benches, etc. (or Other Sound Sources)* (January 1960), which featured irregular, harsh, screeching noises created by dragging heavy pieces of furniture across the floor. In his "Lecture 1960," Young recounted: "When the sounds are very long, as many of those we made at Ann Halprin's were, it can be easier to get inside of them. . . . I began to see how each sound was its own world and that this world was similar to our world in that we experienced it through our own bodies, that is, in our own terms."[56] By 1962 Young turned to the systematic exploration of drone music, with minimally varied tones played at sometimes extreme

volumes for extended durations, a project that he has pursued since the 1960s.[57]

Young began his work with Halprin after his return from the 1959 Darmstadt summer session, where he participated in Stockhausen's Advanced Composition seminar and had his first sustained encounter with Cage's aleatory and indeterminate work—in part through the presence of the pianist David Tudor, who subsequently performed several of Young's compositions.[58] Only twenty-four, Young's musical preparation had been quite compressed. With a background in jazz and an attachment to the "static" structures of medieval chant and Indian classical music, he had studied Webern's work with Leonard Stein (Schoenberg's former assistant and later director of the Schoenberg Institute), and composed serial pieces as an undergraduate in Los Angeles; before starting graduate study in music at UC Berkeley, Young composed *Trio for Strings* (1958), which employed long tones and concurrent harmonies to an almost total suppression of melody. Thus even before moving to New York City in October of 1960 to attend Richard Maxfield's class at the New School, Young had encountered a complex of models quite similar to those documented in Brecht's notebooks.

In May 1960 Young began to compose the short "word pieces" published in *An Anthology*. Although these texts were circulated informally, Flynt suggests that they "crystallized a new genre" of quickly proliferating language works.[59] In their near inaudibility, dispersion, and apparent whimsy, Young's earliest text pieces most clearly reflect Cage's impact: *Composition 1960 #2* begins "Build a fire in front of the audience"; *Composition 1960 #5* proposes "Turn a butterfly (or any number of butterflies) loose in the performance area." In a 1966 interview, however, Young is at pains to differentiate his project from Cage's practice:

> Although there is no question that my exposure to John Cage's work had an immediate impact on aspects of my Fall, 1959, and 1960 work, such as the use of random digits as a method for determining the inception and termination of the sounds in *Vision* [1959] and *Poem for Chairs, Tables, and Benches, Etc., or Other Sound Sources* [1960] and my presentation of what traditionally would have been considered a non or semi-musical event in a classical concert setting, I felt that I was taking these ideas a step further. Since most of his pieces up to that time, like the early Futurist and Dadaist concerts and events . . . were generally realized as a complex of programmed

sounds and activities over a prolonged period of time with events coming and going, I was perhaps the first to concentrate on and de-limit the work to be a single event or object in these less traditionally musical areas.[60]

Young's insistence on the *singularity of the event*—the idea that it is "one thing"—is crucial. It isolates certain structural qualities that re-emerge in durational film and video and suggests how Ono's more var-ied and provocative scores often diverge from this proto-minimal event project. Like Deleuze's analysis of the event as including both "some-thing going on" and "periods when nothing happens," Young's program-matic monotony reduces a structure to a single basic element, which is extended or repeated, potentially endlessly—strategies which return in the viscerally compelling "nothing happens" of films by Andy Warhol, Michael Snow, and Chantal Akerman. In Flynt's analysis, minimalism works precisely through such saturation of uniformity: Young "stripped the form to a core element and saturated the field with that element."[61]

If for Brecht the event takes paradigmatic form in single-word scores like *Exit*, for Young the model is the line. Encapsulating a long-term involvement with sustained tones, Young's *Composition 1960 #7* (July 1960) instructs the performer to hold an open fifth "for a long time." He soon supplemented it with another piece, *Composition 1960 #9* (Oc-tober 1960), published in *An Anthology* as a straight horizontal line on a 3-by-5-inch card. The two scores elegantly diagram the analogous struc-tures: the temporal extension of the sustained tone, the graphic inscrip-tion of the drawn line. Young's subsequent piece, *Composition 1960 #10* (October 1960), transfers this structure into its linguistic analogue: "Draw a straight line and follow it." As Young described the project in 1966, "I have been interested in the study of a singular event, in terms of both pitch and other kinds of sensory situations. I felt that a line was one of the more sparse, singular expressions of oneness, although it is certainly not the final expression. Somebody might choose a point. However, the line was interesting because it was continuous—it existed in time."[62]

The singularity of the event does not preclude its repeatability but in fact permits it. Drawing out the conceptual ramifications of "the idea of this sort of singular event," in 1961 Young decided to repeat *Composition 1960 #10* twenty-nine times, with individual "works" evenly distributed to comprise a full year's work. The resulting *Compositions 1961 #s 1–29* premiered in March 1961, at a Harvard concert organized by Flynt, in

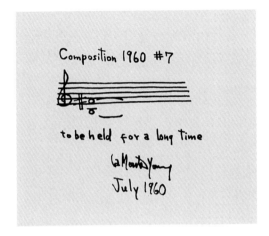

Figure 6.5 La Monte Young,
Composition 1960 #7, July 1960.
Reproduced with permission from *An
Anthology* (1963). © La Monte Young
1963, 1970, renewed 1991. Please see
copyright and licensing information
appearing on the copyright page(s).

Composition 1960 #10
to Bob Morris

Draw a straight line
and follow it.

October 1960

Figure 6.6 La Monte Young,
Composition 1960 #10, October 1960.
Reproduced with permission from *An
Anthology* (1963). © La Monte Young
1963, 1970, renewed 1991. Please see
copyright and licensing information
appearing on the copyright page(s).

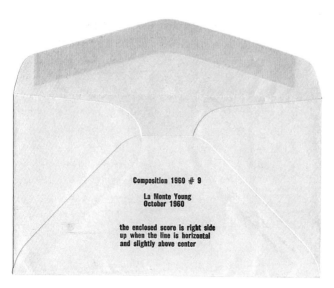

Figure 6.7 La Monte Young,
Composition 1960 #9, October
1960 (envelope). Reproduced with
permission from *An Anthology* (1963).
© La Monte Young 1963, 1970,
renewed 1991. Please see copyright
and licensing information appearing
on the copyright page(s).

Figure 6.8 La Monte Young,
Composition 1960 #9, October 1960
(card). Reproduced with permission
from *An Anthology* (1963). © La
Monte Young 1963, 1970, renewed
1991. Please see copyright and
licensing information appearing on
the copyright page(s).

which Young and his friend and collaborator Robert Morris arduously traced a line twenty-nine times using a plumb line. The piece was re-staged in May at the Chamber Street series, and was eventually published by Maciunas as the book *LY 1961* in 1963. Young recalls: "It can be per-formed in many ways. At that time, I employed a style in which we used plumb lines. I sighted with them, and then drew along the floor with chalk ... I drew over the same line each time, and each time it invariably came out differently. The technique I was using at the time was not good enough." Like most task-structured works, the duration was not fixed prior to performance, but simply entailed the time it took to complete the job—"a whole performance must have taken a few hours"—with the audience coming and going.[63]

Like Young's ongoing efforts "to get inside a sound," the repetition of a simple, durational action over an extended period of time creates a very specific mode of attention. Laboriously performing the line piece as a repeated, real-time task structure, Young would not only concretely link certain spatial models—transferring the line from the graphic space of the card to the three-dimensional architectural container—but bring into focus an altered perceptual/spectatorial position in the process. When critics of minimalism use the awkward metaphor of "theatricality" to describe a certain focused perceptual and bodily relation to objects in real time and space, it is Young's 1961 work (first performed with Morris) that is perhaps the template.

"Readymade Aesthetics" and the Return of the Reader

Now, Duchamp thought mainly about readymade objects. John Cage extended it to readymade sounds. George Brecht extended it fur-thermore ... into readymade actions, everyday actions, so for in-stance a piece of George Brecht where he turned a light on and off, okay? That's the piece. Turn the light on and then off. Now you do that every day, right?

—*George Maciunas (1978)*[64]

If the event can be repeated, it can be repeated by anyone, not just its "author." In both Young's and Brecht's scores, a condition of "maximal availability" is most effectively created through the most minimal means. The simplest structure could produce the most varied results while still retaining a

certain conceptual unity and structural integrity. An extraordinarily compressed verbal inscription, like *Exit* or *Draw a Straight Line*, provides a kind of structure that other artists could use to produce diverse interpretations or realizations—thereby creating new pieces, and effectively blurring the boundary between composer and interpreter far more decisively than, for example, musical scores that simply allow performers to select among or rearrange existing sections. In perhaps the best-known instance of this reauthoring, Nam June Paik made an unorthodox realization of Young's *Composition 1960 #10* at one of the early Fluxus festivals by dipping his head in a bowl of ink and tomato juice and using it to draw a straight line on an unrolled sheet of paper in his *Zen for Head* (1962).

Brecht's realizations of his own and others' scores were characteristically spare, disciplined and antimonumental, often permitting such events to remain unseen or barely perceived. He performed Young's *Composition*

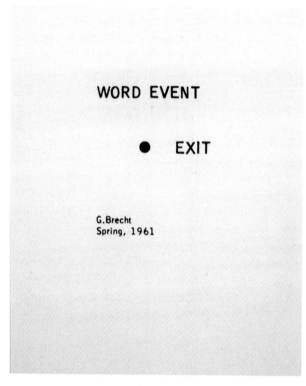

Figure 6.9 George Brecht,
Word Event, 1961.

1960 #2 ("Build a fire in front of the audience . . .) by simply lighting a book of matches placed on an upturned glass on a stool, at an evening at Maciunas's Canal Street Fluxshop in 1964. In a 1964 radio discussion with Kaprow, Brecht claimed that "the occurrence that would be of most interest to me would be the little occurrences on the street,"[65] and while Kaprow, Claes Oldenburg, and others might seek to recreate chaotic urban experiences in elaborately staged interactive environments or happenings, Brecht's event structure would isolate simple, unified everyday occurrences as something analogous to perceptual readymades. As Michael Nyman argues, "Brecht isolated the single, observed occurrence and projects it . . . into a performance activity, which he calls an 'event.'"[66]

What does it mean to see such events as "readymade actions," as extensions of the readymade? A host of ambiguities emerge. While a score like *Drip Music* was performed by Brecht and others as a public act before an audience, it is of course also an event that occurs everywhere, all the time. Certain consequences of the event as a linguistically framed readymade perhaps emerge most clearly in Fluxus activities, as these were staged and interpreted by Maciunas. Quite tellingly, Maciunas would later compare Brecht's increasingly compressed language-based events to the structure of the joke, when he contrasts the "monomorphism" of Fluxus performance to the more "baroque" happenings in a 1978 interview conducted shortly before his death:

> Now monomorphism . . . that's where it differs from Happenings. See, Happenings are polymorphic, which means many things . . . happening at the same time. That's fine, that's like baroque theater. You know, there would be everything going on: horses jumping and fireworks and waterplay and somebody reciting poems and Louis XIV eating a dinner at the same time. So, that's polymorphism. Means many, many forms. Monomorphism, that means one form. Now, reason for that is, you see, lot of Fluxus is gag-like. That's part of the humor, it's like a gag. . . . Now, you can't tell a joke in multi-forms. In other words, you can't have six jokers telling you six jokes simultaneously. It wouldn't work. Has to be *one joke at a time.*[67]

While Maciunas's retrospective comments do not differentiate the frequently language-based (and Cage-inspired) American Fluxus works from the more improvisatory, expressionistic European performances, the structuring role of text was a distinction he was well aware of at the

time—writing to Brecht, in the fall of 1962, that European performers like Wolf Vostell and Daniel Spoerri "do not write down their happenings but improvise them on the spot."[68] Like his often contradictory manifestos and statements, Maciunas's aesthetic was far from consistent, embracing both the more spectacular, even vaudevillian aspects of performance as "visual comedy" and the near-imperceptibility of works such as Brecht's, where the "gag" is more internal. Yet his reference to the structure of joke, and to the readymade model, suggests an intrinsic tension between Brecht's stated understanding of his events as "an extension of music" opening onto a kind of total, multisensorial perceptual experience, and the experience of the scores as tightly focused, extremely compressed linguistic structures that produce a more cognitive, even conceptual response.

In the 1964 letter to Tomas Schmidt that includes Maciunas's oft-cited comparisons of Fluxus objectives to those of the Soviet LEF group as "*social* (not aesthetic)," Maciunas argues,

> The best Fluxus "composition" is a most nonpersonal, "ready-made" one like Brecht's "Exit"—it does not require any of us to perform it since it happens daily without any "special" performance of it. Thus our festivals will eliminate themselves (and our need to participate) when they become total readymades (like Brecht's exit).[69]

And in correspondence with Brecht, Maciunas approvingly recalls events like *Piano Piece* (a "vase of flowers on(to) a piano") as occurring virtually unnoticed, unperceived as a separate work. Maciunas describes this falling back into the continuum of everyday existence in terms of a "readymade" or "non-art event":

> By non-art I mean anything not created by artist with intend to provide "art" experience. So your events are non-art since you did not create the events—they exist all the time. You call attention to them. I did not mind at all that some of your events were "lost" in our festivals. The more lost or unnoticeable the more truly non-artificial they were. Very few ever thought the vase of flowers over piano was meant to be a piece & they all waited for a "piece" to follow.[70]

Maciunas proceeds to distinguish perceptual pieces such as Brecht's from "art," which "may use readymade sign, exit, etc.," but which

transforms them, since the "situation is *not* readymade (or event is not readymade)." The Fluxus politicization of the readymade as a strategy leading to an eventual elimination of the author function was at least partially shared by Brecht, who later insisted, "All I do is bring things into evidence. But they're already there."[71] If Young's events intensify a single sensation to the point of total environmental control, Brecht's scores tend toward the unseen, toward things that can pass unnoticed or disappear back into the quotidian.[72] This procedure of "bringing things into evidence" by means of language extends the performative and linguistic potential of the readymade, as an act of framing that need not be limited to the types of physical objects that characterized Duchamp's production. The ambivalently performative potential of the Duchampian readymade, read as a nominating linguistic gesture, an act of naming or categorizing, has been extensively discussed in the Duchamp literature, most notably by Thierry de Duve.[73] Yet this nominalist model alone doesn't account for the intrinsic doubleness of the readymade structure, its dual existence as both manufactured object and linguistic act, as Benjamin Buchloh has argued.[74]

In the historical recovery of Duchampian legacies in the late 1950s, of which Brecht was intimately aware, the readymade provided a model to move from the aesthetics of dispersion and chance juxtaposition of Brecht's earlier scores toward a simple linguistic structure focusing attention on existing things. Brecht's transfer of this strategy from the manufactured object to the temporal perception occurred, as Maciunas suggests, via Cage: as Brecht would cryptically comment in a 1967 interview, "Duchamp is alone is one thing, but Duchamp plus Cage is something else."[75] Brecht was also drawn to Duchamp's writings, newly available in the 1959 Robert Lebel monograph, and in Richard Hamilton's 1960 typographic rendition of Duchamp's *Notes for the Large Glass.* Alongside Japanese poetic models such as haiku, Duchamp's brief, cryptic notes, with their spare, attenuated use of language and attention to paradox, perhaps provided an impetus for the increasingly compressed event scores.[76] More critically, however, the transfer of the readymade structure to perceptual phenomena propels the gradual interiorization of performance in the event scores.

Brecht's distance from conceptual art can be seen in his retrospective description of *Six Exhibits* (1961) as a kind of music: "If we perform it right now, for example, we can look at the ceiling, the walls, and the floor and at the same time we'll hear sounds: our voices, the birds outside, and

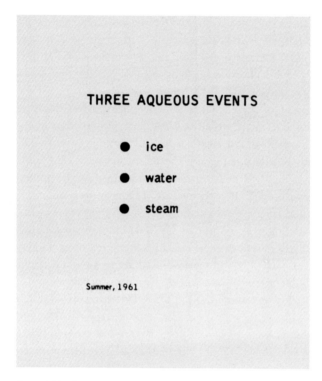

Figure 6.10 George Brecht,
Three Aqueous Events, 1961.

so forth. All of that belongs to the same whole, and that's the event."[77]
In this account, we are invited to actively perform the piece as if listen-
ing to Cage's *4'33"*—inadvertently demonstrating the conservatism of
this perceptual model, grounded in the express intentions of a centered
subjectivity. Yet Brecht's events implicitly use language as a kind of *naming*
that singles out and isolates perceptual phenomena in ways that exceed
subjective intention.[78] By focusing on things that are happening all the
time whether noticed or not—signs posted, faucets dripping, phones
ringing, substances existing in states whose change is too slow to per-
ceive—Brecht aligns the temporality of language with the temporality of
the event: continual, recurring, agentless. In scores such as *Exit* and *Two
Signs* ("• Silence / • No Vacancy") the event is internal to the score and
to the reading of the score, so that actual performance, although possible,
is no longer necessary to enact or complete the piece. As Brecht remarks,

SIX EXHIBITS

- ceiling
- first wall
- second wall
- third wall
- fourth wall
- floor

Summer, 1961

Figure 6.11 George Brecht,
Six Exhibits, 1961.

"There isn't any way in which *Exit* should be performed. There's only an 'exit' sign hanging over the door."[79]

This shift is accomplished through language. While an earlier score like *Motor Vehicle Sundown Event* used imperative verbs to direct the actions of a subject external to language, its listlike, numbered, vertically arranged form structurally equates these commands with descriptions. Although Young's and Ono's scores primarily use imperative verb forms, Brecht, after his early works, eliminates them—instead, a mere gerund ("dripping"), noun ("water"), or preposition ("on," "off") is enough to indicate action or process. Others, such as *Exit* or *Silence*, occur endlessly in continuous oscillation of verbal form.[80] By 1961, most of the scores feature extremely condensed, almost telegraphic uses of language: brief phrases and single words, presented vertically, with minimal punctuation. Where punctuation does occur, it functions almost algebraically, as if to reduce language to a set of spatial relations, or more operationally, as if to qualify an action. Everything extraneous is omitted.[81]

As realized in the Maciunas-designed edition *Water Yam*, Brecht's precise, graphic formats increasingly cross the musical model of the score with the visual space of printed ephemera.[82] In these cards, the implicit

reference is not so much to the linear, sequential structure of the line or sentence but to the gridded two-dimensionality of the ad, poster, or flyer, the printed instruction card, sales ticket, or receipt, in which condensed snippets of text are inserted into a visually defined field. This is not the textual spacing of the book, or the bodily pause of poetic "breath," but the space of modern graphic design in its complete interpenetration of visual and textual materials—a space that has programmatically invaded poetry since Mallarmé.[83] And, reminiscent of the elaborate Mallarméan protocols for reading, Brecht's scores would go out into the world in a series of boxes whose idiosyncratic format (and silly name) would claim a ludic domain of esoteric "play" while refusing any reinsertion into instrumental forms of culture.[84]

Despite the esotericism that marks so many subsequent Fluxus projects, we can nonetheless draw a different series of lessons about the focused, relentless, and potentially unlimited capacities of a single word or extended single sound. In their use of language as a device to cut into the evanescent everyday, Brecht's "insignificant and silly gestures" open an infinite universe of possibilities, just as Young's precise operations move into the zones of the minimal and the series, of the same but inevitably different because extended virtually interminably—the line or the sound would go on in some sense "forever." In both, the event is pared down to a minimum: a simple, basic structure that can be endlessly reenacted and reinscribed in new contexts, different in each instance and yet retaining a certain coherence. Inevitably calling to mind Lawrence Weiner's highly condensed and yet generalizable "statements," Brecht's most interesting scores reduce language to a kind of object, and yet also establish it as a kind of repeatable, replaceable structure, open to unlimited, unforeseeable realizations.

My reference to Weiner here is not innocent. While the public memory of Fluxus continues to be of the almost vaudevillian European concerts and peculiarly fetishistic editions, the event scores and related projects offered a very different model which was widely if erratically disseminated.[85] If I am, in effect, reading Brecht through Weiner, it is because I believe that Weiner's explicit activation of the receiver is itself modeled on the implicitly performative positioning of the viewer/reader/listener in these event projects—just as his repeated statements that "there's no way to build a piece incorrectly" inevitably echo a wider ethic of indeterminacy.[86]

THREE GAP EVENTS

● missing-letter sign

● between two sounds

● meeting again

To Ray J.
Spring, 1961
G. Brecht

Figure 6.12 George Brecht,
Three Gap Events, 1961.

When it engages these questions at all (that is, in its most progressive versions), modernist art history emphatically locates this "return of the reader" in the linguistically oriented forms of late 1960s conceptual art by Weiner, Kosuth, Graham, and others. For this model to emerge as a radical rupture within neo-avant-garde visual art, the innovations of the postwar interdisciplinary activities around Cage must be (momentarily) acknowledged and then quickly repressed—just as Lucy Lippard, in her 1973 book *Six Years: The Dematerialization of the Art Object*, starts her chronology with Brecht's pamphlet *Chance Imagery* (1957/1966), citing some of his early events as among those projects that "anticipate a stricter 'conceptual art' since around 1960."[87] While critics continue to argue that the conceptual use of language as an artistic medium propels something like a "withdrawal of visuality" or "dematerialization" of art, and a current generation of artists often seems intent on trawling the 1960s for remnants

of ephemeral practices that can be turned into commercially successful objects, the event scores of Brecht and Young present language as a model for *a different kind of materiality*, one structured from the outset by repetition, temporality, and delay—conditions Jacques Derrida has termed "the iterability of the mark." That this practice has enormous implications for all visual art in the late twentieth century is suggested by a quote from Vito Acconci—"Language: it seemed like the perfect multiple."[88]

Notes

This essay was drawn from a chapter on the work of George Brecht, La Monte Young, and Yoko Ono in my dissertation, "Language Models in 1960s American Art: From Cage to Warhol." An earlier version was presented in November 1999, at the Réclame lecture series "Otherwise Photography/Intermedia Otherwise: Prototypes and Practices of the 1960s," organized by Judith Rodenbeck; and a revised version appeared in my book *Words to Be Looked At: Language in 1960s Art* (Cambridge: MIT Press, 2007). My thanks to Lutz Bacher, Benjamin Buchloh, and Mark So for their readings and comments.

1. The Chambers Street series, held from December 1960 to June 1961, presented performances of music by composers Terry Jennings, Toshi Ichiyanagi, Joseph Byrd, Richard Maxfield, Henry Flynt, and La Monte Young; poetry and theater by Jackson Mac Low; dance by Simone Forti; and, for the final session, an "environment" by sculptor Robert Morris. Documentation of the series can be found in the set of printed programs available in the Jean Brown Collection at the Getty Research Institute, Los Angeles (hereafter, GRI), the Hans Sohm Archives at the Staatsgalerie Stuttgart, and elsewhere. Credit for curating the series has been claimed by both Young and Ono. See the rather vitriolic exchange of letters from 1971 held in the Getty collections. The most detailed account of this early 1960s pre-Fluxus moment can be found in Henry Flynt, "La Monte Young in New York, 1960–62," in *Sound and Light: La Monte Young, Marian Zazeela*, ed. William Duckworth and Richard Fleming, *Bucknell Review* 40, no. 1 (1996): 44–97.

2. La Monte Young, ed., *An Anthology of Chance Operations, Indeterminacy, Concept Art, Anti-Art, Meaningless Work, Natural Disasters, Stories, Poetry, Essays, Diagrams, Music, Dance Constructions, Plans of Action, Mathematics, Compositions,* by George Brecht, Claus Bremer, Earle Brown, Joseph Byrd, John Cage, David Degner, Walter De Maria, Henry Flynt, Yoko Ono, Dick Higgins, Toshi Ichiyanagi, Terry Jennings, George Maciunas, Ray Johnson, Jackson Mac Low, Richard Maxfield, Malka Safro, Simone Forti, Nam June Paik, Terry Riley, Diter Rot, James Waring, Emmett Williams, Christian Wolff, La Monte Young. George Maciunas, Designer. Published by La Monte Young and Jackson Mac Low, 1963; reprinted in 1970 by Heiner Friedrich, New York.

3. For years, the sole monograph on Brecht's work was Henry Martin's *An Introduction to George Brecht's Book of the Tumbler on Fire* (Milan: Multhipla Edizioni, 1978), which, although focused on Brecht's post-1964 *Book of the Tumbler on Fire* project, reprints some of Brecht's earlier writings and several important interviews from the 1960s and 1970s.

4. Accounts of these exhibitions are available in the set of catalogs edited by Jon Hendricks, *Paintings & Drawings by Yoko Ono, July 17–30, 1961 / Instructions for Paintings by Yoko*

Ono, May 24, 1962 (Budapest: Galeria 56, 1993), vols. 1 and 2, and in Alexandra Munroe et al., *Yes Yoko Ono* (New York: Japan Society/Harry N. Abrams, 2000).

5. Yoko Ono, *Grapefruit* (bilingual edition; Tokyo: Wunternaum Press, 1964), and *Grapefruit: A Book of Instructions + Drawings by Yoko Ono* (New York: Simon and Schuster, 1971), with an introduction by John Lennon.

6. As Ian Pepper notes, *4'33"* established "composition" as "an autonomous process of writing, as graphic production that is not secondary to, and has no determined relation to, sound in performance. . . . By defining 'music' as *writing* on the one hand, and *sound* on the other, and by erecting an absolute barrier between the two spheres, Cage initiated a crisis in music that has barely been articulated, let alone worked through." "From the 'Aesthetics of Indifference' to 'Negative Aesthetics': John Cage and Germany 1957–1972," *October* 82 (Fall 1997): 34. As I elucidate in *Words to Be Looked At* (17–24 and 268–270), exactly when Cage wrote the "text score" of *4'33"* remains unknown, though it clearly was circulated by 1958.

7. Roland Barthes, "The Death of the Author," in *Image-Music-Text*, trans. Stephen Heath (New York: Hill and Wang, 1977), 143.

8. Umberto Eco, *Opera aperta* (Milan: Editoriale Fabri, 1962), partially translated in *The Open Work* (Cambridge: Harvard University Press, 1989).

9. Barthes, *Image-Music-Text*, 163. While Barthes's own sources are more frequently in the "modern text" of Balzac, Mallarmé, or the *nouveau roman*, music is also a model for this writing, which must be operated, performed, and written anew—even if Barthes's model, in "Musica Practica" (1968) is, paradoxically, Beethoven (the composer who represented, for Cage as well as Young, the anathema of modern music). In addition, Barthes's speculations in "From Work to Text" are grounded explicitly in the new methodological space of *interdisciplinarity:* the "text," an "interdisciplinary object," is a kind of writing dislodged from the stability of literary containers and functions—author, oeuvre, genre, book, tradition. In this classic essay, the aesthetic upheavals of the 1950s and 1960s in both music and art are posed as reversing or modifying a historical trajectory of bourgeois culture in which the participation of "practicing amateurs" has given way, first to a class of surrogate interpreters, then to the passive consumption of fully professionalized works in technically reproduced forms—as "the gramophone record takes the place of the piano" in the bourgeois home.

10. Even the publication of Barthes's "The Death of the Author" in *Aspen* 5/6 in 1967, often credited with injecting certain poststructural concerns into the context of American conceptual art, could arguably be posed partly as a circuitous reimportation of Cagean models of desubjectivization and indeterminacy—part of a series of conceptual loops and borrowings made no less complicated by the name Brecht, which the critic Jill Johnston has suggested was not the American artist's actual surname.

11. Umberto Eco, "The Poetics of the Open Work," in *The Open Work*, 251 n. 1. Eco proceeds to argue that, "For the purpose of aesthetic analysis, however, both cases can be seen as different manifestations of the same interpretative attitude. Every 'reading,' 'contemplation,' or 'enjoyment' of a work of art represents a tacit or private form of 'performance.'"

12. Despite Cage's growing reputation as a writer and Ono's self-identification at the time as a "poet," these event scores have received little attention as literary or language art. Here it is not only the instability of genre or the relation to live performance but the problem of medium, of unconventional material support, that seems at issue. Yet these idiosyncratic formats, of hand-lettered sheets and small printed cards, seem innocuous, even quaint, and

easily transferred to the format of the page. The obstacles to reading them in relation to literature would seem small compared, for instance, to the videotaped performances of Vito Acconci or the films of Andy Warhol, yet certain vexing questions about the inscription of temporality into language, the positioning of the viewer/reader, and the material structures of new artistic/technical media occur implicitly in event scores in ways that have great relevance to more aggressively technologized works of the later 1960s.

13. In "Language between Performance and Photography," *October* 111 (Winter 2005): 3–21, I address this tripartite structure, and its relationship to conceptual art, through a comparison of Brecht's 1961 *Three Chair Events* (with its implicit language/object/ performance structure) to Joseph Kosuth's 1965–1966 *One and Three Chairs* (with its explicit triangulation of text, object, and photograph).

14. This poetics of semiotic disruption, itself deeply conventionalized by the postwar era, would appear to be what is endorsed by Cage himself in his statements on poetry in "Preface to *Indeterminacy*" (1959): "As I see it, poetry is not prose, simply because poetry is one way or another formalized. It is not poetry by virtue of its content or ambiguity, but by reason of allowing musical elements (time, sound) to be introduced into the world or words." Reprinted in *John Cage, Writer: Previously Uncollected Pieces*, ed. Richard Kostelanetz (New York: Limelight Editions, 1993), 76.

15. Rosalind Krauss, "Notes on the Index, Part II," in *The Originality of the Avant-Garde and Other Modernist Myths* (Cambridge: MIT Press, 1986), 212.

16. Henry Flynt, "Mutations of the Vanguard: Pre-Fluxus, During Fluxus, Late Fluxus," in *Ubi Fluxus ibi motus 1990–1962*, ed. Gino Di Maggio (Milan: Nuove edizioni Gabriele Mazzotta, 1990), 99.

17. Owen F. Smith suggests that "the works that would become 'standard' Fluxus pieces were mostly of a particular type—concrete, simply structured events, dryly humorous and unabashedly literal—such as George Brecht's *Word Event* (in which the word *exit* was written or posted in the performance space. . . . Maciunas and the other artists associated with the organization of these concerts increasingly realized that it was important for Fluxus festivals to present a strong focus on a particular performance form—the event" ("Fluxus: A Brief History and Other Fictions," in Elizabeth Armstrong and Joan Rothfuss, *In the Spirit of Fluxus* [Minneapolis: Walker Art Center, 1993], 88).

18. For a sense of what is at stake in Brecht's boxes, cases, and object collection strategies, in the transformation of assemblage and readymade aesthetics, see Benjamin Buchloh's essays on the work of Robert Watts, Brecht's close friend and collaborator: "Cryptic Watts," in *Robert Watts* (New York: Leo Castelli Gallery, 1990); and "Robert Watts: Animate Objects–Inanimate Subjects," in Benjamin H. D. Buchloh and Judith F. Rodenbeck, *Experiments in the Everyday: Allan Kaprow and Robert Watts—Events, Objects, Documents* (New York: Wallach Art Gallery, Columbia University, 1999).

19. George Brecht, *Notebooks*, vols. 1–3 (June 1958–August 1959), ed. Dieter Daniels with Hermann Braun (Cologne: Walther König, 1991), vols. 4–5 (September 1959–November 1960), ed. Hermann Braun (Cologne: Walther König, 1998), and vols. 6–7 (March 1961–September 1962), ed. Hermann Braun (Cologne: Walther König, 2005).

20. Brecht describes this earlier production in *Chance Imagery* (New York: Something Else Press, 1966) and in an undated letter (c. 1962) to critic Jill Johnston, in which he provides sketches of some of the earlier paintings. In a subsequent letter (c. 1963) Brecht tells Johnston, "My attitude toward painting is changing, I believe it is clearer to me now what particular aspects of the present situation in painting are less nutritious for me: the object-like nature of paintings in a world of process, the egocentric attitudes of painters/

dealers, the *distance* imposed by conventional attitudes toward painting in the viewer/painting relationship (the distance between a painting of a soup can and the viewer being much greater than the distance between the painter and the actual can)" (Jean Brown Papers, Getty Research Library [890164]).

21. George Brecht, *Chance Imagery* [1957], published in 1966 by Dick Higgins's Something Else Press.

22. Dick Higgins, *Jefferson's Birthday/Postface* (New York: Something Else Press, 1964), 49.

23. Ibid., 50–51.

24. Ibid., 51. Other members of the class included Toshi Ichiyanagi, Jackson Mac Low, and (according to Sally Banes) Robert Dunn.

25. Reprinted in *John Cage, Writer*, 81.

26. Brecht, *Notebooks*, 1: 3–4 (June 24, 1958).

27. Bruce Altshuler, "The Cage Class," in *FluxAttitudes*, ed. Cornelia Lauf and Susan Hapgood (Gent: Imschoot Uitgevers, 1991), 17.

28. Originally published 1955–1962, *Die Reihe* [The Row], vols. 1–8, was issued in an English-language edition in 1957–1968.

29. However neutralized they appear in postwar accounts, all these projects had certain military entanglements. Just as American research into cybernetics, cryptography, mass communication, and electronic signal transmission were all propelled by government sponsorship during World War II, German technical innovations in electroacoustic recording, audiotape, microphony, and broadcast technology were in part developed for military applications. It is no coincidence that Cologne and Paris (where Pierre Schaeffer's studio at Radiodiffusion Television France began informally in 1942) became the centers of postwar experimental music. The influential Darmstadt International Summer Course in New Music, first held in 1946, was part of the immediate postwar effort of cultural reconstruction; the area also had a military base where, in 1962, George Maciunas came to work as a designer for the *Stars and Stripes*.

30. Eimert, "What Is Experimental Music?," *Die Reihe*, no. 1 (1955), cited from the English-language edition (Bryn Mawr: Theodore Presser Company/Universal Edition, 1957), 1, 3.

31. Eimert elaborates: "By the radical technical nature of its technical apparatus, electronic music is compelled to deal with sound phenomena unknown to musicians of earlier times" (1). "Tape recorder and loud-speaker are no longer 'passive' transmitters; they become active factors in the preparation of the tape. This is the essential secret of electro-musical technique" (3).

32. Eimert, "What Is Experimental Music?," 3.

33. After Cage left the New School in 1960, Maxfield began a course in electronic music that included Maciunas, Mac Low, and Young as students.

34. Brecht, *Notebooks*, 1: 22 (my emphasis).

35. Ibid., 65–67.

36. While grounded in his professional training, Brecht's interests nevertheless echo the endless fascination with scientific methods and discourses on the part of neo-avant-garde practices from Cage, Group Zero, and "systems aesthetics" to the Experiments in Art and Technology and Pierre Boulez's Institut de Recherche et de Coordination Acoustique/Musique. For a trenchant account of the legitimating (and mystifying) role of scientific

models and discourses in the latter, see Georgina Born, *Rationalizing Culture: IRCAM, Boulez, and the Institutionalization of the Musical Avant-Garde* (Berkeley: University of California Press, 1995).

37. Brecht apparently held a number of patents for tampon design; according to several accounts, Brecht's own father had been a concert flutist in New York.

38. George Brecht, "Innovational Research" (Fall 1960, typed/mimeographed document, 16 pages, Artist's File, MoMA library).

39. Cage's repeated claim that this realization came from his Harvard anechoic chamber encounter is itself an indicator of this remapping of sensory and even bodily perception via new, technologically modified experiences, made possible here by the scientific resources of the postwar research university.

40. See Jacques Attali, *Noise: The Political Economy of Music* (1977), trans. Brian Massumi (Minneapolis: University of Minnesota Press, 1985). While Attali is markedly more *critical* of this process, seeing the phonograph as the template for a culture of mass-produced repetition, his observation that "it makes the stockpiling of time possible" (101) nonetheless echoes Kittler's.

41. Friedrich Kittler, *Gramophone, Film, Typewriter* (1986), trans. Geoffrey Winthrop-Young and Michael Hurtz (Stanford: Stanford University Press, 1999), 23. Yet Kittler also points out that models for this "anti-musical" understanding of sound itself precede the invention of the phonograph, with scientific experimentation with noise going back at least to the early nineteenth century. In their introduction, Winthrop-Young and Hurtz elaborate on this relation between inscription technologies and an aesthetics of "indifference," noting that gramophone and film "both recorded indiscriminately what was within the range of microphones or camera lenses, and both thereby sifted the boundaries that distinguished noise from meaningful sounds, random visual data from meaningful picture sequences, unconscious and unintentional inscriptions from their conscious and intention counterparts" (xxvi).

42. Kittler, *Gramophone, Film, Typewriter*, 4. This problem is by no means specific to music, since any "continuous" material—sound, light, time, the photograph—has the potential to profoundly disrupt signification. As Roland Barthes notes, semiology "cannot admit a continuous difference" since "meaning is articulation" (*Elements of Semiology* [1964], trans. A. Lavers and C. Smith [New York: Hill and Wang, 1968], 53).

43. Gilles Deleuze, *The Fold: Leibniz and the Baroque* (1988), trans. Tom Conley (Minneapolis: University of Minnesota Press, 1993), 76.

44. "An Interview with George Brecht by Irmeline Lebeer" (1973) in Martin, *An Introduction to George Brecht's Book of the Tumbler on Fire*, 84 (my emphasis).

45. "Interview with Allan Kaprow" (1995) in *Off Limits: Rutgers University and the Avant-Garde, 1957–1963*, ed. Joan Marter (Newark: Newark Museum; New Brunswick: Rutgers University Press, 1999), 132.

46. Gilles Deleuze, "On Leibniz" (1988), in *Negotiations,* trans. Martin Joughin (New York: Columbia University Press, 1995), 159–160.

47. Interview with Donald Backer, Department of Astronomy, University of California, Berkeley, August 2000.

48. Douglas Kahn provocatively reads *Drip Music* in relation to the transition from Pollock to Cage, suggesting, "The laboratory techniques through which *Drip Music* developed provided a means to isolate a single gesture from gesture painting ... and a *sound-in-itself*

from all the competing sounds in a Cage composition." See *Noise, Water, Meat: A History of Sound in the Arts* (Cambridge: MIT Press, 1999), 283.

49. Jan Van der Marck, "George Brecht: An Art of Multiple Implications," *Art in America* (July/August 1974): 56.

50. With Terry Riley, Young taught a class in composition during the 1960 summer intensive session, where he first delivered his "Lecture 1960" over a recording of his 1958 "Trio for Strings" (Young, conversation with the author, October 30, 2000). For more information on Halprin's Summer 1960 workshop, see Janice Ross, *Anna Halprin: Experience as Dance* (Berkeley: University of California Press, 2007).

51. Yvonne Rainer, conversation with the author, New York City, January 22, 1999.

52. Simone Forti, *Handbook in Motion* (Halifax: Nova Scotia College of Art and Design, 1974), 56–57. The quotation above is credited as follows: Simone Forti, *Dance Constructions and Instructions for a Dance*, 1961. Reproduced with permission from *An Anthology* (1963), La Monte Young, editor. Copyright © La Monte Young and Jackson Mac Low 1963, 1971, renewed 1991.

53. Sally Banes reports that Forti "enjoyed the use of chance techniques gleaned from John Cage's music scores, seeing aleatory methods not as relinquishing of control but as a means of evoking in performance the original events and structures at the moment of composition." See *Terpsichore in Sneakers: Post-Modern Dance* (Hanover, N.H.: Wesleyan University Press, 1987), 25. In *Democracy's Body: Judson Dance Theater, 1962–1964* (Durham: Duke University Press, 1993), Banes provides an extended account of the workshop Dunn conducted at Merce Cunningham's studio, noting that it was started at Cage's suggestion, and that Dunn had attended Cage's New School class from 1956 to 1960.

54. By all accounts, Brecht was aware of Young's word pieces by the fall of 1960, and they provided a compelling model of isolation and compression.

55. Flynt, "La Monte Young in New York, 1960–62," 59.

56. La Monte Young, "Lecture 1960," in *Happenings and Other Acts*, ed. Mariellen Sandford (New York: Routledge, 1995), 79.

57. In the early 1960s, musicians Angus MacLise, Marian Zazeela, Tony Conrad, and John Cale (later of the Velvet Underground) collaborated with Young in these experiments— a collaboration that eventually led to the long-running dispute between Conrad and Young over authorship of this work and control of the audio recordings Young made at the time. For accounts of this dispute, see Mike McGonigal, "Tony Conrad's High Lonesome Drone," *New York Press*, December 3–9, 1997, pp. 35–36; Peter Margasak, "Amid the Drone, a Feud over Who Composed It," *New York Times*, Sunday, August 13, 2000, sec. 2, pp. 27, 31; Tony Conrad, liner notes to *Early Minimalism, Volume 1* (CD, Table of the Elements 1997; Arsenic 74.9216); and Young's lengthy statement on the MELA Foundation Web pages, "Notes on the Theatre of Eternal Music and *The Tortoise, His Dreams and Journeys*" (2000).

58. Young initially contacted Halprin at Cage's suggestion, having written to Cage after the Darmstadt session (Young, conversation with the author, October 30, 2000).

59. Flynt, "La Monte Young in New York, 1960–1962," 52.

60. Young in "La Monte Young," in Richard Kostelanetz, *Theater of Mixed Means* (New York: Dial Press, 1968), 194–195. Cage's antipathy to the controlling, hyperfocused nature of Young's work is also well known. In the same volume, Cage stated his preference for a more dispersed or open mode of attention: "I would like the happenings to be arranged

in such a way that I can see through the happening to something that wasn't in it. We'd be out of the La Monte Young fixation ideal. We'd be in the Duchamp-Fuller-Mies van der Rohe business of seeing through"; in "John Cage," 55–56.

61. Flynt, "La Monte Young in New York, 1960–1962," 77.

62. Young, "La Monte Young," *Theater of Mixed Means*, 204.

63. Ibid., 205.

64. Larry Miller, "Interview with George Maciunas, March 24, 1978," in *Fluxus etc./ Addenda I: The Gilbert and Lila Silverman Collection,* ed. Jon Hendricks (New York: Ink &, 1983), 21.

65. "Excerpts from a Discussion between George Brecht and Allan Kaprow entitled 'Happenings and Events' broadcast by WBAl sometime during May," *ccV TRE,* no. 3 (June 1964): 1.

66. Michael Nyman, *Experimental Music: Cage and Beyond* (New York: Schirmer Books, 1974), 62.

67. Larry Miller, "Interview with George Maciunas," 26 (my emphasis).

68. Maciunas, letter to George Brecht, c. September/October, 1962; Jean Brown Papers, Getty Research Library (890164). Maciunas discusses European production partly analogous to Brecht's: "I sent large envelope with some scores and instructions of European and Japanese compositions that you may want to use for Yam fest. Generally, there are very few Europeans doing compositions, so few I really can't think of anyone. Maybe [Robert] Filliou and . . . [Wolf] Vostell and [Daniel] Spoerri. The last 2 do not write down their happenings but improvise on the spot so I can't tell you or send their things to you. Of non Europeans best are NJ Paik, Ben Patterson, Emmett Williams, Paik again does not write down his compositions, but a few simple ones I can describe."

69. Partially reproduced in *Fluxus etc./Addenda II,* ed. Jon Hendricks (Pasadena: Baxter Art Gallery, 1983), 166–167.

70. George Maciunas, letter to George Brecht, c. fall 1962; Jean Brown Papers, Getty Research Library (890164). (Spellings as in original.)

71. "A Conversation about Something Else: An Interview with George Brecht by Ben Vautier and Marcel Alocco (1965), reprinted in Martin, *An Introduction to George Brecht's Book of the Tumbler on Fire,* 67. Of course, Brecht's cult of noninvolvement or nondifferentiation at times leads to puerile statements (and intended provocations) such as the following: "Yes. An atomic war and a butterfly are all the same. It's simply a process that surrounds everything and in everyplace and in every moment" (69); and the assertion that all aesthetic and other phenomena are simply 'Just different arrangements. . . . For example Le Corbusier builds a new building and I move the newspaper from here to there. The two things are equally new. They're arrangements. Everything that happens is simply reorganization. Everything that exists is simply a process" (70).

72. This capacity for reabsorption into the everyday appears to be structured into Brecht's work; in a note to Dick Higgins, dated January 16, 1977, he writes: "My work has been disappearing since I started to make it. First wife threw out all early drawings and paintings, ladder stolen from Bianchis, other work abandoned by Al [Hansen], etc." Dick Higgins Papers, Getty Research Library (870613).

73. See Thierry De Duve, *Pictorial Nominalism* (Cambridge: MIT Press, 1989) and *Kant after Duchamp* (Cambridge: MIT Press, 1996).

74. Benjamin Buchloh, "Ready Made, Objet Trouvé, Idée Reçue," in *Dissent: The Idea of Modern Art in Boston* (Boston: Institute of Contemporary Art, 1985). This implicit model of the performance as a kind of readymade, Buchloh has argued, suggests that early Fluxus production needs to be seen in terms of the transformation enacted in the "newly discovered readymade aesthetic"; Buchloh, "Cryptic Watts," 5.

75. "An Interview with George Brecht by Henry Martin," in Martin, *An Introduction to George Brecht's Book of the Tumbler on Fire*, 79.

76. Maciunas usually referred to the event score form as "neo-haiku" in his charts and diagrams, and Ono, in particular, may have had access to Japanese avant-garde readings of Duchamp and surrealist poetics that would relate them to enigmatic forms such as puzzles, koans, and haiku. On Ono's relation to Japanese avant-garde traditions and the Japanese reception of Duchamp, see Alexandra Munroe, "Tokyo Fluxus and Conceptual Art," in *Japanese Art: Scream Against the Sky* (New York: Harry N. Abrams, 1994).

77. "An Interview with George Brecht by Irmeline Lebeer," (1973) in Martin, *An Introduction to George Brecht's Book of the Tumbler on Fire*, 84. Brecht has often been at pains to distinguish his goals from what he perceives to be those of conceptual art: "It depends on where you put the emphasis because concept art has to do, by definition, with the conceptualizing faculty of the mind, whereas to me the events are total experiences. There's no more emphasis on conceptualizing than there is on perception or memory or thinking in general or unconscious association. There's no special emphasis, it's a global experience. I've seen conceptual art pieces that look a lot like my scores in *Water Yam*, so it's possible that these people knew of my event scores and took them as concept pieces, but from my point of view they're not. Calling them conceptual pieces would be using a very narrow view of them" ("An Interview with George Brecht by Michael Nyman" [1976], 117).

78. In "Innovational Research," Brecht cites Cassirer from *An Essay on Man* (1944): "The function of the name is always limited to emphasizing a particular aspect of a thing, and it is precisely this restriction and limitation upon which the value of the name depends. It is not the function of a name to refer exhaustively to a concrete situation, but merely to single out and dwell upon a single aspect."

79. "An Interview with George Brecht by Gislind Nabakowski" (1974), in Martin, *An Introduction to George Brecht's Book of the Tumbler on Fire*, 93.

80. Yet this structure by no means precludes one from staging performance- or object-based "realizations"—Brecht himself performed several versions of *Drip Music* in the early 1960s, which range from explicit action (pouring water from a pitcher) to simply setting up a situation (a wet rag hanging over a bucket).

81. This process of paring down is verified by notes from 1961, in which handwritten notebook drafts are edited, and blocks of more explanatory text crossed out; Dick Higgins papers, Getty Research Library (870613).

82. The published form of *Water Yam*, while modeled on Brecht's cards, was at least partly Maciunas's design; in the 1978 interview with Larry Miller, Maciunas claims that the piece was produced "well, by me, he [Brecht] just gave me the text" (18). In "George Maciunas: A Finger in Fluxus," Barbara Moore provides a detailed analysis of some of Maciunas' graphic production, noting that "Maciunas exercised almost total control in the area of graphic design" (*Artforum* 21, no. 2 [October 1982]: 38). The distinctive look and typeface of these Fluxus publications, including *Water Yam*, resulted from Maciunas's production: "For nearly eight years every body of text … was published straight and unaltered from Maciunas' IBM Executive model typewriter, which was equipped with a condensed sans

serif type" (40). Although Brecht and Maciunas shared a number of design inclinations, including an obsession for printed ephemera, printers' insignia, and odd diagrams and snippets of text, the difference in their aesthetics can be seen by comparing the Brecht-produced and edited *VTRE* broadsheet (1963) with the first Maciunas-produced *ccVTRE* no. 1 (1964), which features a more crowded, rectilinear composition, and mostly sans serif font, and largely eliminates hand-drawn or handwritten elements. Both are reproduced in *Fluxus etc.*, ed. Jon Hendricks (Bloomfield Hills, Mich.: Cranbrook Academy of Art Museum, 1981).

83. In postwar experimental music, Mallarmé's work would also provide a crucial model for new permutational and performance procedures, evident in the early texts by Pierre Boulez in the *Nouvelle Revue Française*—"Recherches maintenant" (November 1954), and "Aléa" (November 1957)—and Hans Rudolf Zeller's much-cited essay in *Die Reihe*, no. 6 (1960/62), "Mallarmé and Serialist Thought"—facilitated by the publication of Mallarmé's notes on the structure of the Book in Jacques Schérer's *Le 'Livre' de Mallarmé* (Paris: Gallimard, 1957).

84. The name "Water Yam" came from the "Yam Festival," a series of events Brecht loosely coorganized with Robert Watts in 1962–1963, culminating in May 1963; so titled "because Yam is May spelled backwards."

85. Alongside Cage's 1961 compilation *Silence*, *An Anthology* was one of the key books of the early 1960s, and Brecht's *Water Yam* scores—small, cheap, popular, and easily reproducible—were eventually among the better disseminated of the Fluxus editions, despite the enormous limits of Maciunas's commercial efforts. A Maciunas letter to Emmett Williams, dated April 2, 1964, states "At this time we have sold in New York 4 Brecht *Water Yams,* 996 still on our hands, or $600 loss, so there is a limit to my expenditures, especially when there is no workable distribution of these works," Jean Brown Papers, Getty Research Library [890164]).

86. Willoughby Sharp, "Lawrence Weiner at Amsterdam," *Avalanche* 4 (Spring 1972): 69. In the same interview, Weiner comments that "I don't care aesthetically which of the three conditions the work exists in.... It would be a fascist gesture on my part if I were to say that you can accept these things only on a verbal information level, which would be type on the page, or you can accept them only on an oral information level. It doesn't matter if it's physically conveyed or whether it's conveyed verbally or orally" (66).

87. Lucy Lippard, *Six Years: The Dematerialization of the Art Object* (New York: Praeger, 1973), 11. That this entry is immediately followed by one for Allan Kaprow's 1966 compendium *Assemblages, Environments and Happenings* suggests the extent to which the specificity of early event practices, with their proto-minimal and proto-conceptual elements, would be immediately elided into the more conventionally theatrical and expressive rubric of happenings. A similar dynamic, I think, is at play in the 1994 *October* roundtable "Conceptual Art and the Reception of Duchamp," in which the role of Cage, Brecht, and others is momentarily introduced, and then eliminated—partly through recourse to homogenizing notions of Fluxus. Buchloh's rhetorical question, "Would it be more historically accurate to say: It is not the Duchamp reception that one has to look at when one wants to study the beginnings of proto- and Conceptual art, but it is the Cage reception one would have to concentrate on?," is never addressed; in *October* 70 (Fall 1994): 138–139.

88. Vito Acconci, interview with the author, Brooklyn, October 25, 1995.

The Formalization of Indeterminacy in 1958: John Cage and Experimental Composition at the New School

Rebecca Y. Kim

John Cage's instructorship at the New School for Social Research from fall 1956 through summer 1960 constitutes a relatively minor episode in the succession of international engagements that distinguished his career in the late 1950s. The "Experimental Composition" course that Cage held for twelve consecutive terms during that time, however, reveals important and overlooked aspects about his theorization of "indeterminacy" in 1958. Indeterminacy was Cage's boldest challenge to the European musical tradition and the vehicle for a set of experimental techniques aimed at transforming the composer's musical work from fixed object to mutable process based on the self-governed interpretations of the performer. Thus when Cage introduced this new paradigm to the European avant-garde in his historic 1958 address "Composition as Process: Indeterminacy" at the Internationale Ferienkurse für Neue Musik in Darmstadt, the aftershocks were legion.[1] Luigi Nono renounced indeterminacy as the folly of composer indecision in 1959, recapitulating a similar charge made about chance by Pierre Boulez in his 1957 invective "Aléa." Cornelius Cardew, initially an exponent of indeterminacy's performer-governed processes, concluded in 1972 that the only means of achieving Cage's "'beautiful idea' of letting sounds be sounds" and "people [be] people" was through a false naiveté.[2] While Europe's tumultuous reception is central to understanding Cage's discourse as a pointed critique of European new musical practices beholden to tradition—indeed, Cage never saw reason to deliver the talk in America—reception abroad has tended to overshadow the early formulation and transmission of indeterminacy in the United States.

Cage's own shift from object to process occurred while teaching "Experimental Composition" at the New School, with his first proto-indeterminate works and first "composition indeterminate of performance" materializing between semesters: *Winter Music* (January 1957), *Concert for Piano and Orchestra* (piano score, January 1958; full score, May 1958), and *Variations I* (January 1958). Cage referred to this parallelism matter-of-factly: "I felt that I had made so many changes in music, that I had a responsibility to teach at the New School. . . . I was definitely shifting from object to process."[3] Still, he acknowledged the New School post as a unique opportunity: "I was as free as a teacher could be. I was thus able, when opportunity offered, to learn something myself from the students."[4]

I do not propose a causal connection between Cage's pedagogical and compositional activities but will instead examine the creative reciprocity between New School artists exploring the limits of composition and Cage's burgeoning concept of performer freedom. I focus on the notebook of his student, the artist George Brecht, from the summer 1958 term and an unpublished analysis that potentially informed Cage's Darmstadt lecture that September. At Darmstadt, however, Cage's exegesis of indeterminacy was more didactic than Brecht's documentation of his teachings at the New School would suggest. The incongruity points to the larger epistemological rift between the practice and theorization of indeterminacy, a rift that derived from indeterminacy's origination in America and its formal presentation in Europe, which ultimately yielded divergent transmissions on either side of the Atlantic. Though indeterminacy first emerged in 1950 with the experimental activities of Cage's New York colleagues Earle Brown, Morton Feldman, Christian Wolff, and David Tudor, it was not formally defined as such until Cage's 1958 Darmstadt lecture. A 1954 European tour had granted Cage an earlier opportunity to introduce indeterminacy abroad, especially with the principle of chance generalized from composition to performance in his *Music for Piano* series (1953–1956). The tour predated major forays into chance by Boulez and Karlheinz Stockhausen, however, thus reflecting a phase of relative concord before signs of artistic rivalry and cultural nationalism surfaced in Euro-American interchange. By 1958 Cage's response to the limited applications of chance in European composition, known as "aleatory," was to differentiate indeterminacy culturally and technically, as a specifically American practice that challenged the dialectic of composer control and performer freedom with a thorough-going use of chance applied especially to performance. Below, I present

an overview of the New School course before tracing Cage's formulation of indeterminacy in summer 1958 according to Brecht's documentation and unpublished analysis.

Experimental Composition

Cage's post at the New School represents a major starting point in the reception history of indeterminacy in the United States, especially for a generation of artists who attended "Experimental Composition" for one or more terms. The course established Cage as the figurehead of such 1960s artistic movements as happenings, events, Judson Dance Theater, the international Fluxus movement, and intermedia.[5] Cage first offered the course as "Composition: Experimental Music" in the Department of Music of the New School for Social Research during the fall 1956 semester, but by summer 1958 he had renamed it "Experimental Composition," excising music from the title and reinforcing the course's focus on works that transcended the music designation. The course description was as follows:

> A course in musical composition with technical, musicological, and philosophical aspects, open to those with or without previous training.
>
> Whereas conventional theories of harmony, counterpoint and musical form are based on the pitch or frequency component of sound, this course offers problems and solutions in the field of composition based on other components of sound: duration, timbre, amplitude and morphology; the course also encourages inventiveness.
>
> A full exposition of the contemporary musical scene in the light of the work of Anton Webern, and present developments in music for magnetic tape (musique concrète; elektronische Musik).[6]

The class met weekly in fifteen afternoon sessions lasting one hour and forty minutes, with attendance varying between three to twelve students per semester; during summers, meetings occurred twice weekly across seven weeks in evening sessions of one hour and fifty minutes.[7] Cage structured the course as a workshop to accommodate a range of students with negligible to moderate musical training, thus following a less technical direction than that prescribed above. When the course was offered a second time in spring 1957, Cage divided participants hierarchically into beginning and advanced levels, as listed in table 1. The

Table 1 Courses taught by John Cage, New School for Social Research, 1956–1960[a]

Course Number and Title	Meetings
Fall 1956 (Mon., Sept. 24, 1956–Fri., Jan. 18, 1957)	
#1031 "Composition: Experimental Music"	T 4:20–6:00 PM
Spring 1957 (Mon., Feb. 4–Fri., May 24, 1957)	
#1032 "Composition: Experimental Music" (Beginning)	T 2:00–3:40 PM
#1034 "Composition: Experimental Music" (Advanced)	T 4:20–6:00 PM
Summer 1957 (Mon., June 17–Thurs., Aug. 1, 1957)	
#242 "Virgil Thomson: The Evolution of a Composer"	T/R 8:20–10:10 PM
#244 "Composition: Experimental Music"	T/R 6:00–7:50 PM
Fall 1957 (Mon., Sept. 30, 1957–Wed., Jan. 29, 1958)	
#1181 "Erik Satie: The Evolution of a Composer"	T 2:20–4:00 PM
#1213 "Composition: Experimental Music"	T 4:20–6:00 PM
Spring 1958[b] (Mon., Feb. 10–Wed., May 28, 1958)	
#1214 "Composition: Experimental Music"	T 4:20–6:00 PM
Summer 1958 (Mon., June 23–Thurs., Aug. 7, 1958)	
#321 "Experimental Composition"	T/R 6:00–7:50 PM
Fall 1958[c] (Th., Sept. 25, 1958–Wed., Jan. 28, 1959)	
#1097 "Advanced Composition"	T 4:20–6:00 PM
(with Henry Cowell and Frank Wigglesworth) (cancelled)	
#1101 "Experimental Composition"	T 6:20–8:00 PM
Spring 1959[d] (Mon., Feb. 9–Tues., Fri., Jun. 5, 1959)	
#1100 "Advanced Composition"	T 6:20-8:00 PM
(with Henry Cowell and Frank Wigglesworth) (cancelled)	
#1102 "Experimental Composition"	T 4:20-6:00 PM
Summer 1959[e] (Mon., Jun. 22–Thurs., Aug. 6, 1959)	
#345 "Experimental Composition"	M/W 6:00–7:50 PM
#353 "Mushroom Identification"	Sun. 10:00 AM–5:00 PM
Fall 1959 (Wed., Sept. 23, 1959–Sat., Jan. 23, 1960)	
#1189 "Experimental Composition"	T 4:20–6:00 PM
#1289 "Mushroom Identification" (with Guy Nearing)	Sun. 10 AM–5:00 PM

Table 1 (continued)

Course Number and Title	Meetings
Spring 1960 (Mon., Feb. 1–Sat., May 20, 1960)	
#1192 "Experimental Composition"	T 4:20–6:00 PM
Summer 1960[f] (Mon., Jun. 20–Thurs., Aug. 4, 1960)	
#337 "Experimental Composition" (cancelled)	T/R 6:00–7:50 PM
#349 "Mushroom Identification" (with Guy Nearing)	Sun. 10:00AM–5:00 PM

Notes:

a. The New School's Raymond Fogelman Library holds limited documentation of Cage's courses from the Dean's Office and correspondence with Vice President Clara W. Mayer. The following *New School Bulletins* were consulted for table 1: vol. 14, no. 1 (Fall 1956), vol. 14, no. 18 (Spring 1957), vol. 14, no. 32 (Summer 1957), vol. 15, no. 1 (Fall 1957), vol. 15, no. 19 (Spring 1958), vol. 15, no. 32 (Summer 1958), vol. 16, no. 1 (Fall 1958), vol. 16, no. 19 (Spring 1959), vol. 16, no. 33 (Summer 1959), vol. 17, no. 1 (Fall 1959), vol. 17, no. 18 (Spring 1960), and vol. 17, no. 31 (Summer 1960). Cage first appeared in the *Bulletin* as an invited guest for the October 23 meeting of the fall 1955 special course, "Greenwich Village Series"; *New School Bulletin* 13, no. 1 (Fall 1955): 54.

b. Postponed from February 11 to 18 due to a concert at North Carolina College. Unpublished document, Dean's Office, January 30, 1958, Raymond Fogelman Library, New School University.

c. For the fall 1958 term, Cage arranged for Feldman and Maxfield to teach "Experimental Composition"; memo dated September 25, 1958, Raymond Fogelman Library, New School University. Cage cancelled "Advanced Composition" on October 1 due to his European concert tour, and informed Mayer of his Milan residency in a letter from Copenhagen dated November 1.

d. On the cancellation of "Advanced Composition," see unpublished document, February 17, 1959, Raymond Fogelman Library, New School University. "Experimental Composition" was delayed to February 17 since Cage had not returned from Europe; Maxfield substituted, as specified in a document from February 16, 1959.

e. Bruce Altshuler indicates that Cage and Guy Nearing first gave "Mushroom Identification" in summer 1958 on Sundays, but there is no record of this in *New School Bulletin* 15, no. 32 (Summer 1958); see Altshuler, "The Cage Class" in *FluxAttitudes*, ed. Cornelia Lauf and Susan Hapgood (Gent, Belgium: Imschoot Uitgevers, 1991), 22. Recollections by former students suggest that Cage may have offered the course informally that summer, though officially it was first offered in summer 1959; *New School Bulletin* 16, no. 33 (Summer 1959): 33. After Cage's departure, Nearing gave the course, occasionally with Lois Long.

f. A memo dated June 27, 1960 noted Cage's cancellation of #337. The mushroom course may have been held since Cage ordered pamphlets from the U.S. Department of Agriculture, "Some Common Mushrooms and How to Know Them." Unpublished documents, June 6, 14–15, 1960, Raymond Fogelman Library, New School University.

advanced section was implemented for only a semester, however, and though a separate course was offered as "Advanced Composition" in fall 1958 and spring 1959, both were canceled due to Cage's European tour and residency at the Studio di Fonologia in Milan (where he completed *Fontana Mix* and *Aria*) between November 1958 and March 1959, during which time Richard Maxfield substituted as instructor for "Experimental Composition."

No official records of enrollment survive for these courses. Various accounts indicate, however, that the following participants attended "Experimental Composition" in summer 1958, several of whom were affiliated with the visual arts community at Rutgers University in New Brunswick, where part of the Yam Festival and other intermedia experiments vital to the 1962 formation of Fluxus were staged: composer Stephen Addiss (b. 1935), artist George Brecht (1926–2008), artist Al Hansen (1927–1995), artist, poet, and composer Dick Higgins (1938–1998), photographer Scott Hyde (b. 1926), artist Allan Kaprow (1927–2006), poet Jackson Mac Low (1922–2004), and actress Florence Tarlow (1922–1992); visitors included artist Jim Dine (b. 1935), filmmakers Al Kouzel (1923–1990) and Harvey Y. Gross, sculptor George Segal (1924–2000), and artist Larry Poons (b. 1937).[8] The summer 1958 term saw an unprecedented enrollment of artists, and while word of Cage's course spread through Brecht and Kaprow, two events brought Cage into closer contact with the art world by the summer 1958 term: a lecture at Rutgers in March and the first retrospective concert-exhibit of his music in New York in May.

Prelude

On March 11, 1958, Cage presented a lecture entitled "Communication" to art students and faculty at Rutgers University, a talk he chose to reprise in modified form at Darmstadt in September. The subject derived from the theme of an art department lecture series, "Modern Forms of Communication," for which Kaprow, who was on faculty and had petitioned with colleague Robert Watts to invite Cage, would present a final lecture-event on April 22 that he later cited as his first public happening, modeled after Cage's 1952 multimedia event at Black Mountain College.[9] Cage delivered "Communication" as an assemblage of questions and quotations ordered by chance operations, with David Tudor simultaneously performing at the piano. If Cage's inversion of the conventional lecture

format appeared to undermine the theme of the series, it conveyed his musical convictions to accurate and maddening effect. Having concluded by the late 1940s that communication was a flawed aim of music, Cage's rhetorical stratagem for the lecture reflected his belief in raising questions rather than making statements—an approach that also raised the ire of his Rutgers audience. When Cage gave the talk at Darmstadt six months later, it elicited greater unease due to the accusatory form of his questions and the added theatric of lighting upwards of nineteen cigarettes.[10] The following excerpt comes from the original version that Cage delivered at the Voorhees Chapel on the Douglass College campus of Rutgers:

> Here's a little information you may find useful about the European Avant-Garde, the European Musical Avant-Garde: In France, it's Pierre Boulez. In Italy, Luciano Berio, Maderna and Nono. In Belgium, Henri Pousseur. Sweden, Bo Nilsson and Bengt Hambraeus. Germany, Karlheinz Stockhausen. You can read about it in magazines: *La Domaine Musicale, Incontri Musicali, Die Reihe, The Score*. Here, in America, there's nothing to read.
>
> Is there really going to be a discussion with students from 12 to 12:30?
>
> Are about 8 of us really going to lunch with your Dean and Faculty?
>
> That lunch, what will it be?
>
> Vegetarian?
>
> Have they dropped meat?
>
> We wouldn't like it, would we, if they had dropped meat?
>
> Will there be anything to drink?
>
> Of course, it's the middle of the day, isn't it?
>
> But, to repeat, will there be anything to drink?[11]

As an orator, Cage said what he had to say in a manner that effectively conveyed it. Thus, although he described European musical life as abundantly rich, with no shortage of avant-garde composers and discourse, the real message resided in the comparatively closed, declarative statements that communicated these conditions. In contrast, he cast American musical life as mundane, lacking in any nationally recognized avant-garde figurehead, and artistically thirsty with "nothing to read," but articulated these conditions in the open form of questions. In Cage's rhetoric, raising questions was the preferred mode of experimental

inquiry, and an indicator that avant-garde musical life in America held more promise.[12] Kaprow, Watts, and Brecht echoed this view explicitly in their joint grant proposal, "Project in Multiple Dimensions," finalized in summer 1958 while Kaprow and Brecht attended Cage's course: "Rutgers University, by virtue of its remarkable location in respect to New York City, and particularly because it has no traditions in art which could encumber any new ideas, is in a remarkable position . . . [to] become one of the most exciting places in the world of art."[13]

Like the "Communication" lecture, Cage's Town Hall retrospective concert on May 15, 1958, was organized by artists, in this case Robert Rauschenberg, Jasper Johns, and filmmaker Emile de Antonio, who also arranged a lead-in exhibit of Cage's scores at the Stable Gallery from May 5 to 15.[14] The concert drew from Cage's varied oeuvre of percussion, prepared piano, electronics, and vocal music, and featured the premiere of his magnum opus in graphic notation *Concert for Piano and Orchestra*. Kaprow and Brecht attended the concert, as did Dick Higgins, for whom the event was an important awakening as a sophomore English major planning to study composition in the fall with Henry Cowell at Columbia University: "It awoke me to the complexities, implications and variety of Cage's achievement. I felt I *had* to study with Cage too." Elsewhere Higgins elaborated: "I came to take Cage's course because I couldn't think what else to do. What I got from it was a sense of general activity and a taste for my own direction, to which previously my own skepticism had been very unkind."[15] Stephen Addiss was similarly studying music both uptown and downtown: "it made an interesting combination; Mannes [College of Music] offered Schenker analysis, while Cage offered a world of freedom and invention!"[16] If the Rutgers lecture highlighted Cage as a theatrical raconteur, then the Stable and Town Hall retrospectives featured a visionary composer-artist claiming that music composition was "a way of waking up to the very life we're living," as outlined in the 1957 essay "Experimental Music," printed in the concert program along with "The Future of Music: Credo" (1940). No one was talking about composition in these terms, and Cage's broad vision, combined with the breadth of works featured at Rutgers, Stable, and Town Hall, were important preludes to "awakening" the creative interests of artists that summer.

The uncomplicated emphasis on creative activity of whatever kind is perhaps the most enduring legacy of Cage's "Experimental Composition" course. It is sometimes forgotten that after the summer 1958 term

Cage was absent from New York for nearly seven months, through mid-March 1959, due to his Milan residency and extended European tour. During that time, there was an efflorescence of activity among a cadre of former students, demonstrating that the course was more a creative catalyst than an instructional vehicle intended to proselytize students with Cage's views. This distinction is sometimes made, however, at the expense of oversimplifying Cage's method of instruction as nondoctrinaire. Cage stated in 1987: "The principle of my teaching was not to teach—not to teach a body of information, but to lead the students, to tell them who I was in terms of what we were studying, which was composition—then, the rest of the time would be spent with what they were doing—so there was a conversation."[17] Furthering this point, Cage stated in 1990, "I told them that if they weren't at experimental points, I would try to prod them to where they would be. That was my general plan of action, and I learned a great deal."[18] Though Cage expressly avoided lecturing to students, weekly critiques of student work invariably led to discussions about what constituted "experimental" composition, which surely did not exclude instances from his own works. Any creative reciprocity was also in line with the school's philosophy: "Teaching at the New School is intended to be exploratory, not authoritarian, its methods to be inquiry, not judgment. It is a common enterprise of student and professor and therefore depends to a large extent on self-discipline and mutual education."[19] "Mutual" learning best describes the dynamic exchange between Cage and New School students. Cage learned from course members, and they learned from Cage, who neither refrained from presenting his own compositional views, which challenged historical assumptions about the organization of sound, nor from giving composition assignments that directly referenced his works, as Brecht's notes reveal.

Summer 1958

Framed by the concert-exhibit in May and his Darmstadt debut in September, the summer 1958 term spanned a unique time of retrospection and anticipation for Cage. Recollections by former students offer accounts about the content of "Experimental Composition," but Brecht's notebooks provide the most detailed documentation, beginning with the summer 1958 term, when he first enrolled in the course.[20] A general structural pattern can be discerned between concepts that Cage presented in meetings and composition assignments undertaken by Brecht. At the

first session, Cage outlined five traditional parameters or "dimensions" of sound: frequency, duration, amplitude, overtone structure (timbre), and morphology (attack, body, decay).[21] Having proposed in the course description to explore sound beyond the conventional prioritization of frequency, Cage enumerated these parameters nonhierarchically and compared their "classical treatment" with the recent "trend toward continuity." For instance, whereas frequency was classically treated as a discrete series of twelve "definite tones," recent developments in microtonal tuning and electronic sound production supplanted this model with a "frequency *field*" in which a potentially infinite number of tones were available. Cage similarly explained amplitude as an indivisible field but noted that new-music composers such as Bo Nilsson continued to use a limited, graduated series—even if divided into twenty dynamic levels, as in *Quantitäten* (1958).

From day one, Cage outlined a compositional approach rich with possibilities but underexplored by the European avant-garde. A sound *field* challenged the traditional conception of parameters in dialectically opposed relationships of high-low, long-short, loud-soft, bright-dark, or staccato-legato, for example. Dialecticism was the general subject of critique in "Composition as Process: Indeterminacy," but at the New School Cage alluded to this European worldview in broad strokes for the purpose of establishing the course's *nondualistic*, empirical approach. Brecht noted, "At one time Cage conceived of a sound-silence opposition, but after the anechoic chamber experience ([high] note nervous system noise, low note blood circulating) concluded silence was non-existent. . . . 'Events in sound-space.'"[22] After this first meeting, Brecht sketched a work organized in three durational sections, for three instruments (cellophane, voice, mallet) to be played by three performers with precisely determined timings, durations, amplitude range, and vocal text (letters of the alphabet). He omitted frequency specifications, ostensibly in observance of Cage's lecture, and in the piece's third section explored performance variability, the sound-silence equivalency, and coin-tossing—the latter a method that Brecht had documented in his 1957 monograph *Chance-Imagery*, alluding to Cage's use of the *I Ching* oracle: "Performer fills alternate intervals [of time] with sound, choosing amplitude at will. Toss coin to determine whether sound or silence starts."[23]

Brecht's sketches after the second meeting on June 26 also corresponded to Cage's class lecture, the topic of which was durational structure. Alongside a diagram for a 3-by-5 grid, Brecht indicated that each

unit signified 20 seconds: "floor blocks; throw chips on blocks; color for performer; # for duration." He developed the idea in sketches over the next week, calling it *Confetti Music*, in which performers executed sounds according to items scattered on a gridded floor.[24] The grid was flanked on all sides by one to three performers, each assigned to read a color from the scattered "tags" that represented timbre and frequency. For instance, blue corresponded to a gong, and light blue to a higher gong frequency. While *Confetti Music* invoked Arp's *Collage with Squares Arranged According to the Laws of Chance* (1916–1917) and Duchamp's *3 Standard Stoppages* (1913–1914), the Dada precedent from art was historically remote compared to the immediate example of Cage's oeuvre, which encompassed aspects of performance in addition to composition; and though critics conveniently linked Cage with the historical avant-garde, as neo-Dada, his *field* conception of sound was conceptually more in tune, for instance, with the allover paintings of contemporaries like Jackson Pollock, a correspondence that Julia Robinson has rightfully reframed in evaluating the appeal of Cage's concepts to Brecht and other artists at the New School.[25] *Confetti Music* might therefore be seen in historical relationship to works such as Cage's *Music for Piano* (1953–1956), which derived sound events from the given imperfections of paper, as well as *Variations I*, Cage's first "composition indeterminate of performance," premiered in March 1958, which required the performer to superimpose transparency squares marked by points and lines to make parametric readings toward a performance score—a precursor to the portable "kit-type" 1960s event scores by Brecht and others, which Liz Kotz has richly documented.[26] Reciprocally, in light of works such as *Confetti Music*, it is noteworthy that Cage composed *Aria* (November-December 1958) using colors as notation for the first time, which were subject to performer-designated vocal styles.

Subsequent meetings followed this general pattern of instruction in which Cage's compositional idea for a work served as the basis for a course assignment. Higgins recalled that "Cage also showed how he had solved some problems himself. . . . The [student] piece would be played, and then its philosophy would be discussed. The technique of the piece was seldom mentioned, except that inconsistencies and incongruities would be noted."[27] Brecht corroborated this pattern: "At the end of each meeting—after discussing the subject—Cage would give a theme, for example a composition for five portable radios and the following week you'd come back with five radios and six different proposals. Afterwards

we'd play them and everybody would discuss them—it was real democracy (a little chaotic!) and constant change."[28] Indeed, Brecht's first entry for the summer 1959 term outlined this very assignment and cited Cage's work for 12 radios *Imaginary Landscape No. 4* (1951) as the discussion example.[29] Conversely, Cage at times assumed the role of performer, as when Al Hansen created *Alice Denham in 48 Seconds* for an assignment using an array of number durations and Cage realized the work with a toy machine gun.[30] Conceptually, therefore, Cage's pattern of instruction demonstrated the manifold possibilities intrinsic to any compositional idea—a chief premise of indeterminacy. Each assignment substantiated the idea of variability through the numerous compositional strategies devised by students. Yet, while variability and "experimental composition" were discussed regularly, notes by Brecht from the last session show that Cage introduced indeterminacy as a new concept.

The August 7 Meeting

Brecht's entry for the final scheduled summer meeting on Thursday, August 7 consists of five and a half pages of notes analyzing Brown's *4 Systems* (1954) and Stockhausen's *Klavierstück XI* (1956), works that Cage would critique at Darmstadt on September 8.[31] The notebook editors Dieter Daniels and Hermann Braun indicate that Brown substituted for Cage on August 7 and that Brecht's copious notes from that day were not dictations from the lecture but rather intended for an article never published, presumably scripted after the final class.[32] While these suppositions are evidenced by the overall arrangement of the notes and corrections made to the prose, upon closer inspection the resemblance of Brecht's analysis to Cage's "Composition as Process: Indeterminacy" suggests a more specific purpose.

The entry begins with a schematic description of *4 Systems*, alongside which Brecht's marginalia reads, "Music for Changes, Stockhausen No. 11 (on card), Boulez, Cage at Conn. until the 18th." This first half page suggests that students were given a final assignment to compare Brown's *4 Systems* with one of the above three approaches. It is questionable whether Brown was a substitute that day, as conjectured by Daniels and Braun, since Brecht's analysis reveals limited knowledge of Brown's score: "If the Brown piece retains the internal relation between the parts within each of the four systems (and I'm not familiar with the score, so can't know whether this is the case)."[33] Cage may have been present

4 SYSTEMS

for David Tudor on a birthday
Jan. 20, 1954

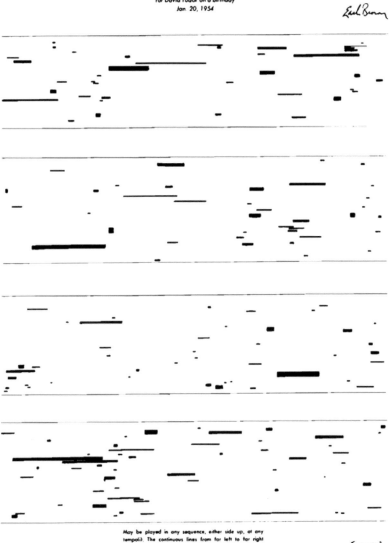

Figure 7.1 Earle Brown, *4 Systems*, 1954.

instead of Brown to administer the assignment just before heading to rehearsals at the American Dance Festival in Connecticut, held between August 14 and 17.

Brecht outlined a general description of *4 Systems*, but its language suggests that Cage dictated this information: "Each card played by each of several performers. Since cards are played top, bottom, or either side up, top to bottom for player A is an inversion of bottom to top for player B. Interpretation of each card in terms of sound is left to each performer."[34] "Inversion" is the operative word here, for Cage would fault Brown in his Darmstadt lecture for allowing an otherwise indeterminate situation to be read alternately according to a determinate relationship: "But with the further permission—that of reading the cardboard right side up, upside down, sideways, up and down—the drawing became that of two different situations or groups of situations and their inversions. Inversions are the hallmark of the conscious mind. . . . What might have been non-dualistic becomes dualistic. . . . [Brown] does not agree with the view here ex-pressed."[35] In other words, had Brown substituted for Cage on August 7, why would he have explicated his own work according to criteria with which he disagreed? At another point in the analysis, Brecht directly ad-dressed Cage when discussing a notational strategy in *4 Systems*: "This is analogous somewhat to your page no. 59 (Stable exhibition)."[36]

While Brecht may have planned to develop these notes into an ar-ticle for publication, its original purpose appears to have been directly related to the course; and though Brown may have been present to talk generally about *4 Systems*, I believe that Brecht initially scripted these pages in connection with a final assignment conceived and administered *by* Cage. This point is significant because the three citations abbreviated in Brecht's marginalia—Cage's *Music of Changes* (1951), Stockhausen's *Klavierstück XI*, and, presuming from the shorthand, Boulez's *Troisième Sonate pour Piano* (1956–1957)—were the same works that Cage was scheduled to discuss at Darmstadt in three lecture-recitals with Tudor entitled "Neue Klaviermusik in den USA und Europa." Moreover, Cage and Tudor planned to perform a piano duo realization of Brown's *4 Sys-tems* in a separate *Kammerkonzert*—hence the hypothetical references in Brecht's notes to "player A" and "player B" for a score that other-wise allows for "any instrument, group of instruments, or other sound-producing media."[37] Therefore, like the pattern of instruction exhibited in prior course meetings at the New School, the final August 7 assignment

reflected Cage's compositional concerns, which at the time involved the theorization of indeterminacy.

An additional development around this time was Boulez's cancellation as *Dozent* or lecturer for the Darmstadt "Special Courses" in order to complete his electroacoustic Donaueschingen commission *Poésie pour pouvoir* for its October 19 premiere. Stockhausen and Bruno Maderna recommended that Darmstadt director Wolfgang Steinecke ask Cage to take over half of Boulez's ten composition seminars scheduled between September 2 and 13.[38] Prior to Boulez's withdrawal around early August, Cage's initial role at Darmstadt had been largely defined in association with Tudor, to whom Steinecke had extended the original invitation for five piano seminars in late 1957. After learning in February 1958 that Cage would also travel to Europe with Tudor, Steinecke arranged for the aforementioned "Neue Klaviermusik" lecture-recitals and *Kammerkonzert*, all for the general program.[39] Steinecke furthermore suggested that Cage discuss issues of form as well as *Music of Changes*, a work somewhat outdated in his oeuvre but central to dominant European notions of Cage at the time, which ranged from dismissive to more serious curiosity, as Amy Beal and Christopher Shultis have noted.[40] Following Boulez's cancellation less than a month before the *Ferienkurse*, Cage replaced the three "Neue Klaviermusik" lecture-recitals with the tripartite lecture "Composition as Process: Changes, Indeterminacy, Communication," each of which presented music simultaneously with texts translated days beforehand.[41] Cage fulfilled Steinecke's request by having Tudor perform excerpts from *Music of Changes* for the opening lecture (September 6), but the title "Changes" more accurately conveyed developments in his technique. The "Indeterminacy" lecture (September 8) was paired with three versions each of Stockhausen's *Klavierstück XI* and Cage's *Variations I*, and "Communication" (September 9) with Nilsson's *Quantitäten* and Wolff's *For Prepared Piano*.[42] Boulez's *Troisième Sonate* was omitted entirely from analysis and performance, not necessarily because of his absence from Darmstadt, but apparently due to the poor quality of the photostat score that Tudor had received from Universal Edition in mid-August, which had been "unreadable."[43]

A principal question is whether Cage knew of his imminent substitution for Boulez by August 7, and if so whether there is any correlation between Brecht's analysis at the New School on August 7 and Cage's presentation at Darmstadt on September 8. Since a critique of Brown's

4 Systems had not necessarily been part of Cage's original lecture plan, and because some of Brecht's observations exhibit striking similarities to the "Indeterminacy" lecture, one might infer that Cage borrowed from Brecht to complete his Darmstadt analysis in time. Shultis indicates that Steinecke's revised Darmstadt invitation to Cage was dated August 8, a day after the final New School meeting, and that Cage sent his affirmative reply on August 15, leaving less than three weeks to prepare the new lectures.[44] It is likely that Cage knew of his substitution for Boulez some days before the August 8 letter, however, since he and Tudor were in regular contact with European colleagues to finalize concert engagements abroad. This foreknowledge may also explain why Cage assigned a final written analysis for the course, which had practical relevance to his preparations for Darmstadt but which departed from his typically compositional assignments at the New School. Another possibility, which I believe was the case, is that Cage had singled out Brecht to undertake an analysis that would assist his Darmstadt lecture. Brecht was seen as one of Cage's most likeminded students, whose works readily assimilated course ideas.[45] In fact, after the summer 1958 term, Cage recommended that German sound artist-musicologist Hans G. Helms ask Brecht to write an article on the differences between European and American new music— perhaps the basis for why Daniels and Braun believe that Brecht's New School notes were originally intended for publication.[46]

Several points of comparison emerge between Brecht's notes and Cage's lecture, but these similarities are offset by contrasting analytical justifications. Brecht similarly cited "inversion" as a problematic "structural correlation" in *4 Systems* but did so in less critical terms than Cage's aforementioned interpretation: "This seems somewhat as though one made chance choices of one's serial manipulations in traditional 12-tone composing."[47] Cage viewed inversion as a stronghold of tradition, but Brecht substantiated his point mathematically by explaining that the rotation of the page was "analogous to the rotation of axes in analytic geometry" and thus the "coordinates" or "sound-events" in the score remained essentially fixed, hence "just another way of expressing the correlation of structure between performers (inversions, retrogressions, etc.)."[48]

Another common point was the citation of Bach's *The Art of Fugue* as a historical reference for indeterminacy based on the work's variable timbre and amplitude. Brecht extended the association further than Cage was inclined to do, however, by comparing Bach's "abstract" score with other musical forms amenable to performer interpretation:

"the harmonic structure of *Cherokee* in its 10th variation by Charlie Parker ... real blues, inspired folk music, etc."[49] While examples from the national vernacular would have aided Cage's case for indeterminacy as a specifically American, performer-governed process, he was loath to compare improvisation with indeterminacy, especially as practiced in the jazz tradition, because of its sonic signification of history, memory, and individual taste—a qualification that aligns indeterminacy's American reception with the racial politics of experimentalism, as George Lewis has shown.[50]

Moreover, while both Cage and Brecht presented indeterminacy as a new term, Brecht went further in researching its etymology. Cage mentioned "precision" and "imprecision" on July 17, though not in relation to determinacy and indeterminacy. Brecht, however, attempted to apprehend the limits of the latter terms according to dictionaries that cited "indeterminacy" as synonymous with "ambiguity," asking rhetorically in his analysis, "I wonder if they really are." He showed that "ambiguity" was derived from "*ambigire*, to waver, be taken in more than one way" and "indeterminate" from "*determinare*, to limit" and attempted to locate a boundary: "*How* limited to be determinate?"[51] Cage was less concerned with semantic distinctions than with indeterminacy's scientific provenance, which resonated ideologically with Darmstadt new musical research. Moreover, Cage had already appropriated the terminology from Wolff's "New and Electronic Music" (1957–1958), a comparative essay on Euro-American practices that ascribed "greater freedom and intransigence" to American new music while characterizing European new music as "thoroughly self-conscious about music history" and believing in a "right way" of composing.[52] Cage ultimately used Wolff's essay as an armature for drafting his lectures in time for Darmstadt ("Communication" directly quoted from Wolff's essay at length), and he borrowed as well from Brecht, who had purposefully researched the semantics of indeterminacy and made observations similar to those by Cage, albeit justified in less ideological terms.

Indeed, Brecht's impartiality suggests that the cross-cultural polemics of new music was not a topic belabored by Cage at the New School and that the summer course was only minimally a rehearsal for his presentation at Darmstadt. This also puts into context the bemusement of participants in summer 1958 when Cage read aloud excerpts from Wolff's "New and Electronic Music" and from a 1952 statement by Feldman, Wolff, Cage, and Boulez, "Four Musicians at Work." Higgins noted the

glaring disjuncture between Cage's concrete mode of inquiry in class and the elevated rhetoric of his theoretical writings: "Some of us, particularly Hansen and myself, couldn't for the life of us imagine why Cage was interested in those things. They seemed so abstract, compared with the very concrete observations that Cage favored in connection with the pieces played in class, and so terribly old-fashioned in their implications. Mostly, they read like legal contracts."[53] Abstract legalese often comes with the territory of musical description and speaking concretely about abstract phenomena, but even American music critic Everett Helm likened the otherly discourse of Darmstadt in 1958 to "a musical trip to the planet Mars."[54]

The difference between New School culture and Darmstadt culture affected the rhetoric, evaluative criteria, and conclusions of Brecht and Cage, and how they structured their analyses. Brecht's comparative analysis of *4 Systems* and *Klavierstück XI* yielded observations relative to each work, and his overall discussion aimed to answer a specific question that he posed twice verbatim: "At any rate, as far as our interest in chance is concerned, perhaps a question to be asked is: To what extent is the sound produced (as the result of the performance of the piece) due to chance?"[55] In Cage's parlance, this was really a question of indeterminacy since it pertained to chance in performance, not solely composition, and because Brecht calibrated this inquiry with an evaluative scale, his analysis did not produce hard and fast conclusions. Brecht surmised that Stockhausen's *Klavierstück XI*, which gave fixed frequencies and durations with limited options for tempo, amplitude, attack, and form (the performer begins with any of 19 phrases based on the eye's whim), established a "notational pre-structure" more open to the "contextual situation" of performance than Brown's *4 Systems*, which left frequency, duration, tempo, amplitude, and attack subject to performer interpretation but confined to an overall "pre-structure." Like Cage, Brecht found indeterminacy less effective overall in Brown's work but again postured his appraisal according to the *degree* or "extent" to which chance played a role—what he called a "scale of situation participation: [situation] non-participation"—thus relating European and American works on one continuum.[56]

In contrast, Cage's analysis surveyed seven works in mutually exclusive succession, each subject to more or less absolute criteria. Cage did not directly compare *4 Systems* with *Klavierstück XI* but concluded that neither was *effectively* indeterminate because both yielded objects rather than processes due to traditional methods of organization. He cited the

flawed prioritization of frequency in Stockhausen's work: "due to the presence in the *Klavierstück XI* of the two most essentially conventional aspects of European music—that is to say, the twelve tones of the octave ... and regularity of beat ... [a performer] will be led to give the form aspects essentially conventional to European music. These instances will predominate over those which are unknowing ... the use of indeterminacy is in this sense unnecessary since it is ineffective."[57] Cage gave similarly swift parametric appraisals of the other six works, demonstrating that indeterminacy was not the facile result of one or two loosely specified elements and arrived at an absolute claim about the success of each as a composition indeterminate of performance. Moreover, though he organized his discussion according to pairs of works—Bach's *The Art of Fugue* and Stockhausen's *Klavierstück XI*; his *Music of Changes* and Feldman's *Intersection 3*; Brown's *Indices* and Brown's *4 Systems*; and Wolff's *Duo for Pianists II* on its own—he refrained from making cross-cultural pairings or any cross-references between works; thus the only European examples, Bach and Stockhausen, were sectioned together. It is ironic that a cultural discussion is largely absent from Brecht's analysis, which directly compared *4 Systems* and *Klavierstück XI*, while Cage made cultural distinctions correlative with the authenticity and "effectiveness" of indeterminacy without any cross-cultural analysis. Cage's rhetorical message was clear—he saw no grounds for even comparing European aleatory with American indeterminacy.

To clarify the unprecedented freedoms of American indeterminacy once and for all, Cage employed metaphors that would have unnerved the postwar European psyche. To temper their severity, however, he applied these metaphors to the American works only, as in his self-critique of *Music of Changes*:

> The fact that these things that constitute it, though only sounds, have come together to control a human being, the performer, gives the work the alarming aspect of a Frankenstein monster. The situation is of course characteristic of Western music, the masterpieces of which are its most frightening examples, which when concerned with humane communication only move over from Frankenstein to Dictator [*Diktator*].[58]

Cage reinvoked the *Diktator* metaphor when discussing Brown's *Indices*, which applied chance to composition but not to performance, leaving musicians to assume their traditional status under a conductor's lead. Cage

politicized the division of labor by comparing the conductor-performer relation to that of master-servant. The situation "under the control of man" was more striking in the German translation, in which *Knechtschaft* was used to express "subservience":

> From that point of view from which each thing and each being is seen as moving out from its own center, this situation of the sub-servience of several to the directives of one who is himself con-trolled, not by another but by the work of another [the composer], is intolerable.[59]

Knechtschaft was closely associated with the "master-slave" or "lordship-bondage" dialectic [*Herrschaft-Knechtschaft*] outlined famously in Hegel's *Phenomenology of Mind* (1807) as a means of achieving self-awareness.[60] While the passage compared total musical control to oppressive social systems, Cage endeavored to explode the control-freedom binary as-sociated with the old power relationships of composer-performer and conductor-performer in order to move beyond dialectics. In its place, he asserted that the dispersal of performers in a spatial field better pro-moted the self-monitoring and self-governance necessary for individual self-awareness—akin to the emancipatory idea of "waking up to the very life we're living" that Cage believed to be the purpose of writing music.

Indeterminacy appeared suddenly and pervasively in Cage's lexicon begin-ning in 1958 based on Euro-American new musical debates about compositional control and performer freedom. While the terminology postdated the preponderance of "indeterminate" works by Cage and his New York colleagues from the early 1950s, it was updated by a radical change in the look of Cage's scores in 1958, characterized by transparent sheets sparely notated with points, lines, biomorphic shapes, and letters.[61] The artists of the New School course undoubtedly affected how Cage thought about the visual presentation of his indeterminate works. Their experiments in sound also contributed to Cage's revived interest in every-day sound objects, such as bird whistles, ice cubes, and toy cats, especially in the works composed and performed in Europe after his Darmstadt appearance—*Music Walk* (September 1958), *Water Walk* (January 1959), and *Sounds of Venice* (January 1959)—recalling his earlier work premiered at the New School in 1952, *Water Music*.[62] While participants in Cage's course utilized the instruments from Cowell's world music course (stored

in the same classroom) to perform compositions in class, they more typically found or invented their own sound-makers. Merce Cunningham recalled Cage once speaking about his aims at the New School: "I'm trying to get them to see that there are possibilities for sound in almost anything that makes sound."[63] This idea had been fundamental to Cage since his 1930s percussion experiments, but the circumstances of 1958 brought to it renewed meaning as Cage's teachings on experimental composition intersected with his efforts to distinguish American new musical practices from those of Europe. *Music Walk*, *Water Walk*, and *Sounds of Venice* were composed and premiered in Europe toward that aim. Coming full circle, upon Cage's return to New York, several New School students who had formed the "Audio-Visual Group" gave a concert of works by Wolff, Cage, Higgins, and Hansen, with guest pianist David Tudor, on April 7, 1959, that reinforced the association of Cage's experiments with the New School reception of indeterminacy-cum-theater.[64]

The relationship of Cage and New School artists alternately diverged and converged after summer 1958, but the unequivocal impact of the course has been an acknowledged constant. Why is this so? In his 1965 postscript to *Chance-Imagery*, Brecht surmised, "In 1957, when this article was written, I had only recently met John Cage and had not yet seen clearly that the most important implications of chance lay in his work rather than in Pollock's. Nor could I have foreseen the resolution of the distinction between choice and chance which was to occur in my own work."[65] Similar verification of Cage's impact appeared earlier in Kaprow's seminal essay, "The Legacy of Jackson Pollock." Originally drafted in late 1956 but published in October 1958, just after the summer course, Kaprow's text articulated for the first time the void felt by artists left bereft by Pollock's death in the summer of 1956: "We were a piece of him: he was, perhaps, the embodiment of our ambition for absolute liberation ... the possibility of an astounding freshness, a sort of ecstatic blindness."[66] Kaprow described the emotional tenor as the "shock of being thrown out on our own," suggesting that while Cage was certainly not the art community's successor to Pollock, the "Experimental Composition" course first offered a month after Pollock's death unequivocally helped to ease the creative loss. Kaprow, Brecht, Hansen, and Alison Knowles had all worked in the abstract expressionist medium prior to encountering Cage's ideas about experimental composition, and each would cite him as decisive in their later pursuits in happenings, events, and intermedia.[67] Cage goes unmentioned in Kaprow's essay, but

the language betrays an implicit homage, particularly toward the end as Kaprow outlines his renewed artistic convictions "to give up the making of paintings entirely" and to "become preoccupied with and even dazzled by the space and objects of everyday life" with the same "amazingly childlike," "Zen quality" that *Pollock* had exercised.[68]

Kaprow's follow-up essay in November 1958, "Notes on the Creation of a Total Art," further evinced Cage's impact through its distinct adoption of musical terminology, description of a sonic field, and allusions to indeterminacy: "There is, therefore, a never-ending play of changing conditions between the relatively fixed or 'scored' parts of my work and the 'unexpected' or undetermined parts. In fact, we may move in and about the work at any pace or in any direction we wish. Likewise, the sounds, the silences, and the spaces between them (their 'here-' and 'there-' ness) continue throughout the day with a random sequence of simultaneity that makes it possible to experience the whole exhibit differently at different times."[69] Kaprow is better known for distancing his work from Cage's, as this binary situation of "fixed" and "undetermined" parts would suggest (recall Cage's caveat of known elements predominating over the unknown), yet Kaprow ultimately credited Cage for revealing a "worldview very different from the one [that artists] were used to."[70]

As a concept theorized for Europe, indeterminacy took on a different life through the works of New School alumni after summer 1958. A broad practice of performance flourished during the 1960s, but the reception history of indeterminacy in art-related performance remained somewhat estranged from the reception history of indeterminacy in music. Higgins offered some perspective:

> The best thing that happened to us in Cage's class was the sense he gave that "anything goes," at least potentially. Only George Brecht seemed to share Cage's fascination with the various theories of impersonality, anonymity and the life of pieces outside of their perceivers, makers, or anyone else. For the rest of us, the main thing was the realization of the possibilities, which made it easier to use smaller scales and a greater gamut of possibilities than our previous experience would have led us to expect. Ultimately, of course, this contributed to the developing of happenings.[71]

The connotations of "anything goes" are usually negative and applied to extreme actions that subvert or exploit the freedoms of indeterminacy.

While Higgins explained that "anything goes" could also refer to limited materials yielding innumerable, unforeseen possibilities, which was not unlike Brecht's belief in "maximum meaning with minimal image" or Cage's conception of indeterminacy as a generative process, those familiar with Cage's ill-fated encounters with musicians who defied the propositions of his indeterminate scores bristle at the suggestion of "anything goes."[72] The broader reception of indeterminacy by artists was based on their recent entrée into the world of performance. Composers, however, faced a long history of performance practice and received tradition and responded to Cage's indeterminacy with the same reserve as they had with his use of chance. Just as chance challenged composer control, indeterminacy challenged the ethics of performer freedom. Thus, perhaps the fundamental performance ethic to be observed by artist and musician alike is Cage's dictum encompassing the whole of the creative process: "Permission granted. But not to do whatever you want."[73]

Notes

1. John Cage, "Composition as Process: Indeterminacy" (1958), in Cage, *Silence* (Middletown, Conn.: Wesleyan University Press, 1961), 35–40.

2. The main target of Nono's 1959 Darmstadt talk was, however, Stockhausen. See abridged text in "Geschichte und Gegenwart in der Musik heute," *Darmstädter Beiträge zur Neuen Musik* 3 (1960): 42–46; English translation based on Helmut Lachenmann's transcription in "The Historical Reality of Music Today," *The Score* 27 (July 1960): 41–45. Pierre Boulez, "Aléa," *Nouvelle Revue Française* 59 (November 1957): 839–857; English translation by David Noakes and Paul Jacobs, *Perspectives of New Music* 3, no. 1 (1964): 42–53. Cornelius Cardew, "John Cage: Ghost or Monster?," *The Listener* (May 4, 1972); reprinted in *Stockhausen Serves Imperialism and Other Articles with Commentary and Notes* (London: Latimer New Dimensions, 1974), 33–40. On the distinction between *chance operations* and *indeterminacy*, as well as Cage's *indeterminacy* and Boulez's *aleatory*, see chapter 1 of Kim, "In No Uncertain Musical Terms," 29–74.

3. Cage interview with William Fetterman, June 11, 1987, "Appendix 1: John Cage on Teaching," in *John Cage's Theater Pieces: Notations and Performances* (Amsterdam: Harwood, 1996), 233.

4. John Cage, "[The New School]" (early 1960s), in *John Cage: An Anthology,* ed. Richard Kostelanetz (New York: Praeger, 1970), 120.

5. See George Maciunas, "Fluxus (Its Historical Development and Relationship to Avant-Garde Movements)" (1965), in *Museums by Artists*, ed. A. A. Bronson and Peggy Gale (Toronto: Art Metropole, 1983), 246–247. Maciunas referred to this genealogy as the "Cage Chart," which situated Cage at center with "concretism," "indeterminism," and "bruitism." Notably, the first Fluxus concert on June 9, 1962, at Galerie Parnass in Wuppertal was titled *Kleines Sommerfest: Après John Cage,* at which Maciunas's essay "Neo-Dada in Music, Theater, Poetry, Art" was read aloud, describing the influence of Cage (and indeterminacy) though not by name; see *Ubi Fluxus, ibi motus 1990–1962*, ed. Achille Bonito Oliva (Milan: Mazzotta, 1990), 214–216.

6. *New School Bulletin* 14, no. 1 (1956): 122. The description went unchanged, except for summers 1959 and 1960, when the last paragraph was omitted.

7. Cage, "[The New School]," 119. Cage's affiliation with the New School for Social Research (renamed New School University in 1994) began in fall 1934 as a student of composition and world music under Henry Cowell.

8. Because Cage actively invited and welcomed guests, an "official" roster for summer 1958 remains elusive. Robert Watts and Robert Whitman lived in the New Brunswick area and visited the course, though Rutgers affiliates Lucas Samaras, Geoffrey Hendricks, and Roy Lichtenstein did not. Musicians who attended the course at one time or another included pianist Robert Dunn (editor of C. F. Peters's 1962 Cage catalog), Toshi Ichiyanagi, and jazz musicians Don Heckman and John Benson Brooks. Barney Childs, "Indeterminacy," in *Dictionary of Contemporary Music*, ed. John Vinton (New York: E. P. Dutton, 1974), 337.

9. Watts was on the organizing board of the Voorhees Assembly lectures and Kaprow an unofficial advisor. See full list of spring 1958 "Communication" lectures in Geoffrey Hendricks, "Beginnings," in *Critical Mass: Happenings, Fluxus, Performance, Intermedia, and Rutgers University, 1958–1972* (New Brunswick: Rutgers University Press, 2003), 16. Kaprow's April 22 event consisted of disjunct actions: processions through aisles, matches lit in front of a mirror, taped lectures by Kaprow played out of sequence from loudspeakers placed in the chapel's four corners, Lucas Samaras enacting a routine with tin cans, colored silk banners dropped from balconies. Joan Marter, "The Forgotten Legacy," in *Off Limits: Rutgers University and the Avant-Garde, 1957–1963* (New Brunswick: Rutgers University, 1999), 8–9, 48 n. 38, 134. Marter notes the erroneous citation of Kaprow's first happening as *18 Happenings in 6 Parts* at Reuben Gallery in October 1959.

10. Amy C. Beal, *New Music, New Allies: American Experimental Music in West Germany from the Zero Hour to Reunification* (Berkeley: University of California Press, 2006), 95–96, 106. Christopher Shultis, "Cage and Europe," in *The Cambridge Companion to John Cage*, ed. David Nicholls (New York: Cambridge University Press, 2002), 37–39, 263 n. 19. Shultis corresponded with Helms in 2001 about the German translation of "Communication" and the deliberate use of *Sie* over *Ihnen*. Helms noted, "John thought—as we did—that at this point in time—to use your words—a 'direct personal attack' was necessary to wake up the sleeping minds."

11. Cage, "Rutgers Original," 5A, undated typescript, folder 11, box 2, John Cage Papers, Special Collections and Archives, Olin Library, Wesleyan University, Middletown, Conn. This may be Cage's reconstruction based on a note that reads, "No pause for music at Rutgers since music was being played there the whole time." Hendricks recalled that "Tudor sat at a grand piano and played a score that was written in circular form and could be started at any point" (Hendricks, *Critical Mass*, 14, 19 n. 16). Tudor may have performed Stockhausen's *Klavierstück XI*, which can be started at any point and has a roughly circular layout. At Darmstadt, however, Tudor performed Wolff's *For Prepared Piano* and Nilsson's *Quantitäten*; the layout of the latter is U-shaped and must be played from start to finish. Hendricks also noted that Rauschenberg, Johns, and Merce Cunningham attended Cage's event, and returned the next week, March 18, 1958, for Paul Taylor's lecture (it is unclear whether Cage attended) when he presented five dances, including *Resemblances*, choreographed to Cage's *Variations I*. Brecht kept a copy of Taylor's program, which listed Rauschenberg and Johns as artistic collaborators; in George Brecht, *Notebooks*, vols. 1–3 (June 1958–August 1959), ed. Dieter Daniels with Hermann Braun (Cologne: Walther König, 1991), 2: 79.

12. An excerpt of "Communication" appeared in the *Village Voice* to publicize the Town Hall concert; "25 Years and 45 Questions," *Village Voice* 3, no. 24 (April 9, 1958): 4. All 45 questions and quotation appeared in the Darmstadt version published in *Silence*.

13. "Project in Multiple Dimensions," in *Off Limits*, 156–157.

14. Cage's scores were reportedly exhibited on the upper level and Rauschenberg's paintings on the ground level. Reviews of the exhibit, which included pages from *Concert for Piano and Orchestra* (1957–1958), *Water Music* (1952), and *Seven Haiku* (1952), were favorable. J. S., *ARTnews* 57, no. 3 (May 1958): 12.

15. Dick Higgins, interview with Nicholas Zurbrugg, July 5, 1993, Barrytown, N.Y., in "Looking Back," *Performing Arts Journal* 21, no. 2 (May 1999): 19–32; Dick Higgins, *Postface* (New York: Something Else), 50–51. After two years at Yale, Higgins transferred to Columbia in 1958 and studied with Cowell in fall 1958 and 1959. Also studying composition at Columbia at that time was future Fluxus member Philip Corner (b. 1933).

16. Stephen Addiss, personal correspondence with the author, August 15, 2003. Addiss had studied with Walter Piston as an undergraduate at Harvard, and after studies at Mannes and the New School toured as a folk musician in the early 1960s under the auspices of the U.S. State Department Cultural Exchange Program. He participated in Cage's course from about fall 1957 to spring 1960 and was also a teaching assistant for Cage at one point. Bruce Altshuler, "The Cage Class" in *FluxAttitudes*, ed. Cornelia Lauf and Susan Hapgood (Gent, Belgium: Imschoot Uitgevers, 1991), 18.

17. Cage, 1987 interview with Fetterman, *John Cage's Theater Pieces*, 231.

18. Cage, 1990 interview with Altshuler, "The Cage Class," 17. Cage made a similar remark to Fetterman in 1987: "I simply wanted to stimulate the people to do experimental work. So I would tell them at the beginning where I was with respect to my work . . . and the whole rest of the class was asking the students where they were." Cage, 1987 interview with Fetterman, *John Cage's Theater Pieces*, 231.

19. "Statement of Purpose," *New School Bulletin* 14, no. 1 (1956): 2.

20. Of the twenty-eight surviving notebooks, seven pertain to 1958–1962, sixteen to 1963–1972, and five to 1972–1980 (Cologne years). Information about the course is limited since Cage did not recall using a syllabus. For general, anecdotal accounts see *A Primer of Happenings and Time/Space Art* (New York: Something Else, 1965); Hendricks, *Critical Mass*; Marter, *Off Limits*; Fetterman, "Appendix 1: John Cage on Teaching," in *John Cage's Theater Pieces*, 231–233; and Altshuler, "The Cage Class," based on interviews with Cage, Kaprow, Mac Low, Alison Knowles, Segal, and Addiss.

21. Brecht, *Notebooks*, 1: 3 (June 24, 1958). Cage began the summer 1959 term similarly; see *Notebooks*, 3: 57 (June 22, [1959]). Higgins corroborated Brecht's account: "In the first class, [Cage] spoke about notation—'So much space equals so much time.' He wrote both words on the blackboard. . . . He showed the class about the various properties of sound and how they could be altered. And stuck a pink pearl eraser in the piano strings. It made a dull, bell-like sound. 'Nice,' he said as the sound died out." Higgins, "[June-July, 1958]," in *John Cage: An Anthology*, 122.

22. Brecht, *Notebooks*, 1: 3–4 (June 24, 1958). Dialecticism or dualism increasingly appeared in Cage's 1950s discourse. See John Cage, program notes for "'New' Music for Piano," Harvard University, April 20, 1956, Sanders Theater; Raymond Fogelman Library, New School University; and John Cage, "Program Notes" (1959), in *John Cage, Writer: Previously Uncollected Pieces,* ed. Richard Kostelanetz (New York: Limelight, 1993), 81–82.

23. Brecht, *Notebooks*, 1: 5–6 (undated entry). Brecht indicated here: "1st piece performed in Cage class." Brecht assisted in organizing his notebooks into their final facsimile reproduction, and thus his editorial annotations are appended to each volume. George Brecht, *Chance-Imagery* (1957) (New York: Something Else, 1966), 12; reprinted in *An Introduction to George Brecht's Book of the Tumbler on Fire,* ed. Henry Martin (Milan: Multhipla, 1978), 130–148. The essay quotes from Pollock, Barr, and Motherwell (whose 1949 anthology Cage recommended in the course), among others. In a 1991 interview appended to volume 1, Brecht referred to a lost notebook from 1956 containing 50–60 ways of using chance in visual art, which had been the basis for *Chance-Imagery*. Michael Nyman interview with Brecht, 1976, in Martin, *An Introduction*, 105–122.

24. Brecht, *Notebooks*, 1: 11, 20–22 (July 1, 1958). At the end of the June 26 entry Brecht noted, "Cage in Indiana," referring to a concert by Cage and Tudor at Ball State Teachers College on July 1. On July 1, Feldman substituted, and on July 3, Maxfield, for which Brecht took copious notes. Brecht, *Notebooks*, 1: 7 (undated; probably June 26, 1958).

25. Robinson also relates Pollock to *Confetti Music* in "From Abstraction to Model: In the Event of George Brecht and the Conceptual Turn in the Art of the 1960s" (PhD diss., Princeton University, 2008), 108–111 (see also chapter 1). On the Cage-Pollock distinction, see Moira Roth, "The Aesthetics of Indifference," *Artforum* 16, no. 3 (November 1977): 46–53; reprinted in Roth, *Difference/Indifference: Musings on Postmodernism, Marcel Duchamp and John Cage* (Newark: G+B Arts International, 1998); Caroline A. Jones, "Finishing School: John Cage and the Abstract Expressionist Ego," *Critical Inquiry* 19, no. 4 (1993): 628–665; and Jonathan D. Katz, "John Cage's Queer Silence; Or, How to Avoid Making Matters Worse," *GLQ: A Journal of Lesbian and Gay Studies* 5, no. 2 (1999): 231–252.

26. Liz Kotz, "Post-Cagean Aesthetics and the Event Score," in this volume; see also Kotz, *Words to Be Looked At: Language in 1960s Art* (Cambridge: MIT Press, 2007), 59–98.

27. Higgins, "[June–July, 1958]," 122–123.

28. Brecht interview with Irmeline Lebeer [ca. 1973], in Martin, *An Introduction to George Brecht's Book of the Tumbler on Fire*, 83.

29. Brecht, *Notebooks*, 3: 57 (June 22, [1959]). Brecht's realization seems to have been *Candle Piece*: "for 6.24. Bring in radio & stopwatch. Music for 5 radios. Compose 4 pieces, play one." Cage had also written *Speech 1955* (1955) for newsreader and 5 radios, and *Radio Music* (May 1956) for 8 radios.

30. Hansen, *A Primer of Happenings,* 97 (image). See also Higgins, "[June–July, 1958]," 122.

31. Brecht, *Notebooks*, 1: 63–69 (August 7, 1958). Tudor gave the world premiere of *Klavierstück XI* on April 22, 1957 at Carl Fischer Concert Hall New York and performed two versions. Brecht attended Tudor's repeat performance on November 17 at Nonagon Gallery.

32. Interview with Brecht, in Brecht, *Notebooks*, 1: end pages. When Daniels and Braun edited the notebooks with Brecht in 1991, some pages and loose notes were reorganized for readability. Other essays by Brecht reflective of his broadening interests included "The Listener as Virtuoso" in Brecht, *Notebooks*, 3: 111, 114–131 (July 15, 1959); and "John Cage and the Modern World View: Space, Time, and Causality," exploring relativity, quantum theory, psychology, and unified field theory in Brecht, *Notebooks*, 2: 64–66 (undated).

33. Brecht, *Notebooks*, 1: 67 (August 7, 1958). While Brecht's entry is too copious and edited to be dictated notes, it may have served for a class presentation since the point-by-point organization is stylistically similar to notes for other works presented in class such

as *3 Lites*. Brecht, *Notebooks*, 1: 56–57 (undated [1958]). The Merce Cunningham Dance Company made it debut appearance at the American Dance Festival in 1958, where Cage conducted the second performance of *Concert for Piano and Orchestra* (with Tudor) for Cunningham's premiere of *Antic Meet* on August 14.

34. Brecht, *Notebooks*, 1: 63 (August 7, 1958).

35. Cage, "Composition as Process: Indeterminacy" (1958), 38.

36. Brecht, *Notebooks*, 1: 63 (August 7, 1958). "Page no. 59" may have referred to a page from *Concert* exhibited at Stable Gallery in May. Brecht typically headed his notes with a guest lecturer's name and did so with Brown. Higgins, however, did not recall Brown as a substitute in summer 1958: "That August Cage was scheduled to leave for Darmstadt, to take over Boulez's class, since Boulez had other commitments. So the last two sessions were turned over to Morton Feldman and Richard Maxfield." Higgins, "[June-July, 1958]," 123. On the other hand, Cage recalled that Feldman, Maxfield, *and* Brown were usual substitutes; Cage, "[The New School]," 119–120.

37. Earle Brown, preface to *Folio and 4 Systems* (New York: Associated Music, 1961). See the original Darmstadt schedule in *Karlheinz Stockhausen bei den Internationalen Ferienkursen für Neue Musik in Darmstadt, 1951–1996: Dokumente und Briefe*, ed. Imke Misch and Markus Bandur (Kürten: Stockhausen-Verlag, 2001), 185–187.

38. Beal, *New Music, New Allies*, 93. Beal writes that the 110 preregistrants for Boulez's seminars were contacted in August with the option to attend five seminars by Maderna and five by Cage. Shultis notes that after the withdrawal, Musikinstitut librarian Wilhelm Schlüter recalled Maderna suggesting Cage to Steinecke in a conversation with Nono. Shultis, "Cage and Europe," 33. Maderna and Nono were already scheduled to give a Kompositions-Studio in the General Program.

39. Beal, *New Music, New Allies*, 92–93. The *Kammerkonzert* program appears to have remained unchanged, and Beal notes that publicity brochures from February 1958 listed Cage and Tudor speaking about *Neue Formprobleme* in connection with recent piano music from the United States and Europe. The "seminars" by Tudor and Boulez were offered to select registrants as "Special Courses" while Cage's lecture was part of the "General Program" for all attendees.

40. Steinecke requested that Cage should forward his lectures quickly so that Alexander Goehr might undertake their translation. Steinecke letter to Tudor, March 22, 1958, folder 2, box 15, David Tudor Papers, Getty Research Institute, Los Angeles. Beal, *New Music, New Allies*, 92; Shultis, "Cage and Europe," 34–35.

41. The three "Neue Klaviermusik" lecture-recitals by Cage and Tudor were originally scheduled on September 5 (Cage, *Music of Changes*), September 8 (Boulez, *Troisième Sonate*), and September 9 (Stockhausen, *Klavierstück XI*). Misch and Bandur, *Karlheinz Stockhausen*, 186–187.

42. Ibid., 188–189.

43. See also the final recital program by Tudor and Cage in the letter from Tudor to Stockhausen, August 20, 1958, in ibid., 186, 204. A letter from Universal Edition to Tudor, July 30, 1958, stated that Boulez's handwriting might be difficult to read; moreover, Boulez had not indicated how the twenty-seven score leaves were to be organized. Box 5, folder 22, David Tudor Papers, Getty Research Institute, Los Angeles.

44. Shultis, "Cage and Europe," 33. Cage replied to Steinecke a day after the American Dance Festival performance: "yes. subject composition as process." The time lapse between the request and reply suggests Cage may have been in New London by August

8. Stockhausen had urged Steinecke to grant Cage a course as early as March: ("[Cage] is worth ten [Ernst] Kreneks"). See letters from Tudor to Stockhausen (February 19, 1958) and Stockhausen to Steinecke (March 1, 1958) in Misch and Bandur, *Karlheinz Stockhausen*, 194–196.

45. After the last meeting, Brecht sketched a work using overlays akin to Cage's transparencies: "A piece in which a sheet of (say) masonite is painted w/ semi-gloss (or slate) white, and set in the woods, to change. An acetate sheet is made to go over it." Brecht, *Notebooks*, 1: 71 (August 11, 1958). The next day, he sketched another work with transparencies, relating it to Dada: "A poem composed of acetate overlays, in which color areas and words interact. Some areas block out words (partially or complete), etc. Compose poem by cutting up a poem from book, or article, etc. à la Tzara." Ibid., 61 (August 12, 1958).

46. Brecht wrote Helms around 1959, "You may remember that a year or so ago we talked about the differences between the mainstreams of European music (Stockhausen, Boulez) and American (Cage, Wolff). At that time you suggested that you might be able to use a paper describing these differences for one of your radio broadcasts." Brecht, *Notebooks*, 3: 142 (undated). Letter from Helms to Brecht, September 25, 1959, in Brecht, *Notebooks*, vol. 4, ed. Hermann Braun (Cologne: Walther König, 1998). Brecht considered submitting an essay on his own works for Helms's *Contexts*, "per Cage's suggestion, on pieces w/out notation" (Brecht listed *Card-Piece for Voice* [7/8/59], *Candle-Piece* for 5 radios [6/23/59], *Time-Table Music*, and jotted the piano part of Cage's *Concert*). Brecht, *Notebooks*, 3: 132 (June 27, 1959).

47. Brecht, *Notebooks*, 1: 68 (August 7, 1958).

48. Ibid., 65.

49. Ibid., 65, 67, 69. Charlie Parker's 1939 experiments on the extended intervals of the chord progressions to Ray Noble's *Cherokee* were seminal to bebop and formed the basis for *Koko*, recorded on Savoy in 1945.

50. George E. Lewis, "Improvised Music after 1950: Afrological and Eurological Perspectives" and "Afterword to 'Improvised Music after 1950': The Changing Same," in *The Other Side of Nowhere: Jazz, Improvisation, and Communities in Dialogue*, ed. Daniel Fischlin and Ajay Heble (Middletown, Conn.: Wesleyan University Press, 2004), 131–162, 163–172 (reprinted from *Black Music Research Journal* 16, no. 1 (Spring 1996): 91–122). See also Lewis, *A Power Stronger Than Itself: The AACM and American Experimental Music* (Chicago: University of Chicago Press, 2008); and chapter 4 of Kim, "In No Uncertain Musical Terms," 208–317.

51. Brecht, *Notebooks*, 1: 65, 69, 41 (August 7 and July 17, 1958).

52. Christian Wolff interview with the author, December 13, 2002, New York. Christian Wolff, "New and Electronic Music" (1957), *Audience* 5, no. 3 (1958); reprinted in *Christian Wolff: Cues, Writings and Conversations*, ed. Gisela Gronemeyer and Reinhard Oehlschlägel (Cologne: MusikTexte, 1998), 24–26.

53. Higgins, "[June–July, 1958]," 123. "Four Musicians at Work," *trans/formation: Arts, Communication, Environment* 1, no. 3 (1952): 168–172. Higgins recalled that during 1959 Cage read from Wolff's "New and Electronic Music" and "On Form" (1960). Higgins, "3 x (Kostelanetz + Cage)," *Performing Arts Journal* 16, no. 3 (September 1994): 64.

54. Everett Helm, "Darmstadt Holiday Courses for New Music," *Musical Times* 99, no. 1389 (November 1958), 620.

55. The first questions differs: "perhaps the question is to be asked . . ." Brecht, *Notebooks* 1: 63, 68 (August 7, 1958). "Our" interest in chance suggests that Cage crafted the question. Brecht also noted, "If chance implies uncertainty, what are we uncertain about?"

56. Brecht, *Notebooks* 1: 67 (August 7, 1958). Brecht had sketched a "contextual situation" in *The Artificial Crowd*, which issued cards to an audience instructed to utter text, clap, or make sounds from milk bottles with objects such as pennies and pebbles. Ibid., 12 (July 2, 1958).

57. Cage, "Composition as Process: Indeterminacy" (1958), 36.

58. Cage, "Composition As Process: Indeterminacy" (1958), 36. That Cage had discussed *Music of Changes* without these critical overtones two days earlier in "Changes" indicates that he wished to distinguish indeterminacy from the limited application of "chance operations" in his earlier output. In addition to Beal's seminal work on postwar German musical culture, see Gesa Kordes, "Darmstadt, Postwar Experimentalism, and the West German Search for a New Musical Identity," in *Music and German National Identity*, ed. Celia Applegate and Pamela Potter (Chicago: University of Chicago Press, 2002), 202–217.

59. Cage, "Composition as Process: Indeterminacy" (1958), 37; translated into German, *Musik-Konzepte* (January 1999), 156: "Von einem Standpunkt aus, der jedes Ding und jedes Wesen als aus seiner eigenen Mitte heraus sich bewegend ansieht, ist diese Knechtschaft, in der mehrere durch die Direktiven eines einzigen gehalten werden, der selber zwar nicht von einem anderen, aber von dem Werk eines anderen kontrolliert wird, unerträglich."

60. Georg Wilhelm Friedrich Hegel, *The Phenomenology of Mind*, trans. J. B. Baille (New York: Harper, 1967).

61. See the nine works that Cage designated "indeterminate of performance": *Variations I* (and *Extra Materials*) (1958), *Music Walk* (1958), *Fontana Mix* (1958), *Theater Piece* (1960), *Music for Amplified Toy Pianos* (1960), *Music for "The Marrying Maiden"* (1960), *Solo for Voice 2* (1960), *Cartridge Music* (1960), and *Variations II* (1961). Annotated in *John Cage*, ed. Robert Dunn (New York: Henmar Press/C. F. Peters, 1962).

62. For a fascinating art-music coincidence, particularly the *pseudomorphosis* of Cage's early indeterminate notations and François Morellet's *5 lignes au hazard* (1958; 1971), see Yve-Alain Bois, "Chance Encounters: Kelly, Morellet, Cage," in *The Anarchy of Silence: John Cage and Experimental Art*, ed. Julia Robinson (Barcelona: Museu d'Art Contemporani de Barcelona, 2009), 188–203.

63. Cunningham speaking on the panel "John Cage as Educator," 1999, New School University, organized by Susan Hapgood for the school's 90th anniversary. Also on the panel were Alison Knowles and Jackson Mac Low, with Bruce Alshuler moderating. Unpublished VHS.

64. Harold C. Schonberg, "'Advanced' Music Beeps and Plinks," *New York Times*, April 8, 1959, p. 43.

65. Brecht, *Chance-Imagery* (1957), 15. Brecht signed the postscript November 1965.

66. Allan Kaprow, "The Legacy of Jackson Pollock," *ARTnews* 57, no. 6 (October 1958): 24–26, 55–57; reprinted in *Allan Kaprow: Essays on the Blurring of Art and Life,* ed. Jeff Kelley, expanded ed. (Berkeley: University of California Press, 2003), 1–9. Pollock died on August 11, 1956.

67. Knowles's first solo exhibit at Nonagon opened April 28, 1958, a week before Cage's Stable exhibit, for instance, and though she never attended his courses, she was irrevocably affected by what Higgins reported such that the abstract expressionist works she exhibited

at Nonagon were her last. Knowles interview with the author, November 14, 2006, New York.

68. Kaprow, "The Legacy of Jackson Pollock," 7.

69. Kaprow's "Notes on the Creation of a Total Art" was written for the "Environment" exhibition catalog, Hansa Gallery, November 25–December 13, 1958. In Kelley, *Allan Kaprow: Essays*, 11–12.

70. Kaprow continued, "For Western artists the prevalent myth of the tragic sufferer held sway over everyone's imagination. . . . The real world was terrible, so the artist's calling was to create in fantasy a better world or, if not a better, at least a more critical one. . . . In Cage's cosmology (informed by Asiatic philosophy) the real world was perfect, if we could only hear it, see it, understand it. If we couldn't, that was because our senses were closed and our minds were filled with preconceptions." Allan Kaprow, "Right Living" (1987), in *A Tribute to John Cage* (Cincinnati: Carl Solway Gallery); reprinted in *Allan Kaprow: Essays*, 223–225. On Kaprow's distinction from Cage, see Branden W. Joseph, "Chance, Indeterminacy, Multiplicity," in *The Anarchy of Silence*, 210–213.

71. Higgins, "[June-July, 1958]," 124.

72. George Brecht, personal statement, "Project in Multiple Dimensions" (1958), 158.

73. John Cage, "Seriously Comma" (1966), in *A Year from Monday* (Middletown, Conn.: Wesleyan University Press, 1967), 28.

John Cage and Investiture: Unmanning the System

Julia Robinson

> Discourses are not once and for all subservient to power or raised up against it, any more than silences are. We must make allowance for the complex and unstable process whereby discourse can be both an instrument and an effect of power, but also a hindrance, a stumbling block, a point of resistance, and a starting point for an opposing strategy.
>
> —*Michel Foucault*[1]

Discourse, as a means of channeling and altering power relations, is the crucial auxiliary of John Cage's compositional practice. The historical record on Cage is comprised, to an unusual extent, of the testimony of his own words. His writings and lectures were published as the book *Silence* in 1961 at the start of his great renown, and they fueled it.[2] This was hardly Cage's first use of multiple discursive approaches to establish his project, but it was the first time they were mapped. His programmatic speech-acts were arranged there in not-quite-chronological order, with anticonventional layouts, which added to his record a system of meaning that exceeded the discipline of music. *Silence* was the first register of Cage's accumulated "performances," and the first glimpse of them as part of a systematic strategy of performativity.[3]

Cage's pivotal position in the history of modern music and in late twentieth-century art derives, in part, from his acute sense of how performance could become *performative*. For Cage, performance did not simply take the form of concerts of his music. In the course of his career, it ran the pedagogical gamut from carefully choreographed lectures to

concert-demonstrations. These were his means of establishing his radical approaches to composing while undermining and fracturing the power relations that such a model of authorship implied. This essay considers the scope of Cage's performativity—in the full sense of that word—as so many strategies of "investiture." It examines the systematic discursive interventions marking each new phase of his work that have positioned Cage as a singular figure among his peers, and a force of change within the history of twentieth-century aesthetic practice.

The historian Eric Santner defines the concept of "investiture" as concerned with "impasses and conflicts pertain[ing] to shifts in the fundamental matrix of the individual's relation to social and institutional authority." As Cage was well aware, official power and authority, in artistic disciplines, as in life, comprises

> rites and procedures of *symbolic investiture* whereby an individual is endowed with a new social status, is filled with a symbolic mandate that henceforth informs his or her identity in the community. The social and political stability of a society ... would appear to be correlated to the efficacy of these symbolic operations—to what we might call their *performative magic*—whereby individuals "become who they are," assume the social ... [role] assigned to them by way of names, titles, degrees, honors, and the like.[4]

Santner's investiture model is based on the psychoanalytic case of Daniel Paul Schreber at the turn of the twentieth century. Schreber was a German judge who succumbed to paranoia. Santner argues that the case of this patient of important social standing, undone by the system, represents a crisis of modernity. Pointing to a patriarchal order that has exceeded rationality, Schreber's key symptom is to desire his own "unmanning."[5] His case reveals a symbolic order so weakened—"corrupt," even "rotten"—that all its symbols have turned simulacral: a failed order writ large in the mind of a paranoiac subject. Decades later, as modernity/modernism ceded to the conditions that would come to be called postmodern, Cage confronted a similarly fragile field of simulacra—and responded by redirecting *its* tokens of symbolic power to set his own project on its course. Cage's singularity, in work and life, is that he was intimately aware of the functions of symbolic power and more radically distanced from them than most.

From beginning to end, Cage's career is shaped by critical negotiations concerning symbolic investiture: as a Californian coming to New York to study composition in the 1930s; as an American composer encountering his peers in France, Germany, and other European cities in the late 1940s and 1950s (perhaps most notably, Pierre Boulez), and using Schoenberg as a credential; as a spokesman for "Experimental Composition" and the "New York School" (which included Morton Feldman, Christian Wolff, and Earle Brown) before often-hostile audiences; as a "composer" who relied on chance operations; as the figurehead of an American "Experimental Music" defined increasingly against the contemporaneously emergent models of the European avant-garde, clarifying the stakes of the difference (in a word, *indeterminacy*) at the very center of New Music (Darmstadt); as an experimental composer relying on a traditional orchestra in a traditional setting (e.g., the New York Philharmonic's presentation of Cage's *Atlas Eclipticalis* of 1961 in 1964); and on and on, through his Norton Lectures at Harvard at the end of his life, written and delivered as a mesostic poem instead of a conventional lecture.[6] Cage found himself repeatedly confronting disciplinary limits. His constant work to counter unidirectional dictates at the level of the score (buttressed by his developing discourse of investiture) adumbrated an ethics and politics that could implicate a larger social sphere, and ultimately did so.[7]

The 1930s: Lectures, Schoenberg, and the Power of Investiture

From an early moment, Cage seems to have been well aware of the functions of symbolic investiture. He may already have glimpsed its performative dimension—the ways in which the framework of "authority" is pure projection, pure *representation*—in his first "work" in Depression-era Los Angeles. At the outset of an ambitious lecture series on modern art and music, which he was delivering to local housewives, Cage admitted outright that he was not an expert on the subjects about which he would be speaking.[8] However, he promised to work hard every week to prepare. The success of the lectures must have revealed to Cage that expertise was not as valuable as the "performative magic" of his smile, warm manner, and disarming sense of humor—all of which would become trademarks of this pioneering figure.[9] What Cage referred to as the "sunny disposition" with which he had been "blessed" turned out to be crucial to the signification system that underwrote his *effect*.

In 1933 the young Californian composer went to New York to study with Adolf Weiss, a former student of Arnold Schoenberg. Cage's first mentor and teacher, Henry Cowell, had advised him that this training would prepare him to one day meet the master. He accomplished his goal and returned to Los Angeles in 1935 to study with Schoenberg. The *discourse* that has placed this early moment of Cage's career on the record is legendary, but it is worth quoting, precisely for its *performative magic*:

> I told him . . . I couldn't pay him anything at all. He then asked me whether I was willing to devote my life to music, and I said I was. "In that case," he said, "I will teach you free of charge." . . .
>
> Several times I tried to explain to Schoenberg that I had no feeling for harmony. He told me that without a feeling for harmony I would always encounter an obstacle, a wall through which I wouldn't be able to pass. My reply was that in that case I would devote my life to beating my head against that wall.[10]

Schoenberg is supposed to have referred to his former student as "Not a composer but an inventor—of genius."[11]

This period of Cage's life served him in unquantifiable ways. Schoenberg apparently taught Cage *how to live as a composer*; he imbued that life decision with unassailable legitimacy.[12] Put differently, Schoenberg taught Cage a lesson about symbolic investiture in the discipline of music, and he only needed to learn that lesson once. This is a rare chapter of the Cage history in which he defers utterly to another musical master (albeit with scant reference to that master's actual musical output).[13] In the course of its repetition throughout his career, Cage transformed the Schoenberg account from undeconstructed primal scene to polished origin story.[14] James Pritchett notes that, actually, Schoenberg did not have a lasting effect on his student's music, suggesting that his function for Cage lay elsewhere: "Throughout his life, when asked why he composed music, Cage would speak of his vow to Schoenberg."[15]

Percussion and Prepared Piano: The Future of Music

During his first professional appointment at the Cornish School of the Arts in Seattle in 1938, Cage learned another important lesson. While he had been given the title of "instructor," it was probably not lost on Cage that a major component of his job description was to be the "accompanist"

to the dance. Merce Cunningham, whom Cage met at this time, was probably never in his own career confronted with the concept of being hired as "accompanist" to the music. The relationship of music to dance asserted a hierarchy that privileged what could be *seen* over what could be *heard*. Cage's work with dancers presumably functioned as a kind of low-tech laboratory for thinking through the innate power relation of the visual versus the auditory.

Imaginary Landscape (1939) was one of the earliest works that Cage wrote for the dance. At this time, he conceived of the necessity of separating the music and the dance even as they happened simultaneously, lest he spend his composing career being dictated to by choreography. Since *Imaginary Landscape* was composed for, among other things, two variable-speed turntables playing frequency records, the dancers—one of whom was Cunningham—were faced with a new challenge. Choreographer Bonnie Byrd recalled, "We had quite a hard time with the music . . . we were not used to working with music that we could not hold onto in some way."[16]

The broad spectrum of noise-making possibilities in percussion gave Cage a world of "new sounds." This aperture within music led him to privilege units of time over harmonic progression, and a micro-macrocosmic model of organization whose structural emphasis would later serve his more radical acts of evacuating the traditional contents of musical composition.[17] At this moment Cage went on the record with his first "speech act" (the initial entry in *Silence*) in the form of a lecture called "The Future of Music: Credo" (1940), given at the Cornish School.[18] Astonishingly resolved in terms of Cage's career as a whole, the lecture starts with this statement:

> I believe that the use of noise to make music will continue to increase until we reach a music produced through the aid of electrical instruments, which will make available for musical purposes any and all sounds that can be heard. Photoelectric, film, and mechanical mediums for the synthetic production of music will be explored. Whereas, in the past, the point of disagreement has been between dissonance and consonance, it will be, in the immediate future, between noise and so-called musical sounds.[19]

One of the most salient lines from this text defines a break with tradition in almost iconoclastic terms: "If this word 'music' is sacred . . . we can substitute a more meaningful term: *organization of sound*."[20]

Percussion's allowance for experimentation made it a useful vehicle by which to expand the boundaries of composing. "Cage's model of the Composer," writes Pritchett, "was the inventor of new sounds and new instruments, and, along with that, the necessary invention of new forms and methods of composition ... above all else, Cage saw the advocacy of percussion music—the musical reclamation of noise—as his primary task."[21] This is arguably the start of Cage's critique of traditional approaches to composition, and his first discursive attempt to assert an underrecognized "Other" to the established, celebrated (and *entertaining*) musical forms of the day.

It was during his exploration of percussion as "dance accompanist" in Seattle that Cage came upon one of the best-known "inventions" of his career: the prepared piano.[22] Cage was to provide the music—*Bacchanale* (1940)—for Syvilla Fort's choreography, but the dance required that the stage be cleared of the cumbersome array of percussion instruments. This prompted Cage's most transgressive act yet: he opened the lid of the piano, and inserted objects in between the strings, dampening, halting, and otherwise altering their normal vibrations. This created a whole range of new sounds, and defamiliarized that centerpiece of bourgeois culture, shaking the foundations of its symbolic power. As he announced, "The piano had become, in effect, a percussion orchestra under the control of a single player."[23]

If the prepared piano was an extension of percussion, it was also a transformation of a musical instrument that asserted its presence *visually* (if not sculpturally), attracting new kinds of attention to that object. As such, it was an extraordinary performative statement. Perhaps surprisingly, when Cage came to New York and was offered a debut performance at the Museum of Modern Art, he chose not to feature his newest invention.[24] This decision hints at Cage's rare abilities regarding self-investiture at an early stage. For a number of reasons, percussion was a more logical platform on which to introduce Cage's ambitions of changing music and bringing it closer to "modern life." His opening up of percussion had to be understood first, lest the prepared piano appear as merely an abstract negation, or a gesture of meaningless iconoclasm. Introducing "more new sounds" into an already eclectic genre of modern music had a logic to it. Of course, Cage's act of situating his ambitious debut in a museum dedicated to modern art rather than music was also crucial. It would have been quite a different event if it had been scheduled at the Lincoln Center, for example.[25] A museum guarantees an audience prepared

for an avant-garde statement with implications beyond the purely musical.

At many levels it was a gamble; and it paid off. Cage's February 23 concert debut garnered him a spread in *Life* magazine the following month.[26] The article featured a series of impressive photographs of the performance. A banner image running across the top edge of the first page presented the entire stage, with a caption that emphasized the visual impact: "At full strength, orchestra includes eleven players, all of whom dress formally for concerts."[27] Other captions, for images showing the slightly odd array of instruments, were even more flippant, exposing the author's mixed feelings about investing this event with musical importance. Nonetheless, the article cannot but have been valuable for Cage. It evoked a scene of "earnest, dressed-up musicians," a "very highbrow" audience, listening intently, "conducted by a patient, humorous, 30-year-old Californian named John Cage," whom the author described as "the most active percussion musician in the U.S." It also put on the record a succinct early statement by Cage on his aims: "Cage believes that when people today get to understand and like his music . . . they will find new beauty in modern life," which is "full of noises made by objects banging against each other."[28] For all its ambiguity, the *Life* coverage rendered Cage's investiture moment as a fait accompli.

The 1940s: From Incommunicable Emotions to Permanent Emotions

The decade of the 1940s in New York was a tumultuous one for Cage. While he was consolidating his emerging reputation—benefiting somewhat from the support and positive reviews of Cowell and Virgil Thomson—he was also coming to terms with his outsider position in an oppressively heteronormative society as he divorced his wife and committed to a relationship with Cunningham.[29] The challenge of functioning outside the sanctioned symbolic order of the patriarchal American society of the 1940s cannot but have affected his urgent ongoing efforts to "organize" his position professionally. This issue, taken as part of a larger symbolic whole (rather than merely biographically), is significant in regard to Cage's rare place in his generation and his consistent adeptness in thinking beyond conventions and limits that had not previously been questioned.

Having launched himself through percussion, Cage apparently sensed that the prepared piano was the emblematic invention that would define

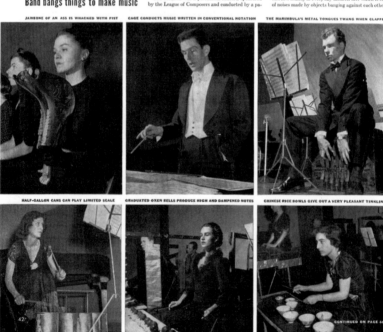

Figure 8.1 "Percussion Concert:
Band Bangs Things to Make Music."
Life, March 15, 1943, p. 43.

him as an original/originating figure. Recoding the initial account of *discovering* the prepared piano in Seattle, Cage moved to consolidate that form as truly his. This can be seen in his efforts to render this "experimental" find more rigorous. Pritchett explains:

> In his earliest pieces, he gave only the most general indications of what kind of object to use; in later scores, he became increasingly precise, giving the size of screws and bolts ... specifying the precise position of the preparation on the string, giving measurements from the piano dampers accurate down to a sixteenth of an inch. . . . In the table of preparations for *The Perilous Night* [1944] he ... indicated to which specific Steinway models the measurements are applicable.[30]

These meticulous instructions are an early instance of Cage's consistent strategy of consolidating the "experimental" with as many of the hallmarks of rigor, knowledge, and expertise—the outward signs of what I have been describing as "symbolic investiture"—as possible. In the two or three years after its invention, the prepared piano became a complete system, and one even associated with a brand: Steinway.

Cage's *The Perilous Night* (1944) was a new turning point. This was a dramatic, passionate piece written at the height of his emotional turmoil, and it taught him a critical lesson about "expression." Cage was struck by a sense that audiences did not grasp this work. There seemed a vast disparity between the composer's aims and what was actually experienced:

> I had poured a great deal of emotion into the piece, and obviously I wasn't communicating this at all. Or else, I thought, if I were communicating, then all artists must be speaking a different language, and thus speaking only for themselves. The whole musical situation struck me more and more as a Tower of Babel.[31]

This idea of each artist speaking his or her own language—making "signature" statements, *disciplined* into stylistic coherence as the language of modernism—seems ominous.[32] If the troubled moment that Cage was diagnosing comes too early to call the end of an autonomous field of modernist expression, it might have been one of its harbingers. Pritchett states that audiences were not getting the "point" of Cage's music. *The Perilous Night* convinced the composer that there should not be a point. It was Cage's first indication of the idea that music should be an

operation—a dynamic intervention into a larger perceptual field—rather than a finite construction delivering a finite model of subjectivity.

After the impasse he encountered with *The Perilous Night*, friends advised Cage to seek out psychoanalysis. He tried, and quickly discovered philosophical points of reference that suited him better. He stated that an East Asian text he had discovered, the *Gospel of Sri Ramakrishna*, "took the place of psychoanalysis."[33] Cage was also studying the work of the Indian art historian Ananda K. Coomaraswamy at this time. Coomaraswamy's *The Dance of Shiva* introduced him to the model of the *rasa* (aesthetic quality) and its forms, manifested as the "nine permanent emotions."[34] The latter became the crucial means by which Cage was able to shift *personal* emotions onto a more universal course. His magnum opus for prepared piano, *Sonatas and Interludes* (1946–1948) is focused through this model; it allowed Cage to retain the force of contrasting emotions in the music, just not his own. Written over a two-year period, *Sonatas and Interludes* is an important record of Cage's recalibration of his rationale for composing.

A significant figure for Cage at this time was a musician named Geeta Sarabhai, who came to New York from India to study Western music. She and Cage planned an exchange: he would teach her counterpoint and contemporary music, while she taught him Indian aesthetics. When Sarabhai returned to India, she left Cage with a concept that she had gleaned from her teacher in India, regarding the "purpose" of music: "To sober and quiet the mind, making it susceptible to divine influences."[35] A recurrent quote in the Cage literature, it bears further consideration. Rather than referring to the performance of a piece of music (only), it also addresses the performer (as a listener). Beyond the notions of meditation that the phrase might also evoke, *susceptibility* suggests a different kind of hearing and/or perception, and a new, as yet unimaginable degree of openness. Introduced as a compelling model of receptiveness, through its repeated citation, this piece of "wisdom" and the place from which it emanated become catalysts, which Cage would use to undermine the powerful position of Western music. At the micro level, the concept is intended to condition the subject to absorb change, to be able to receive all manner of noises, and to be open to a horizon of as yet unfathomable technologies. At the macro level it posits "Asia" as the inspiration and point of reference for new approaches to music.

At this point, we are able to discern the beginnings of a Cagean system, where the force of his declared inspiration, whatever it is at the

time, becomes less significant than his skill in converting it to something like a symbol. In 1946 Cage initiated a new direction in his work in the form of a lecture called "The East and the West," which contained his first formal reference to Coomaraswamy. David Patterson notes that the reference is modest but auspicious in that it "signals the new role of Asia in Cage's creative thought and anticipates what would become his extensive use of Asian concepts and terms in his own aesthetic rhetoric."[36] In describing what amounts to a new rhetorical strategy, Patterson offers a striking choice of words, announcing that from this material: "Cage shaped his first *genuine* 'collection' of appropriations."[37]

For all the suturing of Cage and Coomaraswamy in the Cage literature, according to Patterson the two did not occupy common ground in terms of aesthetics or philosophy. But if the Coomaraswamy reference was going to function in the emergent system of appropriation, it could not hover as an ambiguous signifier. If anything, the differences between the two figures' thought reveal Cage's strategic use of Coomaraswamy, as Patterson explains it: the "divergences illuminate the nature of Cage's appropriative subversions."[38]

From Coomaraswamy Cage gleaned another crucially *Other-directed* mantra, which stated that rather than self-expression, the purpose of art is "to imitate Nature in her manner of operation."[39] A staple of the literature, Cage's deployment of the term *nature* has often seemed problematic, whether tainted by the bad name given to it by certain groups who embraced it (the hippy counterculture of the 1960s and 1970s, for instance) or undermined by damning critiques such as Theodor Adorno's comment that Cage "appears to ascribe metaphysical powers to the note once it has been liberated from all supposed superstructural baggage [and] this destruction of the superstructure is conceived along botanical lines."[40] However, Cage's fluid signifier, *nature*, like the *landscape* signaled in his "Imaginary Landscape" scores (all treating technology), now reads as extraordinary shorthand for the idea of an incalculable but utterly structured system—familiar, omnipresent, and always potentially dangerous. In Cage's usage, the term *nature* comes to evoke unquantifiable *operations*, networks constantly creating new micro/macro systems and ecologies.

Foucault provides a different perspective on Cage's use of "nature." As he tracks its changing definition, Foucault identifies the horrifying historical function of this term: "the 'nature' on which [prohibitions] were based was . . . a kind of law."[41] Parallel to the retooling of the concept of *nature* is the impact of *life's* entry into the political system:

For the first time in history, no doubt, biological existence was re-
flected in political existence; the fact of living was no longer an in-
accessible substrate that only emerged from time to time ... ; part
of it passed into knowledge's field of control and power's sphere of
intervention. ... If one can apply the term *bio-history* to the pressures
through which the movements of life and the processes of history
interfere with one another, one would have to speak of *bio-power* to
designate what brought life and its mechanisms into the realm of
explicit calculations and made knowledge-power an agent of trans-
formation of human life.[42]

As in his model of *discourse*, Foucault accounts here for flaws in the
system that render it vulnerable or at least suggest that it can be turned
to opposite ends: "It is not that life has been totally integrated into tech-
niques that govern and administer it; it constantly escapes them."[43] In this
light, Cage's concept of creative practice echoing "nature," as an aspect of
a changing technological "landscape," seems as apt as it does ambitious.[44]
Deploying the term *nature* at a crucial, transitional moment in his own
work, Cage was able to engage a new resource, a force of neutrality, self-
governing, and changing, that would refute the notion of a unidirectional
source of power. This was the force that would drive his initial *operation*; it
was his antidote to expression in music.

The Turn of the 1950s: Dismantling Forerunners/Transcending Disciplines

In March 1949 Cage published an essay titled "Forerunners of Modern
Music" in a journal devoted principally to modern art and the emerging
generation of abstract expressionists, *The Tiger's Eye*.[45] Striking out at his
own foundations, Cage explained, "the disintegration of harmonic struc-
ture is commonly known as atonality," which has led to musical ambiguity.
The most crucial "problem" for the contemporary composer according to
Cage was "to supply another structural means."[46] And incidentally, "Nei-
ther Schoenberg nor Stravinsky did this."[47]

Gesturing to the potential of *structure* beyond his own discipline,
the distinctive typographical layout seemed to echo his arguments about
(musical) structure through textual means. With categorical headings
("The Purpose of Music," "Definitions," "Strategy"), a range of font
sizes, and continual deployments of diverse philosophical sources, Cage's
method of investiture begins to take an assertive and systematic form.[48]
After a didactic description of "what rhythm (actually) is," Cage moves

to a dispassionate definition of rhythm as "relationships of lengths of time"—as if he thought it necessary to reskill in order to deskill. He amplifies this move in a significant footnote: "Measure is literally measure—nothing more, for example, than the inch of a ruler—thus permitting the existence of any durations, any amplitude relations . . . any silences."[49] Pritchett indicates the territory being charted in this part of the essay: "What is new here is the description of rhythmic structure without any mention of measures, phrases, or sections—in other words, without any musical, expressive, or syntactic implications at all."[50]

The "Forerunners" essay is an early indication of Cage's emergent ambitions for an aesthetic program relevant to advanced artistic practice at large.[51] Just as he had transcended "expression" in his own work, he found himself in the midst of a rising art movement devoted to just that. And as Cage was developing a new model of "nature," the leading protagonist of this expressive painting, Jackson Pollock, was also aligning his practice with nature. Given such a context, Cage's choice of "sand painting" as the metaphor through which he would clarify his project in the "Forerunners" essay is striking. Pollock had famously pointed out the relevance of "the methods of the Indian sand painters of the West" in a rare statement on his art published in the journal *Possibilities* (of which Cage was an editor).[52] Pollock's drip painting—then gaining a great deal of notoriety—clearly had mobilized chance and temporality. But it/he did so in a manner antithetical to Cage's project in every way. It was chance in the service of expression, and manifest unstructure as opposed to (Cagean) structure. Cage chose to discuss "sand painting" both in the "Forerunners" text and in a lecture at the abstract expressionist forum, the Artists' Club on 8th Street in New York City, in the same period (spring 1949).[53] In both contexts, he appropriates the function of sand painting to stake the claim that pure, ephemeral temporality belonged to music, and *its* arena of performance. "Sand painting," he argued, had nothing to do with *painting*, "permanent pigments" were ineluctably part of "posterity's museum civilization."[54] With the publication of the "Forerunners" text, and the first of several lectures at the Artists' Club, Cage had infiltrated a new artistic arena and created much higher stakes for his discipline-rupturing operation on composition.

Lecture on Nothing

One evening in 1950, Cage walked onto the stage before the usual audience at the Artists' Club to deliver his "Lecture on Nothing." "I am here,"

he began, "and there is nothing to say." For all its brevity, this opening line also included *spacing* and *silences* in addition to the words. Continuing, Cage used all events—some planned, many circumstantial—to perform his emergent concept of composing as a palpable operation to be apprehended as it unfolded. "This is a composed talk," he stated, "for I am making it as I make a piece of music."[55] And he was making it on the spot. Of course, the text was written out in front of him, but beyond that, the conditions of its delivery—the silences, the rhythm, the slippages within the structure of repetition, the concrete circumstances at the venue, and the mood of the audience—all contributed to Cage's performance. The accumulating reality in that contained space at the Artists' Club built the first presentation of the "Lecture on Nothing." "It is like an empty glass," he said, "into which at any moment anything may be poured."[56]

A chief device of the "Lecture on Nothing" is its complex process of dismantling and recomposing statements via a resolved series of *positive negations*, which circulate through the lecture: "I am here and there is nothing to say"; "I have nothing to say and I am saying it"; "we possess nothing"; "nothing is anonymous."[57] Through the use of affirmative verbs—"to be," "to have," "to possess"—juxtaposed with nouns that express negation, Cage constructs a dissolution of simple opposition. The sense of ambiguity—the momentary feeling that equally positive/negative values can be derived from the same clause or sentence—turns out not to be ambiguity at all, but the beginning of a convincing dualism, introduced by means of a performance.

In format, content, and execution, the "Lecture on Nothing" revealed a dramatic shift in Cage's thinking; he had moved away from the earlier South Asian and medieval mystical references and into East Asian sources such as Taoism, Buddhism, and Zen. As Patterson describes it, Cage's introduction of this philosophical material into his discourse was not a gradual process, but a "sudden influx" of new terms and concepts in 1950 (marked in what he calls the "rhetorical lurch" between "Forerunners of Modern Music" and the "Lecture on Nothing"). "The 'Lecture on Nothing' is rooted in a startlingly new and well-developed rhetoric," Patterson explains, the beginning of a systematic "use of 'paradox' [that] became central to Cage's rhetorical strategy of this period."[58] For Patterson, "Cage's network of East Asian rhetorical appropriations" in this lecture is not only "elaborate" but is among "the most provocative to be found in his prose."[59] The composer recognized that the extraordinary model of negation in East Asian thought did not actually amount to

negation but rather a mode of receptiveness that could help him generate a countermodel of listening in relation to that of Western music. Irrefutable in its authenticity, it could be deployed to destabilize conventions. A dynamic model of thought, it could authenticate the *change* that was quickly becoming the conceptual core of Cage's practice.[60]

One of the most significant concepts in the "Lecture on Nothing" again involves Cage's programmatic elaboration of "structure" in his work. He characterizes it as "a *discipline* which, accepted, accepts whatever."[61] "Structure" would ultimately materialize as the matrix that Cage would keep adapting in order to apprehend changes in the sound environment. His treatment of the material of the lecture had multiple aims. If the new philosophical foundation permitted the negation of traditional content, and the assertion of gaps and silences, the six "stock" answers that Cage prepared in advance for question time—as his retorts to no matter what question he might be asked—asserted a calculated dimension of performativity.[62]

This lecture model was developed both to echo and instantiate Cage's aims in composing. Pritchett observes that the "Lecture on Nothing" is derived from his sound-gamut work on composition. Its key idea is that sounds, within a structure, should be allowed to *be themselves*, "free of the intellect."[63] This is indeed a critical feature of the model of discourse, or more properly, counterdiscourse, that Cage was beginning to construct. In light of Foucault's diagnosis of discourse as the organization of life into laws and their microstructures—the disciplines—Cage's interest in stopping the disciplining acts of the intellect deserves our attention.[64] Ostensibly, the discipline to which he is attending is music: he creates the conditions for listeners (including himself) to be open to *anything that happens*, to the actual sounds of the world, and thus to a whole new landscape of fluid content. More generally, Cage begins here to exemplify his repudiation of the fixed ideas that the disciplines impose on subjects and objects. By filling his rhythmic structure with words, and by subjecting the lecture format to a staggered temporality that overrides standard channels of textual meaning, Cage demonstrates the scope and potential of his new methods of composing. He troubles the conventions that structure music and pedagogy (harmonic progression, narrative order), disqualifying the established "rules" of the particular disciplines on which he is drawing. "Each moment presents what happens. How different this form sense is from that which is bound up with memory: themes, and secondary themes; their struggle; their development; the

climax; the recapitulation," he announced.[65] Meanwhile, in this same process, Cage was conditioning his audience's perceptual capacities, exposing them to a new field of stimuli arriving in an unfamiliar order, or no order.

At a formal level, the "Lecture on Nothing" deployed "repetition" in several catalytic ways: as the *exact repetition* of words and phrases appearing at different stages in the progression of the "argument," which generate a false sense of predictability; and as *near repetition*, which drew attention (à la Gertrude Stein) to subtle semantic differences wrought by the same words in kaleidoscopically shifting constellations inflected by timing.[66] This allowed Cage to place emphasis on temporal or rhythmic structure as it defines the whole, while seemingly emptying the "composition" of content in any conventional sense. To grasp the scope of Cage's *operation* in the "Lecture on Nothing," one must resist the fairly natural response of frustration with what appears as its difficult, halting, and willfully eccentric format, which would become more insistent in his subsequent lectures. All of these intricate elements are better read as "information." Cage's lectures are denatured by attempts to draw "meaning" from them conventionally, or by expecting from them a didactic decoding of his practice.

The "Lecture on Nothing" is Cage's first abrasively performative act to define a space for changing technological demands on the senses. Dismissing the obsolete, subjective concept of "beauty," he remarks, "Beware of what is breathtakingly beautiful, for at any moment the telephone may ring or the airplane may come down in a vacant lot."[67] Shifting older more proprietary models of authorship and creativity, Cage introduces ideas of susceptibility, receptiveness, and even connectivity. In its approach to convention, its fluid treatment of time, the "Lecture" advances what I would argue is an early "poetics" of the postmodern:

> Our poetry now is the realization that we possess nothing. . . . We need not destroy the past: it is gone; at any moment, it might reappear and seem to be and be the present. Would it be a repetition? Only if we thought we owned it."[68]

In his definition of postmodernism some three decades ago, Fredric Jameson singled out "the more temporal arts" and the emergence of "deep constitutive relationships" to "technology."[69] To represent the implications of these relationships, he invoked the Lacanian model of a

breakdown in the signifying chain, which generates "an experience of pure material signifiers," and cited an experience of Cage to reinforce his point:

> Think, for example, of the experience of John Cage's music, in which a cluster of material sounds (on the prepared piano for example) is followed by a silence so intolerable that you cannot imagine another sonorous chord coming into existence, and cannot imagine remembering the previous one well enough to make any connection with it if it does.[70]

This new structuring of time—and *remembering*—is an aspect of the postmodern condition in which Jameson recognizes "the waning of our historicity," and with it "a strange occultation of the present."[71] Both phenomena foreshadow the conditions of the critic's larger model of "pastiche." For Jameson, postmodernist pastiche amounts to "blank parody," and it demonstrates "the enormity of a situation in which we seem increasingly incapable of fashioning representations of our own current experience."[72] Cage's "pastiche," or what we have been identifying as his "appropriation" of sources, from Schoenberg to Zen, develops Jameson's inkling about his music into a complete discursive system, one that redefines what it might mean *to "represent" current experience.* As distinct from the superficial (albeit pervasive) effect Jameson diagnoses, pastiche in Cage is less an effect than an ambitious and programmatic operation. It is the recognition of Cage's performative apparatus that makes this difference visible. That Jameson fails to read Cage in this way stems from the fact that he bases his argument on early work—music made for the prepared piano—and not on Cage's complete project.[73]

Changes: Chance and Silence

Cage walked out in front of the audience at the Artists' Club on 8th Street one more time in 1951. As if mirroring the previous year's presentation, this time he offered a "Lecture on Something." A great deal had changed in the meantime. And with major new directions came performative lectures *to invest* them. Interestingly, the "Lecture on Something" was announced as a lecture about Morton Feldman, one of Cage's closest peers. Feldman had just created an innovative "graph" score with undetermined (as opposed to "indeterminate") elements, leading the way toward a new potential

for the score (e.g., *Projection I*, 1950).[74] Apparently, Cage recognized the conceptual scope of this invention and felt the need to enter it into the *counterdiscourse* he was developing. It seemed that Feldman had touched on an aspect of what Cage planned to do more comprehensively. At this moment Cage was involved with the idea of "no-continuity," which, in the "Lecture on Something," he attributed to Feldman, only to give it a particularly Cagean gloss: "No-continuity simply means accepting that continuity that happens. Continuity means the opposite: making that particular continuity that excludes all others."[75] Tellingly, when Feldman was asked what he felt about this lecture on him, he replied, "That's not me; that's John."[76] If the "Lecture on Something" constituted another kind of Cagean appropriation, the appropriation of new musical territory, Cage's magnum opus, *Music of Changes* (1951), would amount to a concrete, performative, consolidation of this takeover.

In the wake of Feldman's graphic score, Cage changed the composing strategy of the last part of *Concerto for Prepared Piano and Chamber Orchestra* (1950–1951), the piece he was working on at the time.[77] This led to *Music of Changes*, Cage's first work composed entirely out of chance operations. From the seventy-page score of the *Concerto for Prepared Piano and Chamber Orchestra* Cage did not go simpler—this was a founding moment—the score became more complex, multifaceted, and elaborate in its operations. *Music of Changes* ultimately ran to eighty-six pages. Among the many reasons for the critical importance of this composition in Cage's project is its exhaustive redefinition of the composer's function by recourse to the *I Ching*. Fracturing the authorial act through the systematic use of chance operations, Cage sought to define a newly dispersed subject model, on the one hand, and a *spatial* field filled with unpredictable musical "events," on the other.

Cage's atomization of the parts of the composition—as independent events, rather than the interdependent components of conventional musical continuity—created a new, more neutral correspondence between time and space in the score. The chart system that Cage used as a tool for composing clarified the means by which he could move beyond old habits and his own subjectivity. Sound charts, durations charts, and dynamics charts fractured every part of every "event." The neutral, uniform, eight-by-eight cell structure of the charts, which corresponded to the sixty-four-cell hexagram chart in the *I Ching*, meant that Cage could toss coins, obtain a hexagram, and then match its number to the corresponding cell in whatever property chart he was using. Because each event

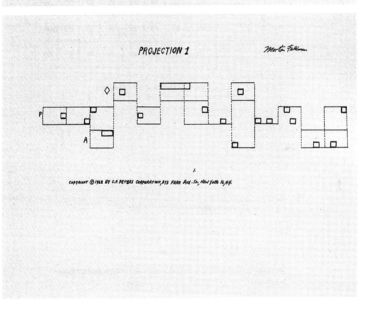

Figure 8.2 Morton Feldman,
Projection I, 1950, prefatory
notes and page one. © 1961.
Used by permission of
C. F. Peters Corporation on
behalf of Henmar Press Inc.

was created through recourse to no less than three charts, Cage could be assured that he would not be imposing his own intentions on each constellation of sounds.

Several events during the composing *Music of Changes* contribute to its complex and ambitious statement. The one most often mentioned is Cage's meeting the virtuoso pianist David Tudor in 1949. Tudor worked on the entire composing process with Cage; he performed each part as soon as it was ready, allowing Cage to progress with a sense of how his new techniques were working. If Tudor's devotion constituted tremendous support, Cage's correspondence with Pierre Boulez, whom he had also met in 1949, perhaps functioned with equal and opposite force. The contact with Boulez adds the consciousness of a European counterpart, who told Cage, "We are at the same stage of research."[78] The third event of great significance in this period was Cage's fabled visit to the anechoic chamber at Harvard University in 1951.[79]

The Anechoic Chamber, Technology, and the Landscape of the Postmodern

The period 1950–1952 was critical in the development of what we might think of as a Cagean system. The "Lecture on Nothing" generated a textual enactment of his new deployment of structure, and positioned Eastern philosophy as the touchstone of his practice; it cleared the way for a new field of experimentation. Soon thereafter, the "Lecture on Something" (1951) *appropriated* Feldman's advance for the new discourse, and the vast and complex *Music of Changes* then definitively staked Cage's claim to the new musical territory being charted. More ephemeral and anecdotal, Cage's visit to the anechoic chamber would turn out to buttress the whole. Taken together, these events become the marks of symbolic investiture.

Cage's visit to the anechoic chamber has developed into a crucial origin story marking a "founding" moment: the founding of his concept of "silence." At this stage of the history, it is crucial to separate the anecdotes—whether true or false—from the symbolic value that Cage gave them to articulate his aims. The raw material of the anechoic chamber story is that Cage entered this putatively "silent" environment, and proceeded, in a sense, to defy technology with his listening capacities, managing to hear, after a while, two distinct sounds: his blood in circulation and his nervous system in operation.[80] If the interpretation of these sounds seems far-fetched, Cage anticipated that reaction; in later

retellings, he relinquished his own claim to this part of the story, instead attributing the diagnosis to the engineer at Harvard.

Cage made the event critical because of what he said about it. As he told and retold the story, the point became that in a space where all the sound is removed, one still hears something—sounds one does not intentionally make—and therefore that sound is not governed by intentionality. The story is crucial not only for what was being instated but for what was being dismantled. The model of symbolic investiture with which we began, the case of Daniel Paul Schreber, has at its center the concept of "unmanning" (*Entmannung*). For the many readers of this case, notably Jacques Lacan, this will to dismantle a powerful system, from individual subjectivity outward, is what makes it "symbolic." In opposition to his own field of the law, which reflects the social order at large, Schreber develops a new vocabulary of symbols by which he is able to dismantle that system *for himself*. Lacan speaks of a "signifying chain" through which Schreber creates his survival model of unmanning, which, Lacan insists, must be read symbolically rather than literally.[81] The extraordinary relevance of this model for our reading of Cage's developing system of symbolic investiture is in its parallel strategy. Cage's moves are negations—albeit rendered positive philosophically and structurally in his work—modes of unmanning his own discipline, its systems, and even its content. The anechoic chamber event, which Cage converts to a critique of intentionality, is the symbol of this process *par excellence*.

The anechoic chamber provided a concrete form, even an architecture, for all Cage's previous "negations." In his polished account, the chamber accomplished a number of feats: it made the space of *no-sound* physical, it made the nonintentional palpable, and crucially, it ushered in these new theoretical premises under the auspices of "technology." Vital in Cage's retelling is that the protagonist, a composer, had an experience of sound that he could not instantly identify. Strategically, Cage first *unmanned* himself, deskilling the masterful arranger of sound, the composer, in order to *unman* the priority of Western music and its laws. It is not a mere detail in the story that he deferred to the Harvard engineer; this is what accomplishes the symbolic unmanning, both micro and macro. Cage would use this "expert" explanation of sound under "silent" conditions to *authorize* his next moves. This technologically created environment—with its silence punctuated by incidental sound—begins to make the structured spaces that Cage generated, exhaustively, in the *Music of*

Changes infinitely more meaningful. The complete story (developed ret-
roactively) created a profound logic for Cage's next two landmark scores:
Imaginary Landscape No. 4 (1951) and *4′33″* (1952).

For Cage, musical expertise had limited what could be composed to
a stifling degree. If the anechoic chamber is an environment in which the
subject is sound, its palpable (and putatively empty) physical space mate-
rialized as a countermodel to the sonic plenum controlled by composers
and allowed Cage to redefine sound as part of a *spatial* field. Pritchett
explains that the concurrent chance techniques with which Cage was
working freed him from musical form, opening up a new idea of "infinite
space." He adds that Cage would spend "the next decade finding com-
positional methods which ... would make more of that space available
to him."[82]

In *Imaginary Landscape No. 4*, a work often considered alongside *Mu-
sic of Changes* because its composing methods were the same, Cage at-
tempted to render this new, desubjectivized "sound-space" mediated by
technology as a score/performance.[83] The "instruments" for the piece are
twelve radios, operated by twenty-four performers (two on each: one for
tuning, one for volume), perhaps implicitly confronting the formidable
"twelve" of Schoenberg.[84] The move made in *Imaginary Landscape No. 4*
is as striking as the voiding of composerly intention in the subsequent
4′33″—though the two scores are rarely examined side by side—and its
symbolic move is as great. Given that *Imaginary Landscape No. 4* includes
whatever will come up in the radio broadcasts, its sounds cannot be pre-
dicted.[85] Since Cage was not a fan of radios, this score reveals all the more
clearly his efforts to contend with the inevitable changes that audio tech-
nology brought to the field of perception; this is the first such instance,
of which many more would follow. By confronting what he found anti-
thetical to the composer, Cage mediated the function of authorship and
the effects of technology, qualifying the power of both, to reclaim some
agency for the subject. Explaining this score, he wrote:

> It is thus possible to make a musical composition the continu-
> ity of which is free of individual taste and memory (psychology)
> and also of the literature and "traditions" of the art. The sounds en-
> ter time-space centered within themselves, unimpeded by service
> to any abstraction, their 360 degrees of circumference free for an
> infinite play of interpenetration. Value judgments are not in the
> nature of this work as regards either composition, performance, or

listening. . . . A "mistake" is beside the point for anything that happens authentically is.[86]

Technological means thus dismantle the traditions of music and restructure attention. Generating the idea of a "landscape" with a cluster of twelve radios as the expanded field of the contemporary "imaginary," Cage used the piece to give a new form to the unpredictability he was introducing into the act of composing. *Imaginary Landscape No. 4* positioned the work as part of a network of communication in which perception is subjected to *reception*.

4′33″

Cage's renowned score, *4′33″*, is at the center of the most comprehensive period of change in his oeuvre. However, its vast notoriety derives in large measure from the fact that it has been simplified, and also that it is usually understood as one definitive thing. *4′33″* is situated between two Cagean landmarks: "Silence" and "Indeterminacy." A more hybrid object than is commonly surmised, Cage completely changed the score at least three times in the course of the 1950s, as he extended the concept of chance operations in composing to indeterminacy in the realm of performance. In a process that included his parallel work on lectures, the changes in the format of the score reflect a period of consolidation and expansion. *4′33″* spearheaded Cage's aims to shift the foundations of the discipline of music, which opened out conceptually to a redefinition of the creative act. As a dismantling of the composer's power of authorship and control—with a new emphasis on "receptiveness," and "nature" (as incidental sound)—it is the very inscription of Cage's *unmanning* of musical convention.

An "empty" score with only a temporal framework (defined initially and then later removed), *4′33″* gave Cage's stunning assertion of "silence" a notated form. In effect, he realized the contained "silence" of the anechoic chamber as a score, sutured in perpetuity to a changing world of sounds. Rarely discussed is the way in which the format of *4′33″* actually developed with Cage's rhetoric; both were directed toward what he needed that score to accomplish as the decade unfolded. The first version of 1952 was measured out on grand staff pages, albeit emptied of notes, asserting the way in which chance can compose "nothing" as well as "something"—that time is all that need remain to concern the composer. The second, graphic, line-drawing version of 1953 opened Cage's project

to an intervention beyond the confines of music since it was linked to the landmark statement of Robert Rauschenberg's *White Paintings* (1951).[87] Making this point allowed him to suggest that the "statement" of *4′33″* brought music into sudden alignment with advanced art. It was an ambitious move, which he evoked as a highly conscious act. With brevity, and artful humility, he managed to position himself as representing the most advanced position in "music." Cage said he *had* to write *4′33″*: "otherwise I'm lagging, otherwise *music* is lagging."[88] The inference being that having written it when he did, the stakes were changed.

The third version of *4′33″* was written in the late 1950s. As Cage had largely dispensed with the score per se, as he established his concept of indeterminacy, this version took the form of pure text. Three words—tacet, tacet, tacet—defined three movements, separated on the page by roman numerals: I, II, III. There was no timing. The score included a note at the bottom of the page describing the specific temporal unfolding of the first performance, since the "reader" had little else to go on. The description of the August 1952 realization implied that those timings

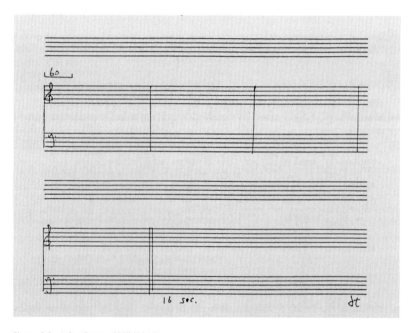

Figure 8.3 John Cage, *4′33″* (1952), drawing by David Tudor. Used with permission.

Figure 8.4　John Cage, *4′33″* (1952),
excerpt from 1953 line version.
Used by permission of C. F. Peters
Corporation on behalf of Henmar
Press Inc.

were circumstantial. Cage later commented to Richard Kostelanetz that movements were not actually needed anymore, adding that he did not even need *4′33″* anymore.[89] Over the three versions, the score became less obviously musical—first dispensing with staff lines, then time measures—and seemingly more abstract. Another way of thinking of this is that *4′33″* became *symbolic*. The fact that Cage spoke of needing/not needing *4′33″*—an odd observation, made of this piece alone—indicates the value of this unfathomably open composition as more symbol than score. If Cage's "silence" signified a dismantling of musical convention as well as intention, *4′33″* was its first important matrix of articulation. The three versions of *4′33″* developed this theoretical position progressively: (1) by removing musical notation, in the 1952 version; (2) by echoing (if not rivaling) advanced painting using the template of a score in 1953; and (3) by converting the musical notation to a textual proposition.[90]

Turning back to Schreber and unmanning, we can consider again the ways in which an authoritative system functions at several levels, above all, at the symbolic level. The example of Schreber, a subject undone by power, has allowed theorists such as Santner to sketch important symbolic connections between law—or "legislative" and, by extension, disciplinary functions—and the modern subject. The elaborate patchwork of symbols and authority figures that Schreber develops as his "recovery mode," might be read as another model of pastiche. As noted at the outset, the symbols of power in the Schreber account appear sequentially as so many simulacra. They are generated by a subject who has relinquished a deterministic patriarchal order to the extent that he is able to figure, even arrange its operations, at least as a partial map, in order to survive.

Such an operation of pastiche as recovery illuminates Cage's "unmanning" of musical composition. In Cage's case, it was not the frail, pathologized assembly of a partial map but the assertion of a thoroughgoing countermodel to power and convention, *invested* through an inventive, performative system of pastiche. Schreber's fragile, susceptible, even masochistic relation to daily stimuli, a reaction to a set of power relations that he previously controlled—in his "healthy" state as an arbiter of the law, as supreme court judge—is a condition of extreme responsiveness analogous to that by which Cage unmans the composer as well as the performer, and empowers the listener. Schreber's state as an open, hypersensitized, receiver, converts the bounded modern subject into a dispersed, uncentered process. The Cagean score—as a desubjectivized matrix of relations—effectively performs this radical dispersal of

subjectivity on the unidirectional control of composing. With *4′33″* the composer gestures toward such receptive conditions, asserting a fragile structure to evacuate old content. What we are left with is a new dynamic between composer-performer-audience, without the power relations, an *unmanned* creative (un)structure, in a word: "indeterminacy."

Experimental Music and Performativity

Cage established the term "Experimental Music" in the course of the 1950s through a series of lectures, performances, and writings. In 1955 he initiated a more systematic testing of the lecture-demonstration model and its performative effects and began to formulate his theories in writing.[91] The three important texts, in varying formats, were: "Experimental Music: Doctrine" (1955); "Experimental Music" (1957), a lecture, also published on the occasion of Cage's twenty-five-year retrospective concert in New York in 1958; and "History of Experimental Music in the United States," commissioned in 1959 by Wolfgang Steineke, director of the Internationale Ferienkurse für Neue Musik at Darmstadt.[92] If these three texts constitute three different acts of performative investiture, Cage's arrangement of them in *Silence* may be seen as a fourth such act. Immediately after the first item in the book, the trailblazing lecture "Future of Music: Credo," Cage inserts the second of the three texts—the most overtly performative one, and the only lecture. Given that he also published this on the occasion of his retrospective, he clearly perceived this lecture to be his strongest statement to date.

"Experimental Music" (1957) begins in an almost casual manner with Cage describing how he used to object to the term "experimental" because it seemed to mean that composers did not know what they were doing. As he seeks to inform his audience of the contrary, he *performs* what comes across as *his own* getting of wisdom. He speaks of the realizations that have not only reconciled him to the term, but rendered it central. Once again strategically opposing a reskilling to a deskilling—using one performatively to justify the other—Cage speaks of his use of the term "experimental" for all the music he now considers important. This paves the way for a landmark move of unmanning, the radical evacuation of the authority position of the composer, which *he* personifies: "What has happened is that I have become a listener."[93]

Cage begins by speaking of sounds not intended, evoking new *effects*, and a new openness, which he identifies as happening not only in the

discipline of music but in art and architecture as well. He then moves to the anechoic chamber account, reiterating its representation of technology's role in perceptual experience. Again, he refers to the engineer who decoded the enigmatic sounds for him. This important *authorization* leads him to a reiteration of the model of the nonintentional—or a turning away from the intended—and a second grand unmanning: "This turning . . . seems to be a giving up of everything that belongs to humanity—for a musician, the giving up of music."[94]

The earlier "Experimental Music: Doctrine," positioned second in *Silence*, is more distanced. Announcing the central idea that "Experimental Music" has no truck with judgments regarding "success" and "failure," Cage creates his own performative model of *authority*: the text is structured as a dialogue comprised of a student's questions, followed by answers that the composer wishes to advance. If the title "Experimental Music: Doctrine" hints at the aim of investiture, the dialogue's "scientific" distance performs that work. After the seemingly casual monologue of the "Experimental Music" lecture, this one assumes a formality, shifting the voice from the first person to the third. "Objections are sometimes made by composers to the use of the term *experimental* as descriptive of their works."[95] The third person abets the performativity as Cage redefines events that happened *to him* in the guise of neutrality. "One enters an anechoic chamber," he states.[96] The dialogue culminates in the dismantling of the key power relationship at the heart of music, as the teacher voice exclaims: "Composing's one thing, performing's another, listening's a third. What can they have to do with one another?"[97]

By the time Cage wrote the *third* "Experimental Music" text he had presented the ideas in many ways—in the form of lectures throughout Europe and increasingly theatrical performances—to illustrate his model of indeterminate composition.[98] Titled "History of Experimental Music in the United States," it starts by dismantling the idea of a *history* with a *story*:

Once when Daisetz Taitaro Suzuki was giving a talk at Columbia University he mentioned the name of a Chinese monk who had figured in the history of Chinese Buddhism. Suzuki said, "He lived in the ninth or the tenth century." He added, after a pause, "Or the eleventh century, or the twelfth or thirteenth century or the fourteenth."[99]

Written for a European audience, this "history" required all the strategies that Cage had built to date. In the opening salvo, Suzuki becomes *symbolic*. He represents "Asia" versus "Europe," and a new model of history, more concerned with performance and exemplification than with timeless facts.

In this third definition of "Experimental Music" Cage aligns his now resolved theoretical program with the development of "indeterminacy" in his composing practice. He proceeds to trawl the history of advanced American music of the twentieth century and enlist the major players to his purpose. The lecture is filled with names, from Cowell to Edgard Varèse, to Boulez to Stockhausen, to his own New York circle. Cage works his "performative magic" by aligning all these figures with indeterminacy. Giving Cowell rare credit for the move of intervening in the piano strings—without stating, of course, that this was the grand precedent to his own prepared piano model—he describes several of his teacher's musical "actions" as being "close to current experimental compositions which have parts but no scores" (i.e., his own).[100]

Continuing through an extensive list of composers, Cage defines what "America" represents, a definition he aligns with "Experimental Music" in that country. "Actually America has an intellectual climate suitable for radical experimentation," Cage announced. "We are, as Gertrude Stein said, the oldest country of the twentieth century."[101] With this turning of the tables on old Europe, Cage enlists Stein to assert the position of America as the heir to modernity. Cage's purpose in the lecture, to establish his project as a "history," prompts him to advance a new definition of history itself. The "History" Cage writes for the director of the Darmstadt courses is not merely a description; it is a process activated and made meaningful through its performative language, and in its very enactment. In case we were in doubt as to the aims of these strategies, Cage's later gloss on his own history delivers this system of symbolic self-investiture in a matter of three sentences: "I didn't study music with just anybody; I studied with Schoenberg. I didn't study Zen with just anybody; I studied with Suzuki. I've always gone, insofar as I could, to the president of the company."[102]

Scoring Indeterminacy

In September 1958 Cage accepted an invitation to speak at Darmstadt and presented three lectures under the title *Composition as Process*. Through

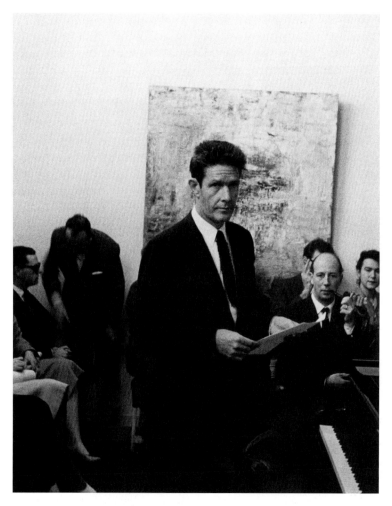

Figure 8.5 John Cage, *Music
Walk*, 1958, performance with
David Tudor and Cornelius
Cardew at Galerie 22, Düsseldorf.
Photographs: Manfred Leve.

three individual lectures—"Changes," "Indeterminacy," "Communication"—all differently challenging, Cage built a broad scaffolding for his controversial new approach to composing.[103] Immediately after Darmstadt, he and Tudor then embarked upon an intense period of writing and performing his indeterminate scores. The first of these was *Variations I* (1958), which deployed the new format of rearrangeable pages and transparencies, far exceeding the limits of the paper score.[104] Since indeterminacy would constitute Cage's most radical unmanning of modern composition, the conditions that would establish it had to be rigorous and lucid, and the audience would have to be new, open-minded, and receptive. For this, Cage returned to an art space, Galerie 22 in Düsseldorf, and the new piece performed on October 14, 1958, was *Music Walk*.

The "score" for *Music Walk* consists of twelve pages and one instruction sheet. Ten pages contain constellations of dots—numbering between two and fifty-two. The other two pages are transparencies: one sheet consists of five parallel lines, the other, of eight (three-by-three-inch) squares each containing five intersecting lines. Transparencies become Cage's emblematic tool of the indeterminate.[105] Indeed, in *Music Walk*, it is the two transparency pages that make Cagean unmanning radically explicit, radically figurative. One transparency presents "five parallel lines," which Cage never allows to be called a "stave" but which cannot help but evoke one. The other sheet offers eight different cases of five lines superimposed to form networks, multiplying that assault on the matrix of musical notation. These eight networks, joined on the transparency as a grid of squares, allow for eight possibilities, to be selected by the performer who will cut the separate cells from the grid, and select one constellation to use. The fact that the grand staff format is evoked, that the five parallel line structure remains central—it is indeed the core structure to be deskilled (as merely parallel lines), fractured (into networks), and relativized (*structure* as multiple choice)—illuminates the "symbolic" role of the indeterminate score in the ongoing project of unmanning. Having completely changed the function of the score, the transparencies—liminal and fragile—remain at the heart of the work/operation as they mediate the variables of performance.

The title, *Music Walk*, this time asserts a provocative quotidian rejoinder to "Music." Performers walk around the stage, from instrument to instrument, whether radio, piano, or other. In a Cagean strategy that harks back to the percussion debut at the Museum of Modern Art more than two decades earlier, a gallery setting and formal attire invested this highly visual performance and its unconventional instruments with seriousness

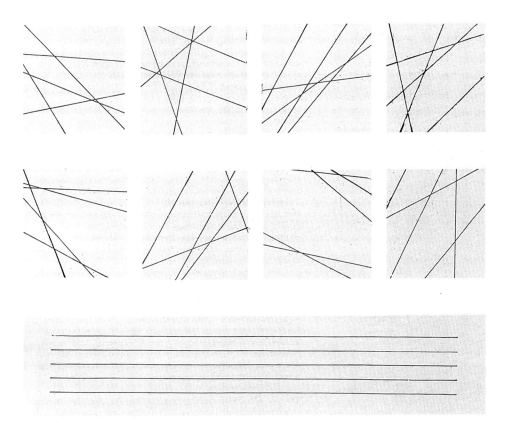

Figure 8.6 John Cage, *Music Walk*,
1958, transparencies (networked lines
and five parallel lines).

and purpose. The more than twenty performances of *Music Walk* that
Cage and Tudor booked in a period of only a few short months indi-
cates the priority they gave to *demonstrating* the execution of the inde-
terminate "score." Along with Cage and Tudor's actions, darting about
the stage, there is an ethics accompanying the unspoken conditions of
performance: "self-governing actions . . . [are] as important to its concep-
tion as the emphasis on movement."[106] In spite of its varied activity, all
its contingencies, *Music Walk* tended to look quite similar across many of
the first performances. As Rebecca Kim notes, "An issue is sometimes
made of the observable consistency of performances by Cage and Tudor
due to their written-out scores, limiting the potential variabilities of an
indeterminate work."[107]

Figure 8.7 John Cage, *Music Walk*,
prefatory notes and page 2.

Why would this be so? This significant factor belongs to a larger criticism of Cage: that even as he espoused freedom through indeterminacy, he cared very much how his work was performed. The explanation for this has everything to do with what we have been describing as the meeting of "performativity" and "performance" in Cage's project, his strategy of symbolic investiture. Just as he could not allow earlier devices such as "Schoenberg," "Coomaraswamy," or "Suzuki" to signify ambiguously, so indeterminacy had to be instituted with programmatic clarity. The "Indeterminate," like the "Experimental"—like the "Nothing" and like "Silence" before them—were Cagean concepts pulled from the ambiguity or ephemerality signified in their conventional meanings, and established by the composer as critical and meaningful neologisms; the clarity revealed across the "consistent" performances was an essential part of this process.

It is worth underscoring, in this context, the fact that Cage's "workshop" of "Experimental Composition" back in New York, his New School class, was the diametric opposite to this international program, which had begun with the series of lectures given at Darmstadt. Having participated in the experimental score-making, and associated performances in Cage's classes, Fluxus artist Dick Higgins read the "Indeterminacy" lecture from Darmstadt and was amazed by the fact that it struck him like a "legal contract."[108] This remains one of the best explanations of the function of performativity in Cage to date.

Changing Fields of Reception

Covering many different cities over several months between October 1958 and March 1959, Cage and Tudor's performances toward the establishment of indeterminacy eventually led to the exponential expansion of this mode of *demonstration* via television. Certain of the new indeterminate scores were actually written expressly for TV—including *TV Köln* and *Fontana Mix* and its offshoots: *Aria, Sounds of Venice*, and the infamous *Water Walk*. When Cage appeared on the Italian game show *Lascia o Raddoppia* in early 1959, answering increasingly difficult questions on mushrooms (over a period of five weeks), he insisted on presenting his new scores as a kind of prelude to the putative main event. A few months after its premiere in Italy, *Water Walk* was repeated on US television: on *The Henry Morgan Show* (June 1959) and on *I've Got a Secret* (January 1960). Fetterman explains that *Water Walk* consisted of "scrupulously determinate

notation." It involved a series of actions, mostly having to do with water
(using "instruments" such as a bathtub and a vase of flowers) and Cage's
staples—radios, a stopwatch, the open piano with objects on its strings,
with the significant addition of a mirror to show the audience what was
happening—to be executed in the challengingly brief period of three
minutes.[109] Cage commented on his experience of executing *Water Walk*:

> I . . . rehearsed very carefully, over and over again with people watch-
> ing me and correcting me, because I had to do it in three minutes.
> It had many actions in it, and it demanded what you might call
> virtuosity. I was unwilling to perform it until I was certain I could
> do it well.[110]

Again, for these appearances, Cage arrived impeccably dressed (albeit
in a suit as opposed to a tuxedo) armed with his trademark smile and
warmth. On *I've Got a Secret*, the host seemed complicit with the interests
of "indeterminacy," as he offered the audience the option of responding
in whatever ways came naturally, and complicit also with the process
of investiture, he quoted from a review on Cage in the *New York Her-
ald Tribune*, which he had on hand, announcing that the *Tribune* takes
Cage seriously as a composer and his music as a new art form.[111] As if
preparing for the worst, the host asked Cage whether he minded if the
audience laughed. In an elegant response that sparked that very process,
and instantly diffused any hostility, Cage stated that overall he preferred
laughter to tears. He then proceeded to execute the piece, without a
hitch, to roaring applause.

Cage's decision to demonstrate the effects of the indeterminate score
through television, a new frontier of "reception"—at a high point in
the history of that medium—reflects the inherent logic of his project.
By the time television had fully arrived, the very period in which Cage
was canvassing indeterminacy, he could enlist it as a kind of "subtext," or
as another vehicle of an ever-widening concept of "composition" and
"communication."[112] If the score, in its many forms, always mapped a
field of future attention, TV was being developed increasingly to con-
trol that "open market." Time, relationality, and the networked circula-
tion of source material constituting the new ether of the televisual, were
echoed and rearticulated in the mutating field that Cage's discursive
model of *pastiche*, and his "Indeterminate Compositions" had set in rela-
tion to the macro conditions transforming attention. In order to render

his composition relevant, Cage put to use all the devices we have out-
lined—modes of performativity from the discursive, to the visual, to the
theatrical—implacably looking to new conditions of reception for his
music. Lest we conclude that this was directed only at self-investiture,
these *devices* must be recognized as occupying critical positions within the
field of constantly modified power relations—between modernity and
postmodernity—that Foucault had diagnosed as "disciplinary" and Gilles
Deleuze would update in terms of "control."[113]

Following Foucault, Jonathan Crary characterizes attention as having
taken shape as an "object" in the course of the twentieth century, in rela-
tion to the organization of labor and subjective desire more generally.[114]
Such a formulation of the sphere of "attention" crucially illuminates
Cage's repeated assertion that he was making *processes* not *objects* as a di-
rect confrontation of the objectification of attention. For Crary, the mas-
sive organization of attention through the advancing media developed
over the past century constitutes a reconfiguration of the disciplinary
mechanisms identified by Foucault; that is, those discursive and disci-
plinary frameworks with which we (and Cage) began. Cage's constant
adaptation of the score, his systematic restructuring of the relationships
between composer and audience, and the discourse he enacted to estab-
lish these moves—culminating in the television appearances he used to
launch indeterminacy—taken together, give an indication of the broad
scope of his project. The charged relationship between visuality, attention,
and control—which Cage continually tried to change and modify in his
work—has become ever more relevant: "Attentive behavior in front of
all kinds of screens," Crary writes, "is increasingly part of a continuous
process of feedback and adjustment within what Foucault calls a 'network
of permanent observation.'"[115] Against this very dominance of the visual,
Cage pitted the dispersal of power relations, creating new composition
tools, and new "composers" (artists as well as audiences).

Cage's exhaustive work on composition and on the investiture strate-
gies this seemed to demand began in earnest when he first eradicated the
functions of subjectivity and expression from his work, confronting the
question: How do you subtract the author and "authorize" the act at the
same time? They were developed in recognition of the public sphere that
would govern (colonize?) the creative act, and indeed, all communication.
Cage used every mechanism at his disposal to render his project as an
intervention into a larger system, while simultaneously unmanning the
discipline of music, which was his platform, through an evolving "chain

of signifiers" he created from scratch. Perhaps most radically of all, Cage's lifelong project—of deskilling, disempowering, unmanning—brought him to the precipice of giving up music altogether in order to leave behind him an expanded concept of composition.

The late twentieth and early twenty-first century have witnessed a total transformation of the function of authorship and medium in artistic practice: from at first tentative engagements with television and manifold new media to more recent artistic declarations of a kind of obsolescence in regard to making choices (in advance) about means, tools, or a priori formats of any kind. No analysis of the history of this process can ignore the space cleared by Cage. As we have tried to show, even a partial map of Cage's model of "communication" cannot but shed light on what has followed. In redefining the "composer," and emphasizing a complex, politicized model of "organizing" the creative means (at the twilight of medium specificity), Cage left a plan for an indeterminate future.

Notes

1. Michel Foucault, *The History of Sexuality*, vol. 1, *An Introduction* (New York: Vintage Books, 1980), 100–101.

2. John Cage, *Silence* (Middletown, Conn.: Wesleyan University Press, 1961).

3. Focused likewise on Cage's voice, the initial wave of Cage literature—the primary, as well as the hybrid, primary-secondary type—followed this lead. Through the extensive collected interviews, the devoted presentation of meticulous mosaics of his statements, and the numerous quotation-heavy analyses accepting *his word* for how things went, the perspective of the composer has remained distinctly present. The many volumes edited by Richard Kostelanetz are the first important example of this, starting with the interview with Cage in his *The Theater of Mixed Means* (New York: Limelight Editions, 1968), followed soon after by *John Cage: An Anthology* (New York: Da Capo, 1970), and continuing into the 1990s and beyond. After *Silence* came the second volume by Cage, *A Year from Monday* (Middletown, Conn.: Wesleyan University Press, 1967), and several other books of writings in the same stout, squarish format as the latter, which had of course followed the format of *Silence*. The collaboration *For the Birds: John Cage in Conversation with Daniel Charles*, ed. Daniel Charles (Boston: Marion Boyars, 1981), is also a key part of this record. More recent is Peter Dickinson's *Cage Talk: Dialogues with and about John Cage* (Rochester: University of Rochester Press, 2006).

4. Eric Santner, *My Own Private Germany: Daniel Paul Schreber's Secret History of Modernity* (Princeton: Princeton University Press, 1996), xi–xii.

5. The Schreber case has captured the interest of key thinkers of the twentieth century—from Freud to Lacan, and from Foucault to Gilles Deleuze and Félix Guattari to Eric Santner—because it is a crucial account of investiture, symbolic orders, juridical and patriarchal injunctions, and disciplines in a state of emergence/cy. For a reading of the Schreber case of particular relevance to what follows, see Jacques Lacan, "On a Question Preliminary to

Any Possible Treatment of Psychosis" (1957–1958), in *Ecrits*, trans. Bruce Fink (New York: W. W. Norton, 2007), 445–488.

6. For a recent study of Cage's catastrophic "collaboration" on *Atlas Eclipticalis* with the New York Philharmonic Orchestra, whom he subsequently described as vandals, see Benjamin Piekut, "When Orchestras Attack! John Cage Meets the New York Philharmonic," in "Testing, Testing . . . : New York Experimentalism 1964" (PhD diss., Columbia University, Department of Music, 2008), 45–110.

7. Micro-macro models pervaded Cage's thought and work. James Pritchett gives a detailed analysis of the micro-macro rhythmic structures—unit groupings that relate to larger ones—in all his concert work from 1939 to 1956 (i.e., up to *Concert for Piano & Orchestra* (1957–1958). James Pritchett, "For More New Sounds," in *The Music of John Cage* (Cambridge: Cambridge University Press, 1993), 10–22, esp. 13.

8. In its counterpatriarchal ramifications, the role of women as teachers, audiences, and intellectual models in Cage's life is significant. This started with his initial study of music with his Aunt Phoebe and his deployment of Gertrude Stein's linguistic structures in (against) his high school examinations. For one account of this see Calvin Tomkins, *The Bride and the Bachelors: Five Masters of the Avant-Garde* (1962) (New York: Penguin Books, 1968), 77–78. Cage also incorporated Stein's work into his own scores ("Three Songs," 1933, and "Living Room Music," 1940); see David Nicholls, "Cage and America," in *The Cambridge Companion to John Cage*, ed. David Nicholls (Cambridge: Cambridge University Press, 2002), 15. Stein stands as an extraordinary counterfigure to Arnold Schoenberg in what we might call the signifying chain of Cage's early practice.

9. The term "performative magic" is Santner's (quoted above). Santner, *My Own Private Germany*, xi–xii.

10. Cited in Tomkins, *The Bride and the Bachelors*, 84–85. The Schoenberg mystique around Cage lingers. David Revill casts doubt on the extent of Cage's studies with him; see Revill, *The Roaring Silence—John Cage: A Life* (New York: Arcade Publishing, 1992), 47–49. Both Nicholls ("Cage and America," 16) and Pritchett (*The Music of John Cage*, 7–10) explain that Cowell was a far more significant influence on Cage than Schoenberg. As described below, a similar phenomenon occurs with Cage's extensive reference to another key "investiture figure" in his life, Daisetz Taitaro Suzuki (see note 102).

11. This statement is cited from a 1940 interview between Schoenberg and Peter Yates. See Tomkins, *The Bride and the Bachelors*, 85.

12. Pritchett, *The Music of John Cage*, 9.

13. The *nonmusical* master Cage will later enlist is D. T. Suzuki.

14. From 1949 onward, Cage radically qualified his relationship to Schoenberg in regard to his own work and the mandate of finding a new "structure" for composition (as discussed below). Despite this, Cage never annuls the symbolic function of Schoenberg in his self-representation.

15. Pritchett, *The Music of John Cage*, 10.

16. Bonnie Byrd, quoted in William Fetterman, "Early Compositions and Dance Accompaniments," in *John Cage's Theatre Pieces: Notations and Performances* (Amsterdam: Harwood Academic Publishers, 1996), 6.

17. In "What Silence Taught John Cage: The Story of *4′33″*," in the exhibition catalog *The Anarchy of Silence: John Cage and Experimental Art* (Barcelona: MACBA, 2009), 166–177, James Pritchett clearly explains how conditions of percussion were crucial building blocks for Cage. See also his chapter "For More New Sounds," in *The Music of John Cage*, 10–22.

18. John Cage, "The Future of Music: Credo," in *Silence*, 3–6. In the latter source Cage dates this as 1937; Pritchett (*The Music of John Cage*, 10) gives the less certain dating of "1937 or 1938"; Leta Miller has since corrected the date as February 1940. See Miller, "Cultural Intersections: John Cage in Seattle (1938–1940)," in *John Cage: Music, Philosophy, Intention 1933–50*, ed. David W. Patterson (London: Routledge, 2002), 47–82. It may be accidental (or symptomatic of the lecture's crucial investiture role) that in the head note in *Silence* Cage asserts the earlier date. He also mentions (*Silence*, 3) that it was printed in the brochure of his twenty-five-year retrospective. Pritchett (*The Music of John Cage*, 10) marks a difference between the lecture and "the published form (of) this 'credo'" in which the original content "is interrupted at various points by expansions of the ideas set forth."

19. Cage, *Silence*, 3–4 (text in capitals, interspersed between lower case).

20. Ibid., 3. This appears in the lower-case text, interspersed between upper-case text (my emphasis).

21. Pritchett, *The Music of John Cage*, 11.

22. The reason for the scare quotes around the term "invention" here is to qualify the oft-cited reference to Cage's invention of the prepared piano. Cage's teacher, Henry Cowell developed the "string piano" by opening the lid and sounding the strings directly. This remains the crucial precedent to Cage's invention. Cage takes some years to mention this; see, for example, his subtle reference in 1958 to Cowell's "use of the piano strings" in John Cage, "History of Experimental Music in the United States," in *Silence*, 71.

23. Tomkins, *The Bride and the Bachelors*, 90 (my emphasis).

24. Of course, by the early 1940s Cage had not yet written the works that would bring that instrument to its full potential. This happened in the middle years of the decade, culminating in his *Sonatas and Interludes* (1946–1948), to which we return below.

25. Peggy Guggenheim, Cage's New York host at the time, had also offered him a concert, but on hearing of the Museum of Modern Art date, she canceled it. Guggenheim undoubtedly grasped the astute move Cage was making in appearing before an art audience. Cage reported to Tomkins that Guggenheim was "furious" when she learned about his planned Museum of Modern Art concert. She not only canceled the concert at her gallery and her offer to pay for the transportation of his instruments across the country, but she promptly asked Cage and his wife to leave her house. Tomkins, *The Bride and the Bachelors*, 94–95.

26. "Percussion Concert: Band Bags Things to Make Music," *Life*, March 15, 1943, pp. 43–44.

27. Ibid.

28. Ibid., 44.

29. Pritchett (*The Music of John Cage,* 36) mentions Cowell and Thomson's support of Cage. In a review for the *Herald Tribune* in 1945, Virgil Thomson included a significant investiture statement against Cage's musical *father*: "Mr. Cage has carried Schoenberg's twelve-tone harmonic maneuvers to their logical conclusion … Mr. Cage has been able to develop the rhythmic element of composition, which is the weakest element in the Schoenbergian style, to a point of sophistication unmatched in the technique of any living composer." Tomkins, *The Bride and the Bachelors*, 96–97.

30. Pritchett, *The Music of John Cage*, 24.

31. Cited in Tomkins, *The Bride and the Bachelors*, 97.

32. In a striking parallel to this issue Cage saw in music, Yve-Alain Bois describes the American painters of the 1940s, first drawing on surrealism before shifting to the singular

statements of abstract expressionism as a transition "from the automatic to the autographic." See Bois, "1947b," in *Art since 1900* (London: Thames and Hudson, 2004), 349–350.

33. Cited in Pritchett, *The Music of John Cage*, 36. Since this issue arose just as psycho-analysis was becoming a reference point for abstract expressionist painters processing the strategies of surrealism, Cage's rejection of it, *for personal reasons*, is not without larger implications.

34. Ananda K. Coomaraswamy, *The Dance of Shiva: Essays on Indian Art and Culture* (New York: Sunwise Turn Press, 1918 / Asia Publishing House, 1948). The nine permanent emotions are: the erotic, the heroic, the odious, anger, mirth, fear, sorrow, and tranquility. See Pritchett, *The Music of John Cage*, 29.

35. Cited in ibid., 37.

36. David W. Patterson, "Cage and Asia: History and Sources," reprinted in this volume, 53.

37. Ibid., 52 (my emphasis). Patterson's paradoxical concept of "genuine appropriation" is a particularly productive one, given what we now recognize as Cage's cusp position between the modern and the postmodern. Hinting at the strategic appropriation I have begun to mark in relation to Cage's strategies of investiture, Patterson concludes: "The manner in which Cage incorporated Coomaraswamy into his own aesthetic became typical of the way in which he approached later sources as well, appreciating their philosophic or aesthetic tenets on a highly selective basis, then recontextualizing, reconfiguring, and in some cases transgressing the intentions and ideals of their original authors." Ibid., 57.

38. Ibid., 56.

39. Notably, Cage always retains the conventional feminine gendering of "nature" and capitalizes it.

40. Theodor W. Adorno, "Vers une musique informelle," in *Quasi una Fantasia: Essays on Modern Music*, trans. Rodney Livingstone (London: Verso, 1992), 287. Branden W. Joseph has convincingly argued against the Adorno critique of Cage, introducing Henri Bergson as a theoretical countermodel. See for example Joseph, *Random Order: Robert Rauschenberg and the Neo-Avant-Garde* (Cambridge: MIT Press, 2003), 47–54.

41. Foucault, *The History of Sexuality*, 1: 39. Foucault is specifically discussing the modern relation of "law" to sexuality: "Doubtless acts 'contrary to nature' were stamped as especially abominable but they were perceived simply as an extreme form of acts 'against the law.'" Ibid.

42. Ibid., 142–143.

43. Ibid., 143.

44. As mentioned, all his "Imaginary Landscape" scores (1–5) from 1939 onward deal with technology.

45. John Cage, "Forerunners in Modern Music," in *Silence*, 62–66. Since this was conceived to appear in print, rather than as a lecture, the peculiarities of its layout are particularly significant.

46. Ibid.

47. Ibid., 63 n. 7.

48. One section, titled "At Random," the font size (when the essay is reproduced in *Silence*) comes down to six points, the same size as the footnotes. Here he asks his readers to tighten their focus, as they squint to read the text (ibid., 64). Cage will return to this same font size for the printing of his 1958 "Indeterminacy" lecture describing the type as "pontifical." See *Silence*, 35–40.

49. Cage, "Forerunners," 64 n. 9. This atomization of units extends the first idea in Cage's "Future of Music: Credo," discussed above, where he replaced the term "music" with "the organization of sounds" (3).

50. Pritchett, *The Music of John Cage*, 47.

51. The immediate context is abstract expressionism. The essay is developed soon after Cage's first visit to Black Mountain (where he met many artists, including Willem de Kooning) and at a time when he is frequenting the abstract expressionist-run Artists' Club in downtown New York.

52. Cage was the music editor of the journal, which lasted for just one issue. See *Possibilities* 1 (Winter 1947–1948), ed. Harold Rosenberg and Robert Motherwell.

53. Cage, "Indian Sand Painting or the Picture that Is Valid for One Day," lecture, the Artists' Club, New York, Spring 1949.

54. Cage, "Forerunners," 65. Another dimension of the investiture stakes of this essay is indicated by the change of title when it was published in Europe, the same year, as "Raison d'être de la musique moderne."

55. John Cage, "Lecture on Nothing," in *Silence*, 110.

56. Ibid.

57. Ibid., 109–126.

58. Patterson, "Cage and Asia," 60.

59. Ibid.

60. Tomkins links Cage's use of "Asia" to his views on change: "A great many of the traditional attitudes of Western thought will soon be obsolete, he feels, and a great many of the older traditions of Oriental [*sic*] thought are becoming increasingly relevant to life in the West. Cage insists that the true function of the art of our time is to open up the minds . . . of contemporary men and women to the immensity of these changes." Tomkins, *The Bride and the Bachelors*, 74–75.

61. Cage, "Lecture on Nothing," 111.

62. The prepared answers can be found in John Cage, "After note to Lecture on Nothing," in *Silence*, 126.

63. Pritchett, *The Music of John Cage*, 56.

64. Foucault develops his theory on discourse in *The Archaeology of Knowledge* (New York: Pantheon, 1982) and later, to different ends, in his *History of Sexuality: An Introduction*.

65. Cage, "Lecture on Nothing," 111.

66. Gertrude Stein famously stated that she never repeats, that there is in fact no such thing as repetition. See Stein, "Portraits and Repetition," *Lectures in America* (Boston: Beacon Press, 1957), 165–208. In his essay "Postmodernism, or the Cultural Logic of Late Capitalism," Fredric Jameson refers to both Stein and Marcel Duchamp as postmodernist *avant la lettre*. See *The Jameson Reader*, ed. Michael Hardt and Kathi Weeks (Malden, Mass.: Blackwell, 2000), 191.

67. Cage, "Lecture on Nothing," 111.

68. Ibid. By "poetry" Cage means text that incorporates the structure of time. He defines it as such later in a preface to his "Indeterminacy" lecture, which begins with a discussion of the "Lecture on Nothing." Poetry is defined as such "by reason of its allowing musical elements (time, sound) to be introduced into the world of words." Cage, "Preface to

Indeterminacy," in *John Cage, Writer: Previously Uncollected Pieces*, ed. Richard Kostelanetz (New York: Limelight Editions, 1993), 76.

69. Frederic Jameson, "Postmodernism, or the Cultural Logic of Late Capitalism," in *The Jameson Reader*, 193.

70. Ibid., 211.

71. Ibid., 205.

72. Ibid., 202.

73. Unfortunately, Jameson's key example in this context is Nam June Paik, who, ironically, derived his model of "composing" with televisions from Cage. See ibid., 214.

74. In 1950–1951 Feldman initiated a groundbreaking series of graphic scores called *Projections* and *Intersections*. For one account of these see Thomas DeLio, *The Music of Morton Feldman* (Oxford: Routledge, 2001).

75. John Cage, "Lecture on Something," in *Silence*, 132.

76. It is pertinent that Cage quotes this statement by Feldman—in effect entering it into the history—in his introduction to the published versions of the "Lecture" (in its first printing, in *It Is* [1959], and in *Silence*, 128). Cage's underscoring Feldman's distancing of himself actually becomes Cage's distancing of Feldman. When *Silence* was published in 1961, Cage added the comment: "To bring things up to date, let me say that I am always changing, while Feldman's music seems more to continue than to change." Ibid.

77. The *Concerto* was composed in the period August 1950–February 1951, while *Music of Changes* started in May 1951. For an extensive discussion of the *Concerto*'s development see Pritchett, *The Music of John Cage*, 60–66.

78. Letter from Boulez to Cage, May–July 1951, in Jean-Jacques Nattiez, *The Boulez Cage Correspondence*, ed. and trans. Robert Samuels (Cambridge: Cambridge University Press, 1993), 97. At this point, Cage and Boulez had a warm and mutually respectful relationship, even if some investiture issues were probably an undercurrent of their dialogue. For a thorough account of the Boulez-Cage relationship and split see Rebecca Y. Kim, "In No Uncertain Musical Terms: The Cultural Politics of John Cage's Indeterminacy" (PhD diss., Columbia University, Department of Music, 2008).

79. For Cage's accounts of this event, see John Cage, "Experimental Music," in *Silence*, 7–12, esp. 8.

80. Evidence of Cage's performative repetition of this story to instantiate his model of silence appears in George Brecht's (June–September 1958) notebook from Cage's "Experimental Composition" course at the New School. On the first page, the first day of class, Brecht notes, "At one time Cage conceived of a sound-silence opposition, but after the anechoic chamber experience (hi-note nervous system noise, low note blood circulating) concluded silence was non-existent." George Brecht, *Notebooks*, vol. 1, ed. Dieter Daniels (Cologne: Walther König, 1991), 3.

81. Lacan, "On a Question Preliminary to Any Possible Treatment of Psychosis," 445–488.

82. Pritchett, *The Music of John Cage*, 78–79.

83. Cage links the concept of "sound-space" to the anechoic chamber experience in the New School class of 1958. After the abovementioned note on the anechoic chamber, George Brecht writes, "Events in sound-space (J.C.)." See Brecht, *Notebooks*, 1: 3.

84. Since Cage later defined his "automatic minimum" for a sufficiently diversified sound experience as *two* (radios for example), this *twelve* stands out all the more. See John Cage, "Experimental Music: Doctrine," in *Silence*, 14.

85. The first performance happened late at night, when many of the radio stations had stopped broadcasting for the evening, which produced a more silent piece than expected. Henry Cowell, who was present in the audience, was apparently disappointed that the "instruments" could not capture sound "diversified enough to present a really interesting, specific result." Cowell found it striking that such a negligible effect did not bother the composer: "Cage's own attitude about this was one of comparative indifference, since he believes the *concept* to be more interesting than the result of any single performance" (my emphasis); cited in Michael Nyman, "Towards (a definition of) Experimental Composition," in *Experimental Music: Cage and Beyond* (Cambridge: Cambridge University Press, 2002), 24.

86. Cage, "Composition: To Describe the Process of Composition Used in *Music of Changes* and *Imaginary Landscape No. 4*," in *Silence*, 59.

87. Cage would go on record, connecting the two moves, in the form of a statement in *Silence*. In the head note to his text "On Robert Rauschenberg, Artist, and His Work," Cage wrote: "To Whom It May Concern: The White Paintings came first; my silent piece came later" (*Silence*, 98). Perhaps the most developed and complex theorization of the relationship of these two works to date is Branden W. Joseph's "White on White," in *Random Order: Robert Rauschenberg and the Neo-Avant-Garde* (Cambridge: MIT Press, 2007).

88. Cage, interview with Alan Gillmor and Roger Shattuck (1973); reprinted in *Conversing with Cage*, ed. Richard Kostelanetz (New York: Limelight, 1994), 67.

89. Ibid.

90. In 1962 Cage wrote a score called *0'00"* (also referred to as *4'33" No. 2*, though as we have discussed, with three preceding versions it would technically be No. 4), which points to the most radical outcome of *4'33"* and clarifies its applicability beyond music. The instructions read, "In a situation provided with maximum amplification (no feedback), perform a disciplined action." Pritchett, has discussed the mystifying place this piece holds within his oeuvre: "The fact remains that it stands apart from all that Cage had composed before it." "Part of the problem of approaching *0'00"*," he continues, "is that it does not appear to be 'music' in any sense." He offers a possible explanation: "Later in the 1950s, Cage taught classes in composition at the New School for Social Research in New York City, classes that were attended by artists who would go on to develop the performance art genre: George Brecht, Allan Kaprow, Al Hansen, and Dick Higgins, among others. *0'00"*, with its simple prescription of a concrete action, is similar to many of their performance art pieces, especially the 'events' of George Brecht, where the focus is on a single action described in simple prose." Pritchett, *The Music of John Cage*, 139.

91. The newly developing scope of performativity in Cage's approach at this time is seen in his "45' for a Speaker." This was a lecture written in relation to a score called *34'46.776" for Two Pianists*, prepared for a presentation at the Composer's Concourse in London (October 1954). The lecture deployed the same time structure as that used for the two independent piano parts, "thus permitting the playing of music during the delivery of the speech." See Cage, head note to "45' for a Speaker," *Silence*, 146. Cage defined a list of gestures and actions for the lecture to be followed as a kind of "recipe" in the absence of determinate notation. "45' for a Speaker" continued the work of "Lecture on Nothing" and "Lecture on Something" but rendered the strategies of performativity more overt. Its content comprised previous lecture material collaged with new ideas, and asserted the pedagogical frame by scripting gestures such as: "Lean on elbow," "slap table," "cough," "brush hair," "blow nose." Ibid., 150–153. "45' for a Speaker" became Cage's contribution to *An Anthology*, the landmark collection of advanced scoring practices compiled by La

Monte Young (1961–1963), and it became a model for postpainterly artistic strategies of that moment. Robert Morris's *21.3* (1963), a lecture using the work of art historian Erwin Panofsky as "content," spoken not quite in sync with a recording of the same lecture (with scripted moves such as sipping water, touching spectacles, etc.), would seem to draw directly on Cage's model. Morris was a close friend of La Monte Young and was present when *An Anthology* was compiled (he removed his own contribution at the last minute). La Monte Young, ed., *An Anthology*, 2nd ed. (New York: Heiner Friedrich, 1970).

92. All three "Experimental Music" texts are reproduced in *Silence*.

93. Cage, "Experimental Music," 7. This appears a decade before Roland Barthes's "Death of the Author" (reprinted in *Image, Music, Text*, trans. Stephen Heath [New York: Hill and Wang, 1977]).

94. Cage, "Experimental Music," 8.

95. Cage, "Experimental Music: Doctrine," 13.

96. Ibid., 15. This text contains another significant criticism of Morton Feldman, as if to dislodge his priority. To a made-up question that begins: "I understand Feldman divides pitches . . . leaving the choice up to the performer" (i.e., that he his working with Indeterminacy)? Cage's teacher protagonist responds, "Correct. That is to say, he used sometimes to do so. I haven't seen him lately." Ibid., 16.

97. Ibid.

98. For a thorough account of the theater pieces see Fetterman, *John Cage's Theatre Pieces*.

99. Cage, "History of Experimental Music in the United States," 67. This dismantling move recalls a famous (performative) questioning of history, and the tautology of its recitation by Gertrude Stein, who will come up later in this lecture: "Let me recite what history teaches, history teaches." See Stein, "If I Told Him: A Completed Portrait of Picasso" (1923), in *A Stein Reader*, ed. Ulla E. Dydo (Evanston: Northwestern University Press, 1993), 466.

100. Cage, "History of Experimental Music in the United States," 71.

101. Ibid., 73.

102. Cited from an interview between Cage and William Duckworth in 1989; see Patterson, "Cage and Asia," 64. After comparing the dates Cage cited for his studies with Suzuki with records of Suzuki's courses at Columbia University, Patterson writes, "his particular role in Cage's aesthetic development is a frustratingly speculative issue" (ibid., 63). Patterson's historical frustration is another fact of Cagean performativity.

103. These lectures clarified Cage's new position, which was against most of his peers—despite his continued use of them as examples—and against the European front, from Boulez to Stockhausen. Christopher Shultis explains some of its strategies: "Delivered on Monday, September 8 [1958], Cage gave examples of European music that he regarded as being indeterminate ranging from Bach's *Art of the Fugue* to Karlheinz Stockhausen's *Klavierstück XI*. However he used these two examples for entirely different purposes. Bach was cited in order to give credibility and historical context to indeterminacy in music. Stockhausen was cited in order to criticize European appropriation of Cage's work, through what Boulez called 'aleatory,' a completely different subject from either Cage's use of chance or indeterminacy." See Shultis, "Cage and Europe," in Nicholls, *The Cambridge Companion to John Cage*, 36. When reproduced in *Silence*, Cage added explanatory head notes. The "Indeterminacy" lecture is announced as "intentionally pontifical." See *Silence*, 35.

104. Pritchett observes (*The Music of John Cage*, 126–137) that given their radical divergence from the traditional functions of the score, the indeterminate "scores" in this period are better thought of as "tools." "No longer defined in advance, these scores become tools for how to enact a performance, which contain many alternatives."

105. The deployment of transparencies to open up the "composition" seems to echo Cage's reading of Duchamp's *Large Glass*, which he said he looked *through* more than at. One could look *at* Cage's transparencies, and through them, allowing numerous incidental effects to enter their structure.

106. Kim notes that the variable elements in the score asserted Cage's concern with an ethics in the space of indeterminate performance where the players respect the positions of others (put simply: if someone is on the record player you are supposed to use, you wait, or choose another). See Kim, "In No Uncertain Musical Terms," 193–194.

107. Ibid.

108. Higgins: "Some of us [in the New School course], particularly [Al] Hansen and myself, couldn't for the life of us imagine why Cage was interested in those things. They seemed so abstract, compared with the very concrete observations that Cage favored in connection with the pieces played in class, and so terribly old-fashioned in their implications. Mostly, they read like legal contracts." Dick Higgins, "[June-July, 1958]," in *John Cage: An Anthology*, ed. Richard Kostelanetz (New York: Praeger, 1970), 123.

109. *Water Walk*'s important precedent is *Water Music* (1952), which Fetterman calls the first of Cage's "theater pieces." This included a poster-sized score displayed to the audience, thus sharing the once-privileged knowledge of the composer and performer. The later TV appearances spectacularized this democratizing gesture, literally, with the use of the mirror.

110. Cited in Fetterman, *John Cage's Theatre Pieces*, 32.

111. The program aired on Wednesday, February 24, 1960, and the host stated that the review was from the Sunday before.

112. This idea was part of an exchange with Branden Joseph (Princeton, 2003). I thank him for that discussion.

113. "We must not look for who has the power," Foucault argued. "We must seek rather the pattern of the modifications which relationships of force imply by the very nature of their process." And further, that "relations of power-knowledge are not static forms of distribution, they are 'matrices of transformations.'" Foucault, *History of Sexuality*, 1: 99. Jonathan Crary discusses Deleuze's updating of Foucault in *Suspensions of Perception: Attention, Spectacle, and Modern Culture* (Cambridge: MIT Press, 2001), 76.

114. Crary, *Suspensions of Perception*, 73.

115. Ibid., 76. A tentative subjective opening that Crary poses as a countermodel to the ubiquitous forms of the control of attention is the daydream, whose history, he adds, will never be written. Crary characterizes his model of the daydream in distinctly Cagean terms: "The daydream, which is an integral part of a continuum of attention, has always been a crucial but indeterminate part of the politics of everyday life" (ibid.).

Acconci, Vito, 132
Addiss, Stephen, 146, 148
Adorno, Theodor W., 2 (n2), 5 (n4), 8–9
 (n6), 16n8, 16n9, 22–23, 29, 80–81, 85,
 86, 90, 92, 181
Akerman, Chantal, 120
Altshuler, Bruce, 109
Aria, 151, 205
Aristotle, 47
Arp, Hans, 151
Atlas Eclipticalis, 173
Attali, Jacques, 112

Bacchanale, 176
Bach, Johann Sebastian, 13, 156, 159
Bakunin, Mikhail, 27
Banes, Sally, 117
Barnett, H. G., 112
Barthes, Roland, 36, 40, 42, 43, 46, 47, 103,
 133n9
Bartók, Béla, 37
Beal, Amy, 155
Beer, Douglas, 46
Beethoven, Ludwig van, 13, 22, 28, 62
Benjamin, Walter, 81
Berio, Luciano, 103, 147
Black Mountain College, 16n3, 65, 75,
 146
Black Mountain Piece, 59
Blyth, Reginald Horace, 61–62
Boulez, Pierre, 5, 10, 16n7, 17, 18, 108,
 111, 141, 142, 147, 152, 154, 155, 156,
 157, 173, 190, 199

Braderman, Joan, 35
Braun, Hermann, 152, 156
Brecht, Bertolt, 47
Brecht, George, 101, 102, 105, 107–112,
 114–132, 142, 143, 146, 148, 149–159,
 161, 162–163
Breuer, Marcel, 75
Brown, Earle, 21–22, 108, 112, 142, 152–
 154, 158, 159, 173
Brown, Trisha, 117
Buchloh, Benjamin H. D., 127
Byrd, Bonnie, 175

Cage, Xenia, 52, 58, 177
Campbell, Joseph, 52, 53
Cardew, Cornelius, 141, 200–201
Cassirer, Ernst, 112
Charles, Daniel, 91
Chopin, Frédéric, 22
"Communication." *See* "Composition as
 Process"
"Composition as Process," 56, 59, 92, 141,
 142, 146–148, 150, 152, 155, 157, 199,
 202
Concert for Piano and Orchestra, 2, 5, 6, 8, 22,
 142, 148
*Concerto for Prepared Piano and Chamber
 Orchestra*, 188
Construction in Metal, 20
Coomaraswamy, Ananda K., 50, 53–57, 58,
 59, 60, 61, 64, 180, 181, 205
Cowell, Henry, 49, 51, 148, 160, 174, 177,
 199, 210n22, 214n85

Crary, Jonathan, 207
Credo in Us, 52
Cunningham, Merce, 37, 50, 52, 90, 161,
 175, 177

Daniels, Dieter, 152, 156
Darmstadt, International Summer Course
 in New Music, 17, 109, 119, 135n29,
 141, 142, 155–158, 197, 199, 205
de Antonio, Emile, 148
de Duve, Thierry, 127
Deleuze, Gilles, 114, 115, 120, 207
Derrida, Jacques, 132
Dine, Jim, 146
Duchamp, Marcel, 38, 77, 81–82, 90, 107,
 127, 151
Dunn, Robert, 117

"East in the West, The," 53
Eckhart, Meister, 53, 60
Eco, Umberto, 103, 104
Eimert, Herbert, 109, 111
Erdman, Jean, 52
"Experimental Music," 78, 148, 197–198
"Experimental Music: Doctrine," 27, 59,
 66, 197, 198

Feininger, Lux, 79
Feldman, Morton, 108, 142, 157, 159, 173,
 187–189, 190, 215n96
Fetterman, William, 205
Flynt, Henry, 107, 118, 119, 120
Fontana Mix, 7, 205
"Forerunners of Modern Music," 60,
 182–183, 184
Fort, Syvilla, 176
Forti (Morris), Simone, 101, 117–118
"45' for a Speaker," 59, 84, 214n91
Foucault, Michel, 115, 171, 181–182, 185,
 207
4'33", 59, 78, 82, 103, 104, 113–114, 128,
 133n6, 192, 193–197, 214n90
Freud, Sigmund, 39
Fuller, R. Buckminster, 38
"Future of Music: Credo," 148, 175, 197

Godard, Jean-Luc, 43
Goldwater, Barry M., 31
Graham, Dan, 109, 131

Graham, Martha, 52
Gropius, Walter, 79
Gross, Harvey Y., 146
Guggenheim, Peggy, 210n25

Hába, Alois, 113
Haikai, 51
Halprin, Ann (Anna), 117, 118, 119
Hambraeus, Bengt, 147
Hamilton, Richard, 127
Hansen, Al, 108, 109, 146, 152, 158, 161
Harrison, Lou, 49, 51, 52
Hays, K. Michael, 79–80
Hegel, Georg Wilhelm Friedrich, 42, 160
Heidegger, Martin, 33n22
Helm, Everett, 158
Helms, Hans G., 156
Higgins, Dick, 107–108, 109, 146, 148,
 151, 157, 161, 162–163, 205
"History of Experimental Music in the
 United States," 197, 198–199
Holiday, Billie, 41
Horkheimer, Max, 86
Huang Po, 61, 65–66, 67
Hyde, Scott, 146

Ichiyanagi, Toshi, 102
Imaginary Landscape, 175
Imaginary Landscape No. 4, 67, 152,
 192–193
Imaginary Landscape No. 5, 22, 24–25
"Indeterminacy," 59, 81, 193

Jameson, Fredric, 186–187
Johns, Jasper, 148
Judson Dance Theater, 38, 143
"Juilliard Lecture," 54, 59, 60, 77–78, 84

Kaprow, Allan, 108, 114, 125, 146, 148,
 161–162
Kepes, Gyorgy, 73
Kim, Rebecca Y., 203
Kittler, Friedrich, 112–113
Knowles, Alison, 161
Koenig, Gottfried Michael, 6, 18, 30–31
Kolisch, Rudolf, 5, 13, 16n3
Kostelanetz, Richard, 196
Kosuth, Joseph, 105, 131
Kotz, Liz, 151

Kouzel, Al, 146
Kristeva, Julia, 40
Kwang-tse, 61, 66–67

Lacan, Jacques, 39, 186, 191
Lao-tse, 68
Lebel, Robert, 127
Le Corbusier, 73–77, 87–89, 93
"Lecture on Nothing," 59, 60, 62, 183–187, 190
"Lecture on Something," 59, 187–188, 190
Lennon, John, 102
Lewis, George, 157
LeWitt, Sol, 109
Lippard, Lucy, 131
Lippold, Richard, 49, 77, 78
Löns, Hermann, 26

Maciunas, George, 102, 107, 123, 125–126, 127, 129, 139n82
Mac Low, Jackson, 102, 146
Maderna, Bruno, 147, 155
Mallarmé, Stéphane, 130
Marx, Karl, 17, 27, 30, 39
Maxfield, Richard, 111, 119, 146
McLuhan, Marshall, 68
McPhee, Colin, 51
Merleau-Ponty, Maurice, 33n23
Metamorphosis, 19
Metzger, Heinz-Klaus, 16n8, 23
Meyer-Eppler, Werner, 111
Mies van der Rohe, Ludwig, 78, 79–80, 82, 85, 89, 90, 92
Moholy-Nagy, László, 78–79
Morris, Robert, 101, 105, 117, 123
Morris, Simone. See Forti, Simone
Music for Carillon I (Graph), 82–84
Music for Piano (series), 3, 142, 151
Music of Changes, 59, 154, 155, 159, 188, 190, 191–192
Music Walk, 15, 160, 161, 200–205

New School for Social Research, 16n3, 107, 109, 111, 119, 141–146, 148–158, 160–161, 162, 205
Nilsson, Bo, 147, 150, 155
Noguchi, Isamu, 57
Nono, Luigi, 9, 18, 28, 141, 147
Nyman, Michael, 125

Oldenburg, Claes, 125
One⁹, 51
Ono, Yoko, 101, 102, 105, 120, 129, 132n1, 139n76
"Overpopulation and Art," 93

Paik, Nam June, 124
Parker, Charlie, 157
Partch, Henry, 51
Patterson, David W., 181, 184
Perilous Night, The, 179–180
Pollock, Jackson, 107, 151, 161, 162, 183
Poons, Larry, 146
Pousseur, Henri, 18, 103, 147
Pritchett, James, 174, 176, 179, 183, 185, 192
"Program Notes," 108–109

Quartet, 19

Rainer, Yvonne, 117
Ramakrishna, 58–59, 60, 64
Rauschenberg, Robert, 44, 148, 194
"Rhythm Etc.," 73, 76, 79, 80, 88, 89, 93
Riley, Terry, 117, 118
Robinson, Julia, 151
Ross, Nancy Wilson, 52
Rousseau, Jean-Jacques, 38
Rutgers University, 146–148
Ryoanji, 50

Santner, Eric, 172, 196
Sarabhai, Geeta, 57–58, 180
Satie, Erik, 55, 62
Schiller, Friedrich, 2
Schmidt, Tomas, 126
Schoenberg, Arnold, 5, 9–10, 12–13, 16n7, 21, 41, 57, 64, 86, 113, 119, 173, 174, 182, 187, 192, 199, 205
Schreber, Daniel Paul, 172, 191, 196
Schwitters, Kurt, 44, 80
Seasons, The, 50
Segal, George, 146
Seven Haiku, 50
Shakespeare, William, 62
Shultis, Christopher, 155, 156, 215n103
Silence, 171, 197, 198
Sixteen Dances, 50
Snow, Michael, 120

Sonatas and Interludes, 50, 180
Sounds of Venice, 160, 161, 205
Spoerri, Daniel, 126
Stein, Gertrude, 186, 199, 215n99
Stein, Leonard, 119
Steinecke, Wolfgang, 155–156, 197
Stirner, Max, 27
Stockhausen, Karlheinz, 5, 14, 17, 18, 19,
 108, 109, 111, 112, 119, 142, 147, 152,
 154, 155, 158–159, 199
Straub, Jean-Marie, 16n7
Stravinsky, Igor, 20, 182
String Quartet, 20
String Quartet in Four Parts, 50
Suzuki, Daisetz Teitaro, 60, 62–65, 68, 69,
 198–199, 205

Tafuri, Manfredo, 80
Tarlow, Florence, 146
Thomson, Virgil, 177
Thoreau, Henry David, 68
Trio, 19
Tudor, David, 119, 142, 146, 154, 155–156,
 161, 190, 200–201, 202, 203, 205
TV Köln, 205
Two³, 51
Two⁴, 51

van der Marck, Jan, 117
Varèse, Edgar, 20, 113, 199
Variations I, 6, 84, 142, 151, 202
Variations II, 84, 85
Vostell, Wolf, 126

Walworth, Dan, 46
Warhol, Andy, 120
Waring, Jimmy, 118
Water Music, 117, 160
Water Walk, 15, 160, 161, 205–206
Watts, Robert, 108, 134n18, 146, 148
Webern, Anton, 9, 10, 12, 31, 81, 108–109,
 119, 143
Weil, Simone, 65
Weiner, Lawrence, 130, 131
Weiss, Adolf, 174
White, Hayden, 42, 45
Williams, Paul, 74–77, 89
Williams, Vera, 75
Williams Mix, 22
Winn, Marty, 41

Winter Music, 3, 142
Wolff, Christian, 108, 142, 157, 159, 161,
 173

Young, La Monte, 101, 102, 105, 112,
 117–123, 124, 127, 129, 130, 132,
 132n1, 137n60

0'00", 214n90
Zimmer, Heinrich, 53